Essential
SURREALISTS

This is a Parragon Publishing Book
This edition published in 2001

Parragon Publishing
Queen Street House
4 Queen Street
Bath BA1 1HE, UK

Copyright © Parragon 1999

Created and produced for Parragon by
FOUNDRY DESIGN AND PRODUCTION,
a part of The Foundry Creative Media Co. Ltd,
Crabtree Hall, Crabtree Lane
Fulham, London, SW6 6TY

ISBN: 0-75254-229-X

Essential SURREALISTS

TIM MARTIN

Introduction by Dr. Mike O'Mahony

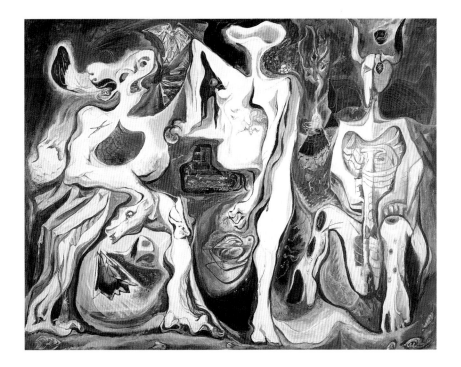

𝑝

CONTENTS

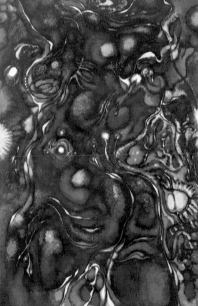

CONTENTS

INTRODUCTION

*T*O describe an event or experience as "surreal" today is to adopt a familiar figure of speech. The word immediately conjures up ideas of the weird and the wonderful, of disjointedness and disorientation, of the inexplicable and the unfamiliar. We imagine worlds in which fish swim through the sky or inanimate objects metamorphose into living beings before our very eyes. Yet such images, more in tune with the world of dreams and nightmares than with everyday life, perhaps originate less in our own imaginations than in the drawings, paintings, and sculptures produced by a group of artists working predominantly in the period between the two world wars.

Surrealism was a broad intellectual movement that originated in the early 1920s, dominated the years between the wars and was briefly revitalized in the post-Second World War years. By the 1960s, the movement had all but died. While France, and particularly the city of Paris, was always Surrealism's spiritual home, the movement spread its influence throughout the world. During the 1920s and 1930s, Surrealist groups also emerged in the European cities of Brussels, Copenhagen, London, and Prague, and gradually reached the more distant shores of Japan, Mexico, and the U.S.A.

Surrealism originated as a response to a crisis in Western culture following the end of the First World War. Its proponents sought to liberate what they identified as the corrupted values of society, values which they perceived as responsible for the devastation caused by the

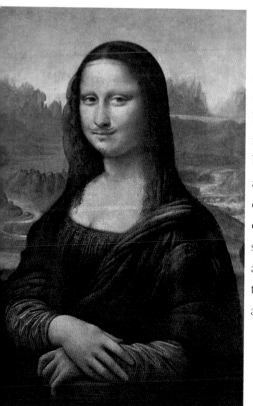

recent international conflict. Many of Surrealism's first supporters emerged from within the earlier movement known as Dada. This fundamentally anarchic movement had originated in neutral Zurich during the First World War. It predated Surrealism by several years and for a short period the two movements co-existed. While Dada and Surrealism both denounced conventional bourgeois attitudes and sought to revolutionize cultural practices, they did, however, adopt distinct strategies. At the heart of the Dada movement lay the concept of protest, subversion, and rebellion. Surrealism, however, adopted a more programmatic approach, embracing the psychoanalytical investigations of Sigmund Freud and the political ideology of Marxism in order to

produce its own intellectual
revolution. An attempted
adherence to these two seemingly
irreconcilable philosophies
contributed to constant debate and
antagonism among Surrealists,
causing rifts, break-ups, and re-
alignments of the major actors
in the Surrealist drama.

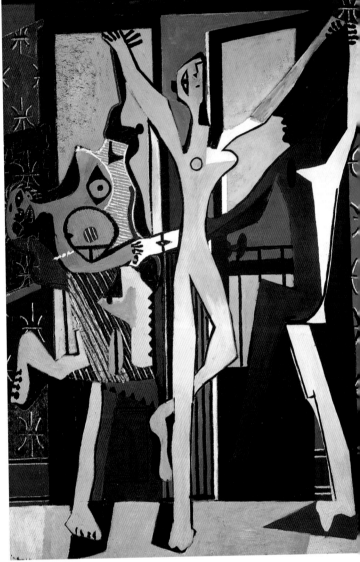

The word "Surrealism" was
originally coined by the French
writer Guillaume Apollinaire.
Describing a 1917 production of
Jean Cocteau's ballet *Parade*,
which featured both the music of
Erik Satie and stage designs of
Pablo Picasso, Apollinaire
claimed that the performance
revealed a truth beyond the real,
"a kind of sur-realism."

This word, however, was
soon appropriated by another
French writer, André Breton, to
describe the activities of a new
literary and artistic movement.
Breton was without doubt the
founding father and most significant figure in the promotion of the
Surrealist movement. Unlike many of his generation, Breton was not a
combatant in the First World War. He did, nonetheless, witness first-
hand the atrocities of the conflict while working as a medical orderly in
a psychiatric ward. Here he encountered patients who had suffered
severe mental breakdown as a consequence of shellshock. It was also
here that Breton first became familiar with Freud's recent investigations
into the workings of the human mind. In particular, he witnessed early
attempts, through such techniques as hypnosis, to unlock the inner
workings of the tormented minds of his patients. These personal
experiences were ultimately to shape the underlying ideology of
Surrealism.

However, while Freudian psychologists valued such techniques strictly as a form of therapeutic treatment—a means by which they could alleviate the suffering of the mentally scarred victims of war—Breton identified a potential method of accessing a new kind of reality in this inner mind, a reality more intense and less controlled by the strictures of social life.

Back in Paris in 1919, Breton, along with fellow writers Philippe Soupault and Louis Aragon, produced a journal entitled *Littérature* (1919–24) which soon drew the attention of other young artists and writers. It was here that Breton and Soupault adopted a new writing technique that they labelled *"Automatism."* In their early experiments, the two writers attempted to produce a poetic work collaboratively, but without any preconceived notions of subject or

style. By interspersing randomly conceived sentences the authors produced a text dictated by arbitrary, irrational thought processes. Even the title of the resulting text, *The Magnetic Fields*, captured the sense of illogicality and disorientation sought by Breton and Soupault.

The dominance of the verbal over the visual within Surrealism at this time was reinforced in Breton's *First Manifesto of Surrealism*, published in 1924. Here Breton defined the objective of Surrealism as a desire "to express—verbally, by means of the written word, or in any other manner—the actual functioning of thought, in the absence of any control exercised by reason, exempt from any aesthetic or moral concern." By the end of the year, however, the tide began to turn. In December 1924, Breton launched a new journal to replace *Littérature. La Révolution Surréaliste* (The Surrealist Revolution) differed from its predecessor in its increasing emphasis on the visual arts. In 1925 Breton's treatise *Surrealism and Painting* was serialized in the journal and, over the next three years, the careers of artists including Yves Tanguy, Salvador Dalí, and René Magritte were launched through the pages of this influential publication.

Following Breton's lead, several artists adopted various Automatist techniques in the production of their works. The painter André Masson, for example, often forced himself to work under conditions of extreme duress, after long periods without sleep or food or under the influence of drugs. Masson believed that by forcing himself into a state of reduced consciousness he would get closer to the workings of his unconscious mind. Another technique adopted by Surrealist artists to circumvent rational thought processes was based upon the popular children's game of Consequences. In this game, a piece of paper is folded into four horizontal strips and the participants each draw a part of a body without seeing the part drawn by their fellow collaborators. The resulting image is thus produced randomly and beyond the overall control of a single rational mind. By adopting this technique, artists including Man Ray, Yves Tanguy, and Joan Miró produced collaborative works which were subsequently called *Exquisite Corpses*, a term deriving from a literary version of the game which threw up the phrase "the exquisite corpse will drink the new wine." Many of these drawings were reproduced in *La Révolution Surréaliste*.

Although experiments with the technique of Automatism dominated early Surrealist practices, artists increasingly turned to the analysis of dreams as a means to access the inner workings of the unconscious. The world of dreams always fascinated the Surrealists and it was here that their greatest fantasies could be given visual form. From the mid-1920s, many Surrealist artists, including most notably Max Ernst, Salvador Dalí, and René Magritte, produced "dream paintings;" works either based directly upon dreams experienced by the artist, or which alluded to the condition of dreaming. In contrast to Automatist works, which relied upon collaboration or spontaneous mark making, "dream paintings" were carefully planned and executed in a highly realistic and detailed style.

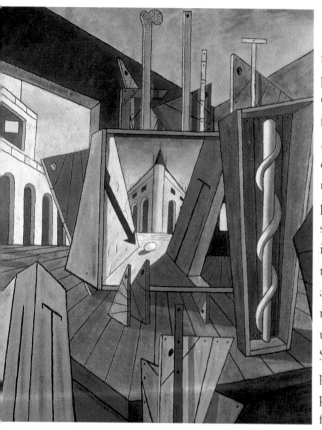

Unquestionably the greatest influence upon the development of "dream painting" was the work of Italian artist Giorgio de Chirico. In the early 1910s, a full decade before Breton's *First Surrealist Manifesto*, de Chirico produced a number of works in which a strange assortment of unrelated objects were incongruously presented within eerie architectural settings. Here, the juxtaposition of unrelated inanimate objects, rendered in a conventional representational style, suggests a significance and meaning that cannot ultimately be resolved. This juxtaposition of the unrelated was of huge appeal to the Surrealists, who regularly plundered its potential to disorient the viewers of their pictures. In particular, Breton deployed a famous quotation from the writings of the nineteenth-century author Isidore Ducasse—the self-styled Comte de Lautréamont—as a kind of rallying cry for Surrealism: "as beautiful as the chance encounter of an umbrella and a sewing-machine on a dissecting table." Breton's emphasis on this quotation perhaps also reveals the darker, more sinister side of mystery as it appealed to the Surrealists. For although Lautréamont's image conjures up mystery through incongruity, it also implies a sense of threat or violence through the notion of dissection. De Chirico's works, while evoking a mood of nostalgia and melancholy, similarly imply an underlying threat. The strange low lighting, long shadows, and empty, elongated perspectives convey a dark and sinister mood to the scenes depicted. Here, strange unreal encounters, represented with the utmost clarity and verisimilitude, seem to encapsulate the world of dreams and nightmares. This simultaneous presentation of the ordinary and the extraordinary, of uncertainty and anxiety, of magic, mystery and threat, subsequently proved irresistible to the Surrealists. While de Chirico never personally joined the Surrealist movement—his post-First World War return to a Classical style was anathema to Breton and his followers—his role as precursor to Surrealism remains undeniable.

The German-born artist Max Ernst was particularly inspired by the condition of dreams and regularly incorporated dream-like imagery into his works. Ernst was particularly fascinated by Freud's analysis of dreams and is known, when in Germany, to have read several of his key texts, including *The Interpretation of Dreams*. Indeed the Freudian notion

of the Oedipus complex—the unconscious desire of a child, found more commonly in a male child, to replace his father and to possess his mother sexually—frequently recurs as a motif in Ernst's works of the 1920s. In his *Pietà or Revolution by Night*, for example, he reconstructs a dream vision in which the artist appears as a Christ-like figure in the arms of his own father. It has been claimed that here Ernst was referring to an incident in his own childhood when he ran away from home. On his return, Ernst's father, also a painter, is reported as having incorporated the image of his son's face in a painting of Christ as a child. Ernst established a notional psychoanalytical basis for the reading of his works, as if the image is a recollection of a particular dream with a specific psychoanalytical interpretation. In effect, Ernst offered himself as a patient for analysis. Yet this element of psycho-biographical self-presentation is very much a mythical construction, a self-fulfilling fantasy which establishes the unconscious mind and the world of dreams as the nexus of a new form of visual representation.

Like Ernst, the Spanish painter Salvador Dalí was also fascinated by the world of dreams and introduced a repertoire of Freudian motifs into his work. Dalí arrived in Paris in 1929 having been introduced to Breton and his group by fellow Spaniard Joan Miró. His works are notable for their small scale and exquisitely rendered detail. By adopting a hyper-real technique, described by one critic as images as if seen through the wrong end of a telescope, Dalí imbued his works with an

almost hallucinatory quality, in which the weird juxtapositions and metamorphoses result in what Dalí himself described, somewhat enigmatically, as "concrete irrationality." To allude to the world of the unconscious, Dalí deployed a particular Freudian-inspired technique which he called his "paranoiac-critical" method. Dalí was fully aware of the contemporary research interests of both Freud and the French psychoanalyst Jacques Lacan. In particular, Freud and Lacan were studying the effects of paranoia and its impact upon the perception and interpretation of its sufferers. Paranoia was seen to result in a confusion

between the real and the imagined, in which inner obsessions distorted the perception of the real world. In an effort to replicate this condition, Dalí deliberately attempted to misinterpret the world around him so that familiar objects adopt unfamiliar forms and are seen in incongruous settings. In Dalí's works, solid objects ooze and melt into languid, biomorphic shapes, while inanimate forms are metamorphosed into living beings before our very eyes.

The Belgian artist René Magritte also produced works that alluded strongly to the metamorphic nature of dreams. Magritte first visited Paris in 1927 and was embraced by Breton's group. By 1930, however, he had fallen out with Breton and returned to his native Brussels. Perhaps more than any other of the Surrealist painters, Magritte's works transformed the ordinary and innocuous into the extraordinary. The objects featured in Magritte's works are often of the most mundane nature: an apple, a pipe, or a bowler hat, yet it is the context in which these works are presented that raises awkward questions. His works, at first glance, seem to suggest a simple narrative explanation, but any attempt at constructing such a narrative is soon confounded, resulting in an inexplicable sense of mystery that imbues his work with a dream-like quality. Magritte, like many Surrealists, was also drawn to silent movies and detective novels, and made frequent references to these forms of popular culture in his work.

By the end of the 1920s, Surrealism had established itself as a major cultural practice under the dominating leadership of Breton. However, the publication of a new periodical, *Documents*, instigated a tense debate between rival factions within the movement. The editor of this new journal, Georges Bataille, shifted the focus of Surrealism away from the magical quality of the dream toward an analysis of the baseness of human instinct. Breton's response to this shift in direction was effectively to re-launch the Surrealist movement. Attacking Bataille for his failure to adhere to the official line, Breton re-emphasized the revolutionary credentials of his movement with the publication of a new manifesto (1930) and the launch of a new journal which was entitled *Surréalisme au Service de la Révolution* (Surrealism at the Service of the Revolution). Earlier in 1927 Breton, along with Louis Aragon and other Surrealists, had declared his commitment to revolutionary politics by joining the French Communist Party. For Breton, however, the struggle to reconcile the spiritual and emotional elements of Freudianism with the strictly material concerns of Marxism proved insurmountable. The International Congress of Revolutionary Writers, held in Kharkov in 1930, brought this issue to a head. The official rejection of Freudianism as an appropriate revolutionary doctrine ensured that Surrealism was increasingly ostracized from the Marxist movement, and by 1933 Breton and several of his colleagues had been expelled from the Communist Party.

During the 1930s, women played an increasingly prominent role within the Surrealist movement, yet it was the exploitation of the idea of "woman" as expounded in the work of male artists that frequently determined the gendered nature of Surrealist art. Within the movement, women were celebrated for being more in touch with the irrational, emotional side of their nature. This deeply problematic assumption led

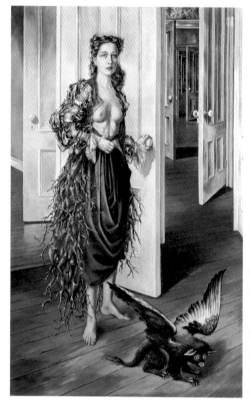

to representations of "woman" as the perfect, Pygmalion-like muse for the male Surrealist artist. Many artists objectified the female body by representing it as a shop mannequin, an empty shell into which the imagination and creativity of the male artist would breathe life. In this way, the female body became the site upon which male artists enacted fantasies, often of an erotic and even violent nature. In the work of Hans Bellmer, for example, the female body is depersonalized, fragmented, and dismembered into a new and deliberately disturbing form of fetish object.

Despite Surrealism's often-problematic attitude toward gender, many women, including Eileen Agar, Leonora Carrington, Frida Kahlo, Meret Oppenheim, and Dorothea Tanning, did participate as major artists within the movement. For them, Surrealism's ultimate emphasis on the examination of the inner being sanctioned a close analysis of their own individualities, allowing their works to reveal many of the complexities and problems inherent within gender-designated roles in society. Surrealism attracted increasing attention in the international arena during the 1930s. Between 1932 and 1935, exhibitions featuring supporters of Surrealism were staged in Brussels, Copenhagen, New York, and Prague while, in 1936, London held the first of a series of official International Surrealist Exhibitions specifically planned to encourage the expansion of the movement abroad. In London, French artists participated alongside such British artists as Eileen Agar, David Gascoyne, Henry Moore, Paul Nash, and Roland Penrose. Over the next four years, Tokyo, Paris, Amsterdam, and Mexico City were all to stage International Surrealist Exhibitions, resulting in an expansion of support for the movement throughout the world. With the outbreak of the Second World War, however, activity inevitably declined. As the Nazis marched into Paris and the occupation began, Breton and many of his Surrealist colleagues, including Ernst, Masson, Tanguy, and the Chilean artist Roberto Matta, fled to the U.S.A. Here their presence was to make a huge impact upon the subsequent development of

modern art. Once on American soil, the Surrealists-in-exile soon established themselves within their new milieu by staging a number of exhibitions. In addition they launched a new Surrealist publication entitled *VVV*. Over the next decade, Surrealism's emphasis on Automatist techniques and the potential revelation of the unconscious mind fascinated many young American painters including Robert Motherwell, Arshile Gorky, and Jackson Pollock. Their subsequent development of Abstract Expressionism owed no small debt to their contact with European Surrealism.

Breton was never comfortable in the U.S.A. and returned to his native France when the war ended. In the aftermath of the conflict, however, Surrealism never regained the heady heights that it had achieved in the inter-war years, losing ground both to the Existentialist movement and to an increasing emphasis on abstraction in the visual

arts. Undaunted, Breton continued to support Surrealist activities among a new, younger generation of artists, until his death in 1966. With the loss of its spiritual and intellectual leader, however, Surrealism was no longer able to retain the focus and cohesion that Breton had consistently imposed, and the movement inevitably declined.

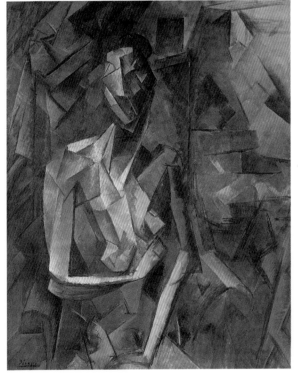

Ultimately, Surrealism proved to be one of the most significant literary and artistic movements of the twentieth century. It changed the intellectual landscape of our time and its legacy—still evident in the way contemporary artists, writers, film-makers, and even advertising agencies continue to explore and exploit the subjective inner world that Surrealism attempted to reveal—continues to shape the way we view the world and our role within it.

MIKE O'MAHONY

HENRI ROUSSEAU (1844–1910)
The Dream, 1910

M.O.M.A., New York. Courtesy of Topham

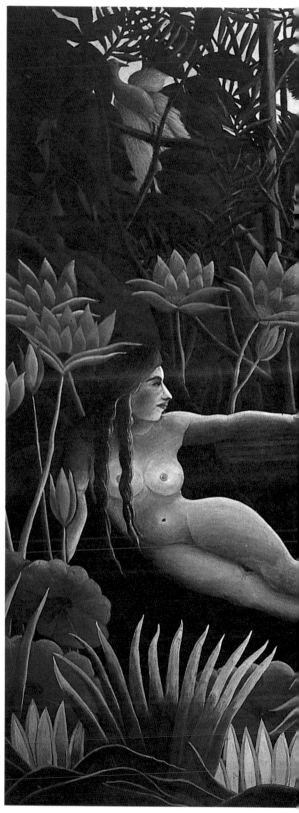

THE Surrealists admired the work of Henri Rousseau, although he died in 1910. He was a "Sunday painter" without any formal training who aspired to paint in the style of the French Academy. The Surrealists admired his extremely personal style, even if Rousseau himself did not. As he painted every detail, the result was not academic realism, but a dream-like style, rich in color. Rousseau claimed to have seen such sights while in Mexico, and though this was probably not true, he was a regular visitor to Paris's botanical gardens, where he studied exotic plants and tropical vegetation. In this picture, Rousseau has depicted a variety of jungle animals lurking with menace or hiding in fear. The reclining female nude remains calm and secure, like a primitive fertility goddess enthroned in her flourishing kingdom. Even the lions seem tamed by her gaze and gesture. Her round sculptural forms recall a long tradition in European painting while the proportions of her body evoke the art of non-European cultures, such as those of Mexico or Africa.

Although this painting has the quality of a scene painted from life, it represents a glimpse of heightened reality, filled with symbolic characters that stems from a very personal, almost eccentric imagination.

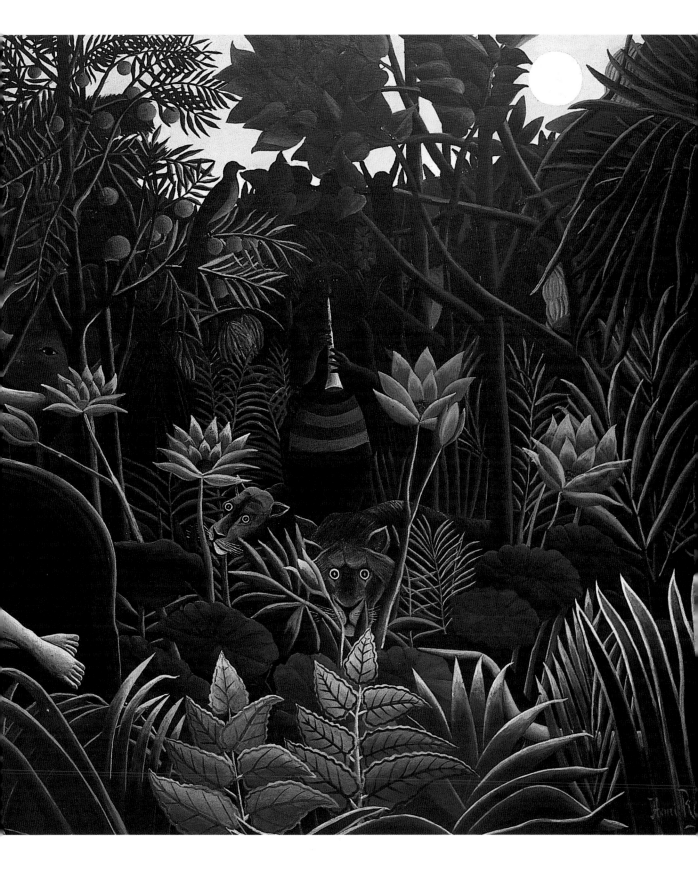

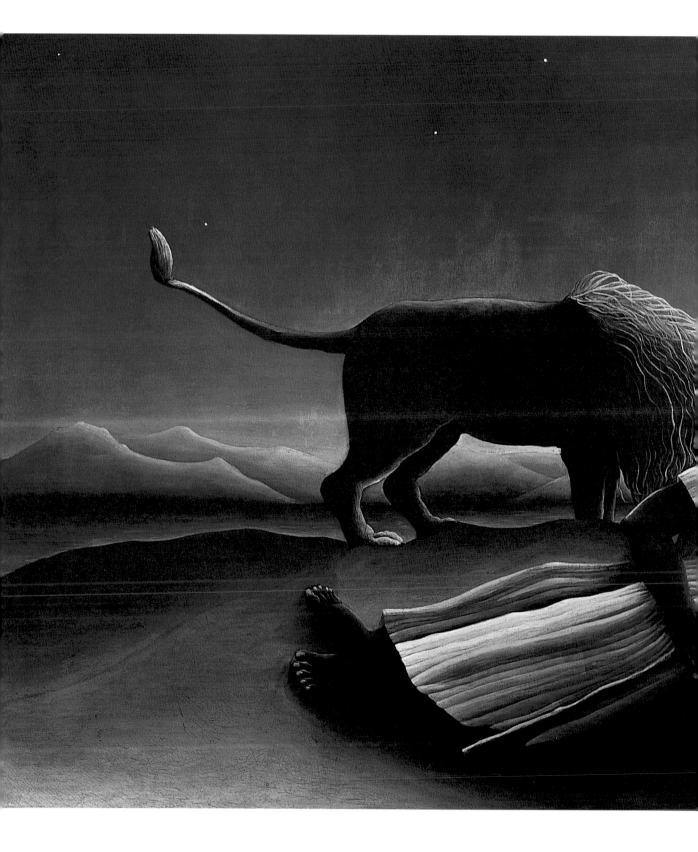

HENRI ROUSSEAU (1844–1910)
Sleeping Gypsy, c. 1910
M.O.M.A., New York. Courtesy of Topham

ROUSSEAU has depicted a desert scene in which a sleeping gypsy musician is visited by a curious lion. Lit by the moon, the landscape is painted in smoothly graded shades of gray. In the foreground, the richly colored stripes of the gown have been subdued by darkness. To keep the forms clear in such light, the artist has given each one a clear, sharp outline. Overall, the style recalls a medieval Italian religious icon. His composition, with its linear rhythm, consistent modeling, and dim light, was self-taught.

Although Rousseau's art was unsophisticated, indeed naïve, the Surrealists enjoyed his work for its intimation of prehistoric art, as though he himself represented a living example of a primitive artist. In this painting, Rousseau recalls a tradition of exotic fantasy painting. Not only has he painted a dream of a far-away land in which man and nature live in suspense and harmony, he also depicts an inner experience which the Surrealists could interpret using Freud's technique of dream analysis.

GIORGIO DE CHIRICO (1888–1978)
The Uncertainty of the Poet, 1913
Courtesy of the Tate Gallery

SURREALISM as a movement took its inspiration from many sources. It evolved from Dada, an earlier, nonsensically named art movement. In the early years of the twentieth century, Dada artists promoted anarchy and experimentation in modern avant-garde art. Although Surrealism evolved out of the disruptive, tragi-comic manifestations of Dada, it also acknowledged the influence of more traditional artists, ranging from the Symbolists and Romantics of the nineteenth century to the work of Italian artist Giorgio de Chirico.

The Futurist movement, which also flourished in Italy at this time, looked to France and to Cubism. De Chirico, however, looked to the Renaissance and ancient Roman art. What made his work avant-garde was the manner in which he distorted the Classical and Renaissance sense of calm, balance, and harmony, as can be seen in *The Roman Villa* (1922). Ancient Italian art idealized the human figure, depicting a rational world in which the viewer could feel confident and optimistic. De Chirico introduced distortions into apparently rational

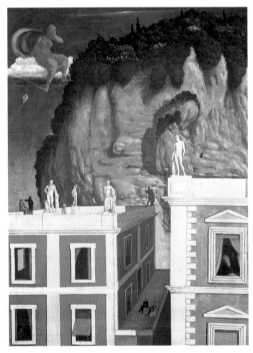

scenes and in so doing made his pictures seem more worried and disturbing. *The Uncertainty of the Poet* has made an unexpected juxtaposition of a twisted classical female torso with a bunch of bananas. This combination suggests many diverse interpretations, yet remains enigmatic and dream-like.

Giorgio de Chirico (1888–1978)
The Roman Villa, 1922
Collection Casella, Florence. Courtesy of Giraudon. (See p. 30)

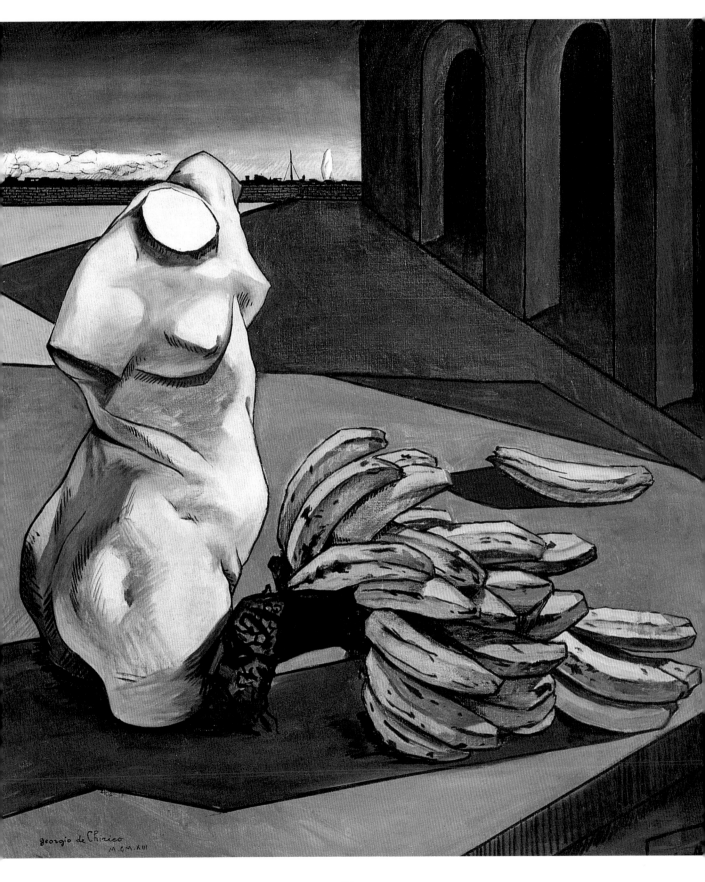

georgio de Chirico
M.C.M.XII

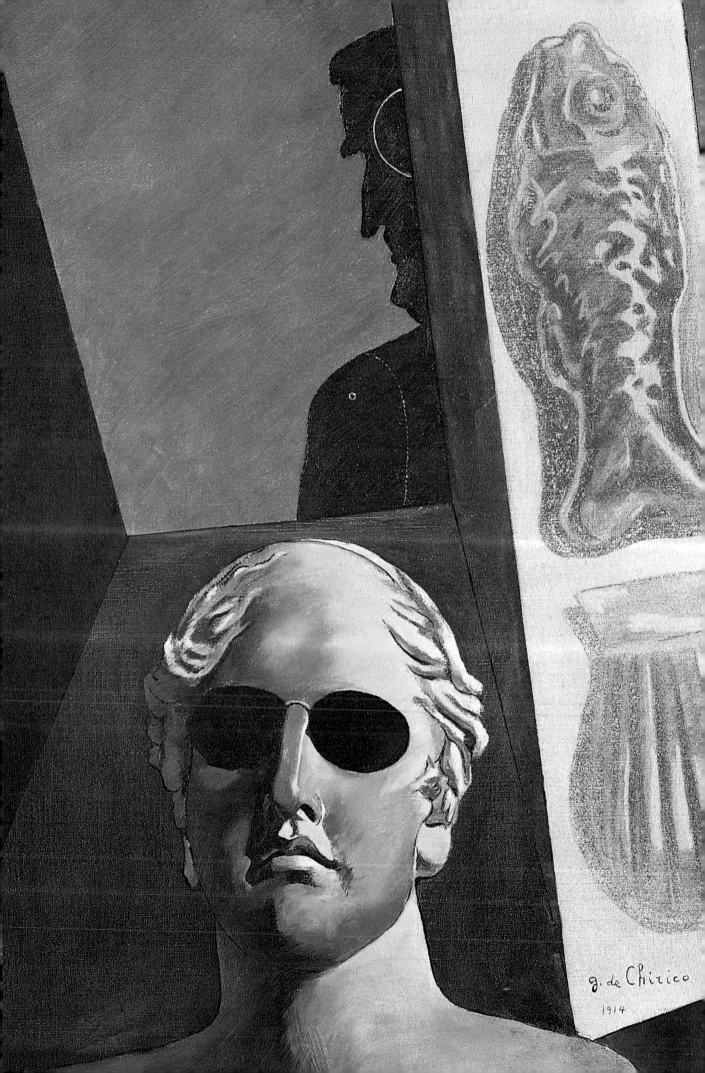

g. de Chirico
1914

GIORGIO DE CHIRICO (1888–1978)
Portrait of Apollinaire as a Premonition, c. 1914
National Museum of Modern Art, Paris. Courtesy of Giraudon

IN 1914, de Chirico made two paintings in tribute to the poet and art critic Guillaume Apollinaire. These painting express his gratitude for the poet's defense of "metaphysical painting," and honor him by using the style of Classical portrait sculpture. As in *The Uncertainty of the Poet* (1913), the Classical object is positioned near an unexpected one, in this instance cooking molds. In keeping with Classical tradition, the poet is blind, although the tradition has been up-dated by the use of sunglasses. Apollinaire may have been the first advocate of modern painting, especially Cubism, but his interests were very broad, ranging from de Chirico to pre-historic and tribal art. Behind the poet a silhouette of a man appears, in the style of the targets used for rifle practice. Just as

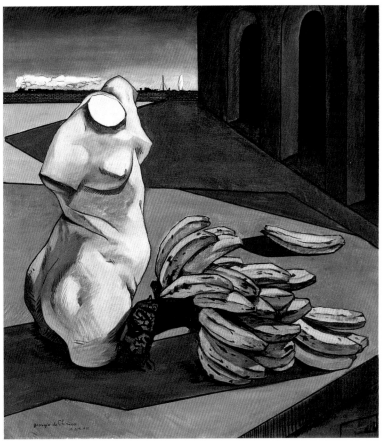

Giorgio de Chirico (1888–1978) *The Uncertainty of the Poet, 1913*
Courtesy of the Tate Gallery. (See p. 20)

the sharp eye needed for shooting contrasts with his blindness, so do the flat black shapes contrast with the acid green background. As it turned out, this painting was a premonition: Apollinaire joined the French army at the beginning of the First World War, and was hit in the head by a bomb fragment. Dying of his wounds shortly after the war, Apollinaire's death robbed de Chirico of one of his most eloquent exponents.

GIORGIO DE CHIRICO (1888–1978)
The Melancholy of Departure, 1916
Courtesy of the Tate Gallery

D E CHIRICO often used the theme of travel and departure in his paintings of trains and railroad stations. In this painting he has used a mysterious map without cities or borders. As de Chirico was born in Greece, this picture could represent his childhood move to Italy. Parts of the routes of several sea journeys have been marked, yet it is never clear whether they are destinations or points of departure. Above the map is an assemblage of objects used to make paintings and an easel to hold the map. These objects form a loose, open sculpture that demonstrates the artist's knowledge of the fundamentals of Cubism, as does Man Ray's *By Itself* (1918). The sculpture stands in a cold light, while around it are warmly colored shadows. The muted greens and browns create a sense of subdued reflection, while the bright yellow and red flag suggests further travels.

This is one of the artist's later metaphysical paintings, in which

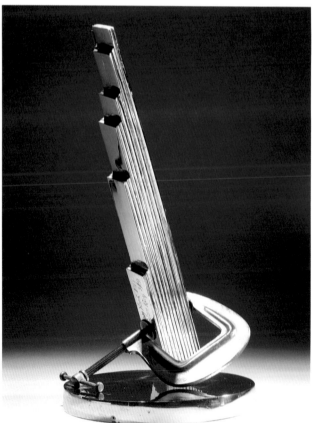

he sought to paint the hidden meanings behind the surface appearance of things. The need to explore such ideas in his work probably owes much to the fact that de Chirico was deeply unhappy at this time, moving from Turin to Ferrara and suffering a nervous breakdown.

Man Ray (1890–1976)
By Itself, 1918
Courtesy of Christie's Images. (See p. 176)

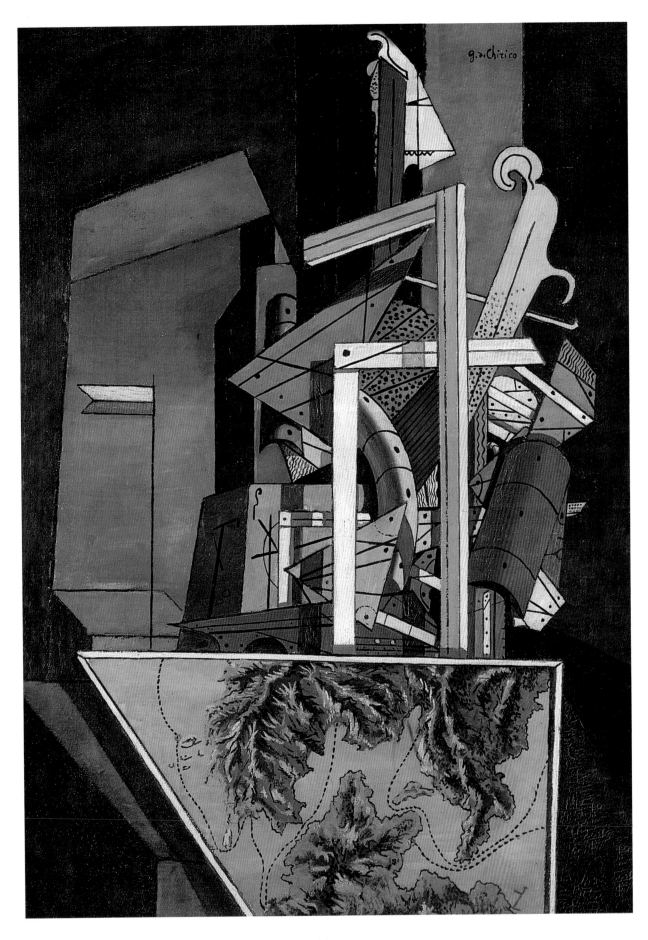

GIORGIO DE CHIRICO (1888–1978)
Metaphysical Interior, 1917
Van der Heyt Museum, Wuppertal. Courtesy of Giraudon

GIORGIO de Chirico was probably the most important influence on the Surrealist movement. His work suggested an internal world, a theatrical space that appealed to André Breton, the founder of the movement. Many artists, such as Dalí, Magritte, and Max Ernst, used de Chirico's work as a starting point in the representation of dreams, hallucinations, and delusions. His influence can be seen in Ernst's work *Perturbation my Sister* (1921).

De Chirico called this "metaphysical painting" because it represented the inner being of things. For de Chirico, every object had two aspects: an everyday image seen by all, and a spectral image, a metaphysical appearance. The latter were only visible to certain individuals in moments of clarity, as if they had the powers of the recently discovered X-ray. In explaining metaphysical painting he said: "To have original, extraordinary, and perhaps even immortal ideas, one has but to isolate oneself from the world for a few moments so completely, that the most commonplace happenings appear to be new and unfamiliar, and in this way reveal their true essence." In this painting, de Chirico has mixed an inner, studio, space with an outer, public, space. Within the studio we see a painting of the external space, suggesting that we experience reality on many different levels.

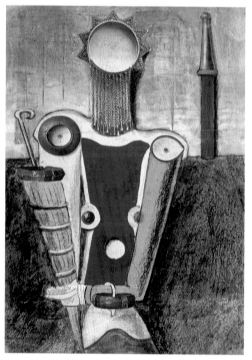

Max Ernst (1891–1976)
Perturbation my Sister, 1921
Victor Loeb Collection, Berne. Courtesy of Giraudon. (See p. 99)

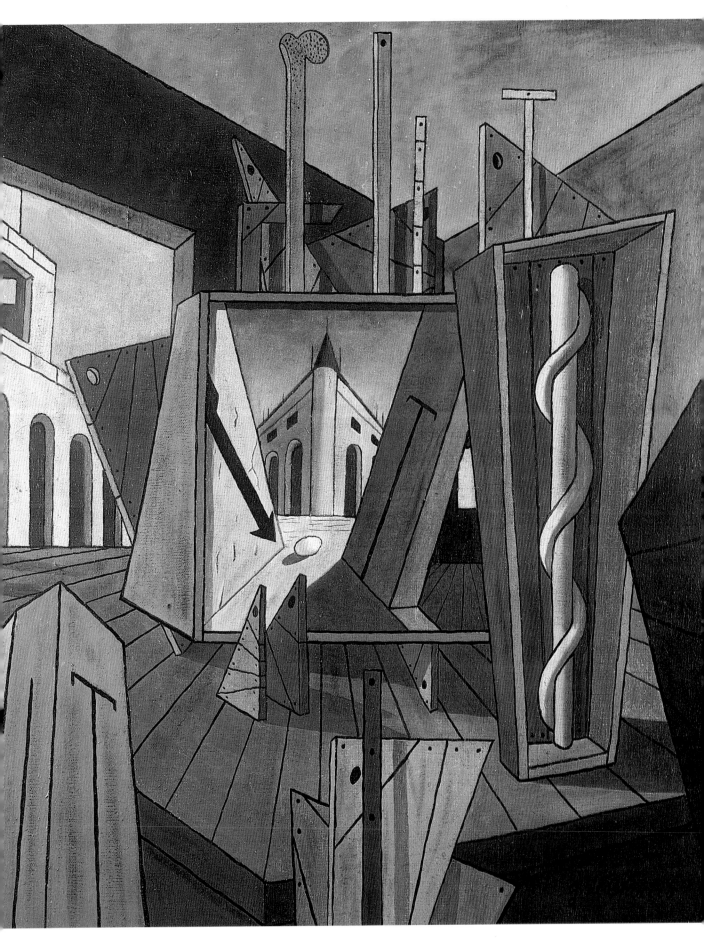

GIORGIO DE CHIRICO (1888–1978)
The Sacred Fish, 1919
M.O.M.A., New York. Courtesy of Topham

THE sacred fish in this painting refer to two different religious traditions. In Christianity, they represent Christ, who said "come with me and you shall be fishers of men." The Christian theme is continued in the placing of the fish at right angles to suggest a cross. In the Classical Roman tradition, the entrails of fish and other animals were used to predict future events and to determine the causes of misfortune. This theme is evoked by the gutting of the fish, although they are laid on a block with a perspective so steep that it is distorted.

This scene is caught in a moment, as if the blue curtain had just been drawn. The light falls from outside, while inside the candle flame has been replaced by the yellow legs of a starfish. The sky is dark and foreboding, the shadows long and cold. The modeling in this painting is firm and sure, indicating a continued interest in clear Classical form. Rather unusually, the artist has used a thick paint laid on with long vertical brushstrokes, which allowed him to experiment with softer edges and shadows, which led to a renewed interest in the paintings of the Old Masters. This was one of de Chirico's last metaphysical paintings before he embarked on a series of copies of Renaissance masters such as Raphael and Mantegna. Compared to the explorations of the masters of Dada, such as Marcel Duchamp, de Chirico was more serious in tone, remarking in 1912 that "a truly immortal work of art can only be born through revelation." Duchamp's best-known Dada image, *L.H.O.O.Q* (1919) betrays the artist's sense of humor as well as well as his rebellion against the contemporary political order.

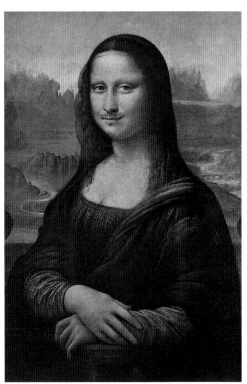

Marcel Duchamp (1887–1968)
L.H.O.O.Q., 1919
Pictogramma Galleria, Rome. Courtesy of Giraudon. (See p. 44)

GIORGIO DE CHIRICO (1888–1978)
The Roman Villa, 1922

Collection Casella, Florence. Courtesy of Giraudon

THIS is one of a series of paintings that de Chirico did on the theme of the Roman villa during the period 1920–22. Unlike the Surrealists, he had a passion for Classical architecture and art; the statues on the top of this villa are accurate copies of Roman originals. However, by placing them on a more modern building, he has evoked a sense of time suspended, while tension is increased by drawing the eye upward despite the downward looking viewpoint.

The painting creates an atmosphere of late afternoon calm and rest. The heat of midday has passed and a sense of calm has descended. While a wistful woman emerges from an interior shade, two men watch a scene set outside the frame of the painting.

By 1922 de Chirico, despite his tremendous early influence on the Surrealists, was criticized by Breton for abandoning his initial inspiration. This painting was too nostalgic for many Surrealists artists, who took it to be a sign of his diminishing abilities. Other artists of the time, such as Andre Masson, were working toward Surrealism via Cubism, as can be seen in *Underground Figure* (1924).

André Masson (1896–1987)
Underground Figure, 1924
Courtesy of Christie's Images. (See p. 79)

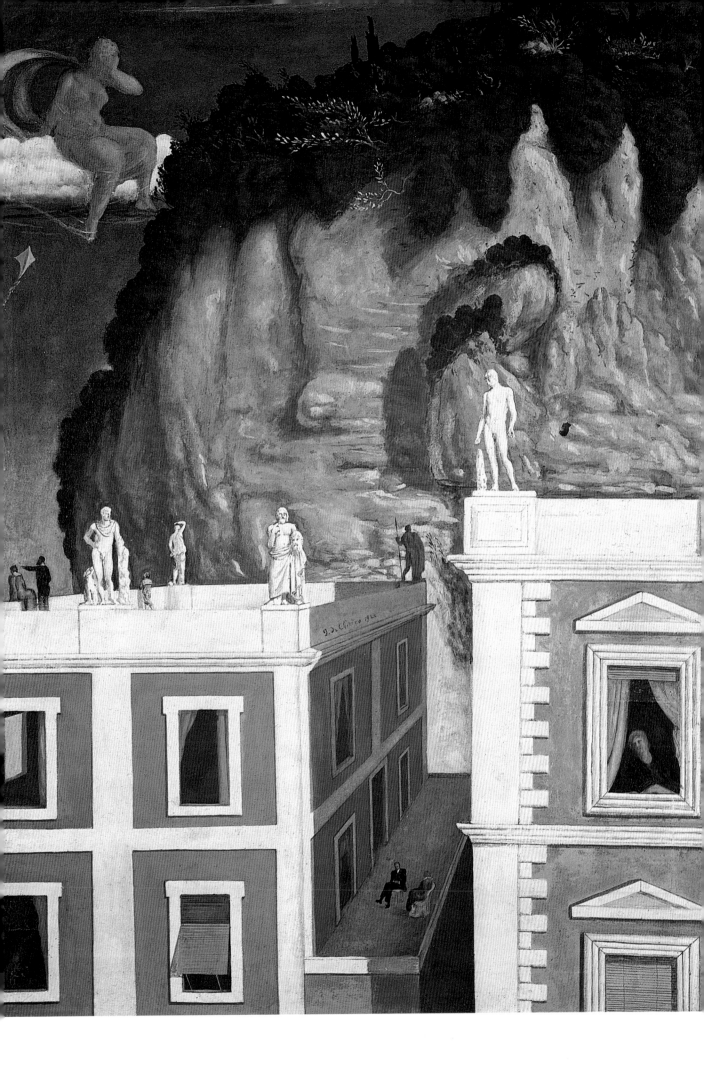

GIORGIO DE CHIRICO (1888–1978)
Hector and Andromaca, 1924 AND *1946*
Courtesy of Christie's Images

DE CHIRICO painted and sculpted two versions of this subject; although they were executed more than 20 years apart, each was created in the aftermath of a world war. In both versions he used the Classical tradition of historical painting, which was meant to edify and impress, and transformed the central character into an armored mannequin. *Hector and Andromaca* represents a moment from Homer's *Iliad*, which recounts one of the oldest ancient Greek legends. In this story of masculine honor and love Hector, the great Trojan champion, bids goodbye to his wife before going off to a certain death in hand-to-hand combat with the Greek champion Achilles, who was the son of a goddess and therefore supposedly invincible. By using mannequins, de Chirico seeks to take the personal sadness out of the story, while making it more universal at

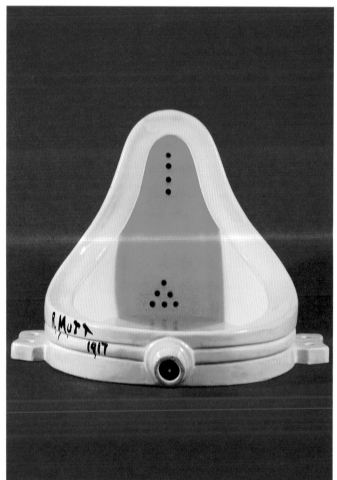

Marcel Duchamp (1887–1968) *The Fountain, 1917*
Courtesy of Christie's Images. *(See p. 42)*

the same time. Tragic loss is known by every generation, as the mannequin makes clear. For many a Surrealist painter, however, de Chirico had struck an overly sentimental chord.

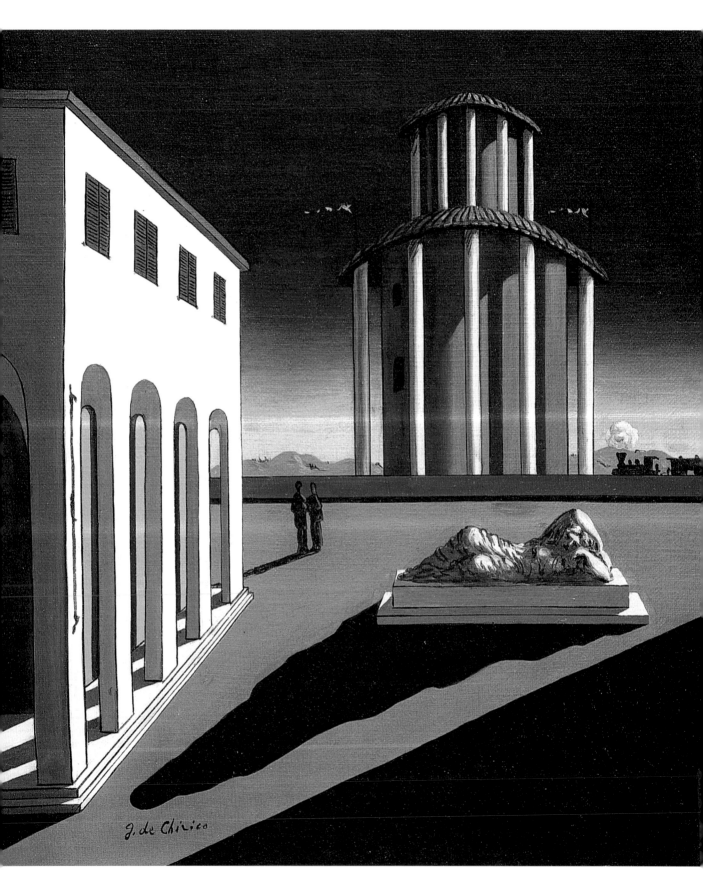

GIORGIO DE CHIRICO (1888–1978)
Piazza d'Italia, c. 1930s
Courtesy of Christie's Images

*I*N the steeply sloping perspective of this urban scene and the dramatic foreshortening of its objects, de Chirico created a strange sense of proximity, without breaking the rules of perspective. He had little interest in the way that the Cubists flattened out pictorial space or dissolved distinctions between object and background. In *Seated Nude* (1909), Picasso virtually abandoned representation for abstraction, but de Chirico turned to a form of distortion that was soon likened to that of a dream state.

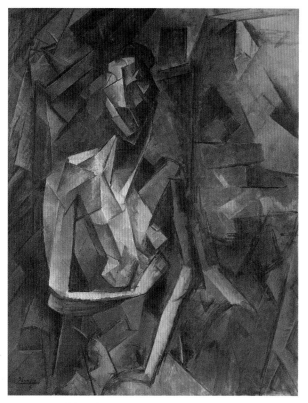

Pablo Picasso (1881–1973) *Seated Nude, 1909*
Courtesy of the Tate Gallery. *(See p. 54)*

De Chirico described the relation between this painting and his experience by saying: "one clear autumnal afternoon I was sitting on a bench in the middle of the Piazza Santa Croce. It was of course not the first time I had seen this square. I had just come out of a long and painful illness, and I was in a nearly morbid state of mind. The whole world, down to the marble of the buildings and the fountains, seemed to be convalescent ... The autumn sun, warm and unloving, lit the statue and the church façade. Then I had a strange impression that I was looking at all these things for the first time, and the composition of my picture came to my mind's eye."

GIORGIO DE CHIRICO (1888–1978)
The Seeker, c. 1930s
Courtesy of Christie's Images

*I*LLUMINATED by a source that lies outside the frame, this painting provides a scene reminiscent of an Italian town square. Distorted and simplified colors and long enigmatic shadows are used to represent a background space devoid of human characters. Human presence is marked instead by the peculiarity of the vision, and in the clearly subjective and personal meanings of the objects assembled in the space. The combination of historical architectural space with personal memories evokes a lost epoch and a lost distant childhood.

De Chirico often used mannequins in his paintings and sculptures, to create a sense of loneliness and stillness. As figures, their

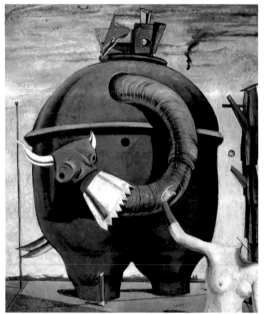

emotions are suspended and their parts are never completed. In this mannequin's chest is a large red wooden object that suggests a heart, and a degree of frustration in love. The cause of this heart-ache is suggested by the shadow of a figure standing outside the frame. Max Ernst also used mannequins in *Elephant of Celebes* (1921).

Max Ernst (1891–1976)
Elephant of Celebes, 1921
Courtesy of the Tate Gallery. (See p. 96)

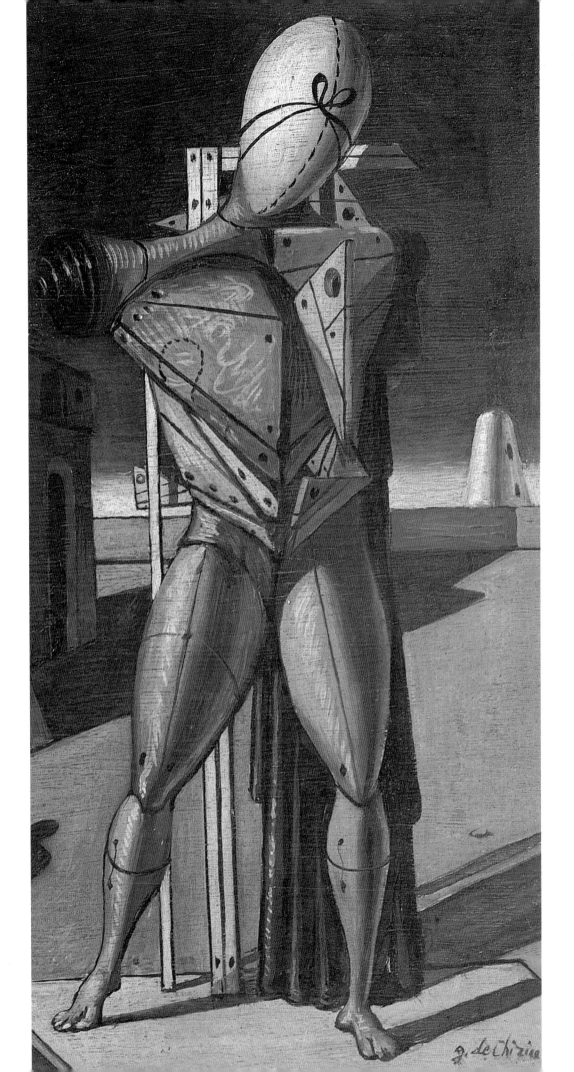

MARCEL DUCHAMP
(1887–1968)
The Chess Players, 1911

National Museum of Modern Art, Paris.
Courtesy of Giraudon

*T*HIS painting demonstrates Marcel Duchamp's gift as an artist, and his interest in the developments going on in Paris at the time, such as Picasso's Cubism. In this painting of his two brothers, with whom he shared an interest in painting and chess, he has taken up Picasso's style. Duchamp's sketch, like the final painting, uses muted colors, especially greens, yellows, and browns, to portray simplified objects and spaces. To this he has added a more curved and organic line that repeats across the surface to create the illusion of motion.

The movement in space that this painting portrays refers more to mental than to physical action. The intense concentration and competition between the brothers occurs in an interior space that is rich in atmosphere and personal resonance. Duchamp was not to stick with either Cubism or Futurism, yet one of his paintings, *Nude Descending a Staircase* (1911) became one of the most celebrated paintings of the period leading up to Surrealism.

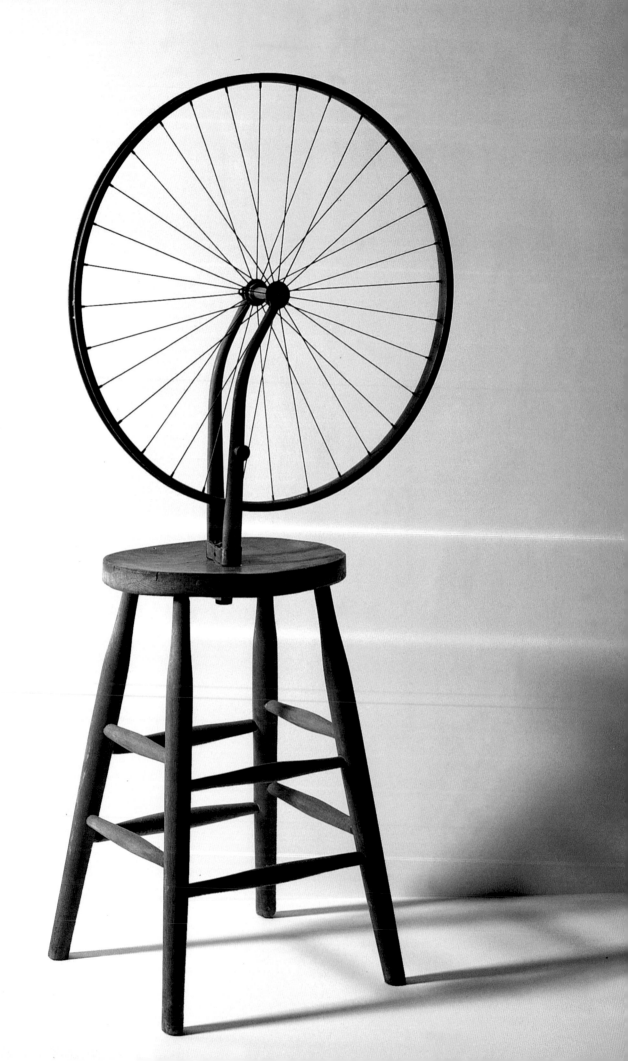

MARCEL DUCHAMP (1887–1968)
Bicycle Wheel, 1913 and 1963
Richard Hamilton College, Henley. Courtesy of Giraudon

BY 1913, Duchamp had originated the concept of "readymade" works of art, in which an object was selected and declared to be a work of art. Among such works, he included a snow shovel, a urinal, a bottle rack, and a coat peg. The pure Readymade was chosen, claimed Duchamp, for its utter lack of artistic qualities. Despite his considerable artistic abilities, he wished such objects to be selected in a state of total indifference, verging on boredom. The Readymades have inspired many books and provoked a wide range of interpretation.

Bicycle Wheel, however, was made because Duchamp found the sight of the spinning wheel gave him pleasure. Set spinning, he would watch it, mesmerized, until it stopped. Later he made other spinning works, such as his rotoreliefs which, with their eccentric circles, added an element of optical illusion. Mass-produced and cheap, they were meant to be viewed on that latest piece of home technology—the phonograph. Instead of listening, you looked. As in this example, Duchamp re-made his Readymades several times, thus provoking the charge that he finally surrendered to the demands of the art market. As Alberto Giacometti's *Caroline* (1962) shows, many disparate styles of painting were current.

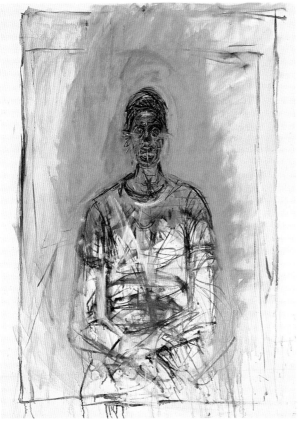

Alberto Giacometti (1901–66)
Caroline, 1962
Kunstmuseum, Bâsle. Courtesy of Giraudon. (See p. 206)

MARCEL DUCHAMP (1887–1968)
The Fountain, 1917
Courtesy of Christie's Images

DUCHAMP defined the Readymade as "everyday objects raised to the dignity of a work of art by the artist's act of choice." He caused general confusion in the art world when he submitted this work for exhibition. In the end, the organizers simply hid the work from sight. He has signed the work using the name of a plumbing manufacturer, as if the artist was not part of the transition from useful object to art object. In effect, nothing of the artist is in the work. However, he raised the question of the difference between art and life, and the value of human creation. In its own ironic way, indoor plumbing was as great a civilizing advance as any art.

Some critics have commented on the temptation to see the work as beautiful, and in this sense Duchamp suggests that anything can be pleasing to the eye. The work is also sexually suggestive. In placing the urinal horizontally it appears more passive, and feminine, while remaining a receptacle designed for the functioning of the male penis.

Duchamp considered this Readymade to be of primary importance, and included it in his *The Suitcase* (c. 1920).

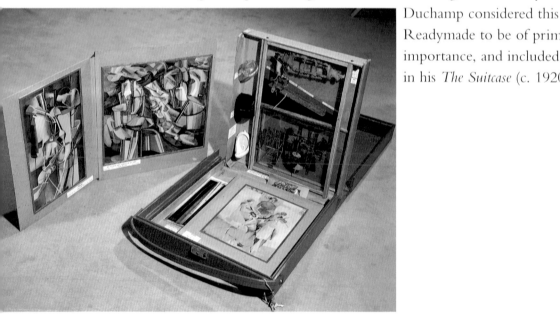

Marcel Duchamp (1887–1968) *The Suitcase, c. 1920*
Courtesy of Christie's Images. *(See p. 47)*

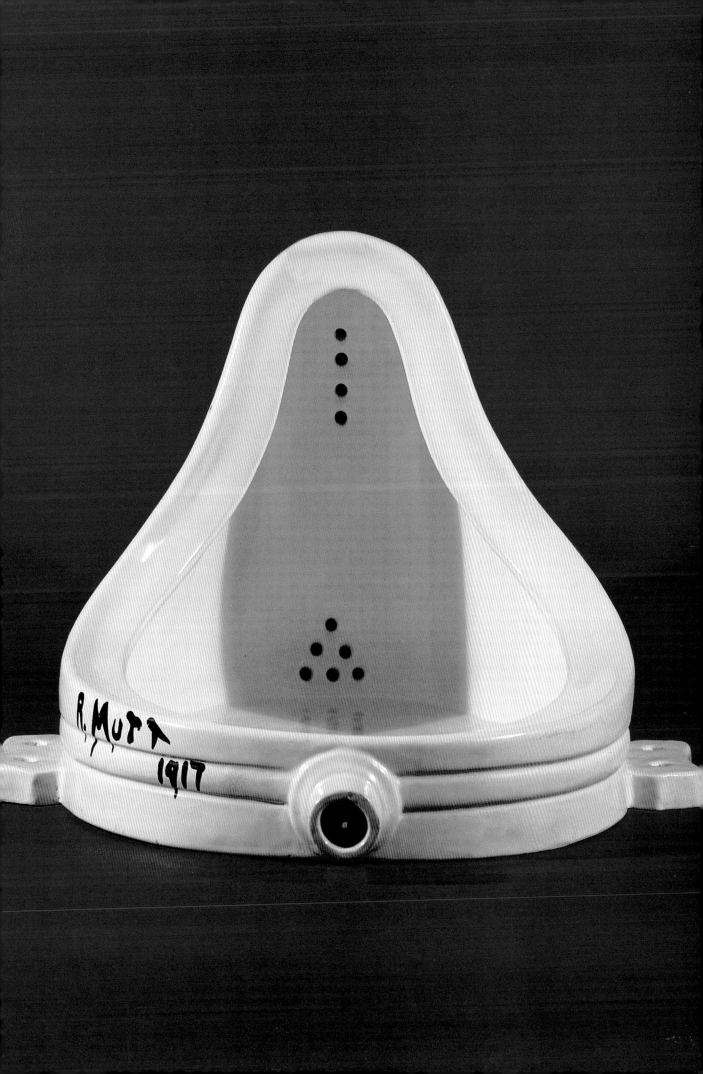

MARCEL DUCHAMP (1887–1968)
L.H.O.O.Q., 1919

Pictogramma Galleria, Rome. Courtesy of Giraudon

*T*HIS is one of the best known of all Dada images. It attacks the art of the museum, and the political system of royal patronage that supported official taste. By putting graffiti on an Old Master, he was making a sign of rebellion, a rejection of tradition, and a loss of values. If Dada was becoming too anarchic to have real political force, this image continued the tradition of Dada humor with the growing Surrealist interest in repressed sexual drives. The abbreviation at the bottom, when pronounced in French, sounds like the phrase "she has a hot arse." This verbal game suggests Freud's belief that verbal mistakes and slips of the tongue were signs of unconscious wishes. While many a connoisseur wrote poetic comments on the meaning of Mona Lisa's smile, Duchamp gives us the code of silent feminine desire. She smiles because she is aroused.

Duchamp often assumed the role of the bored indifferent artist, yet his influence on Surrealism was substantial, even if not direct. Here he has used an existing high art image to play with erotic messages and reversals of sexuality. He raised many questions in this surprisingly simple work and also created a female alter-ego strangely named Rrose Sélavay (Eros That's Life) to make a similar point about the bisexual nature of all human desire. His later work, particularly the sculpture such as *Etant Donnés* (1945–66) become more overtly erotic.

Marcel Duchamp (1887–1968)
Etant Donnés (Taken as Given), 1945–66
Modern Art Museum, Stockholm. Courtesy of Giraudon. (See p. 50)

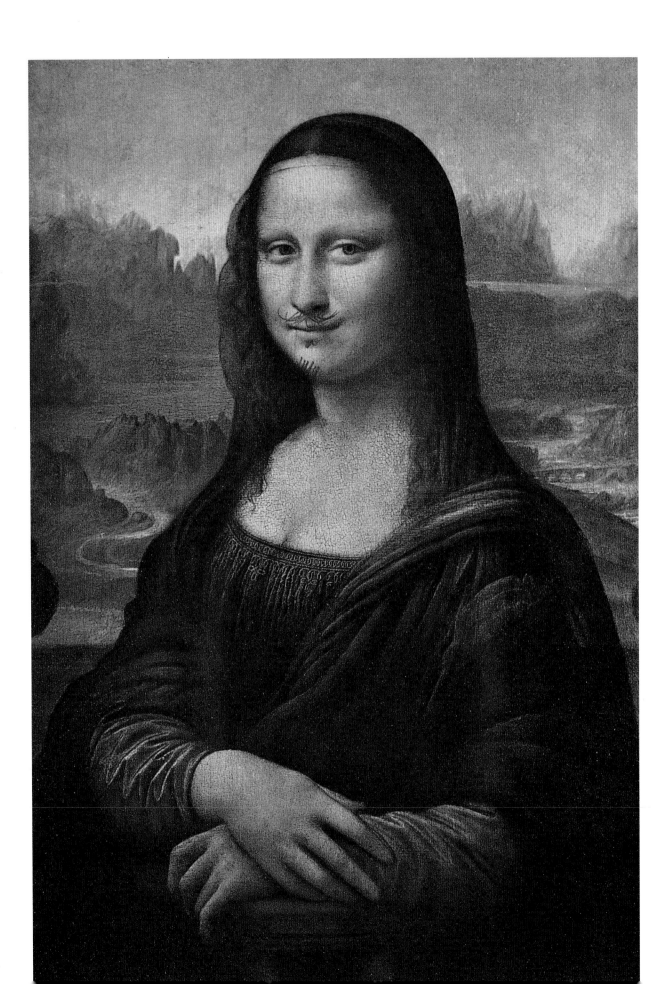

MARCEL DUCHAMP
(1887–1968)
The Suitcase, c. 1920
Courtesy of Christie's Images

DUCHAMP often traveled between America and Europe and, because he liked to take his work with him, he constructed a suitcase containing miniature versions of his work. The case could be unpacked to create an instant display. Rather like a traveling salesman, he displayed his wares as an ironic comment on the art market. There was, however, to be a twist to the irony: during the Second World War, Duchamp smuggled the work out of occupied France using a cheese salesman's identity card.

These suitcases, of which he made 20 copies, were serious and meticulous in their attempt to summarize his work. They included interviews, written statements by the artist, and reproductions of all his major works. If Duchamp had broken many traditions of art and scribbled on the *Mona Lisa*, he was also aware of an opposite feeling. He turned his works into portable mysteries, mixing the reverent with the irreverent. None of the work included was to be considered for its beauty or for its aesthetic pleasure. The suitcases were to be regarded as investigations into the complex problem of love, with its multiple meanings.

MARCEL DUCHAMP (1887–1968)
The Bride Stripped Bare by Her Bachelors, Even, 1917-23
Courtesy of Christie's Images

*T*HIS small work was made as part of a series of documents known as *The Green Box*, in preparation for *The Large Glass*. The simple, green painting is reminiscent of lighted advertising signs on the front of cinemas. While Duchamp was busily ignoring artistic tradition with his Readymades, he was also working on a way to surpass painting, including Cubism, altogether. His answer was to work on glass, and to develop a beauty based on mathematical relationships. He made many careful drawings and designs for this work before making the final piece in leaded glass.

Along with this work, Duchamp included in *The Green Box* a set of detailed notes for those who wished to read about *The Large Glass*, and added reproductions of his preparatory drawings. The notes explain that the upper part of the work represents the bride, while the lower part represents a group of bachelors who take shots at the woman above. The work's veiled reference to sex made it popular with Surrealists. The machine-like side of sex was treated with gentle humor and wit. Compare this with the overt sexuality of *At the First Clear Word* (1923) by Max Ernst.

In 1923, Duchamp could not decide how to finish the work, but declared it complete when the glass was cracked during shipping. The fact that the cracks were delicate and expressive appealed to his iconoclastic views of art.

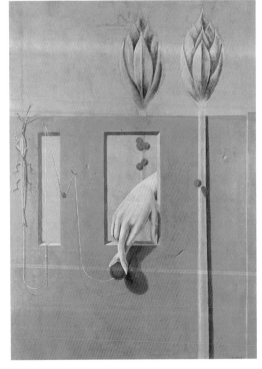

Max Ernst (1891–1976)
At the First Clear Word, 1923
Courtesy of Giraudon. (See p. 102)

MARCEL DUCHAMP (1887–1968)
Etant Donnés (Taken as Given), 1945–66

Modern Art Museum, Stockholm. Courtesy of Giraudon

FOR many years Duchamp claimed that he had retired as an artist. During this time he worked quietly on two major sculptures. The second one, *Etant Donnés*, was graphically explicit to the point of being pornographic. It can only be viewed by peeking through a small hole in an old battered door. In this work Duchamp suggests the primary pleasure which the eye seeks, yet at the same time suggests a degree of violence and loss of human subjectivity. The woman lies on her back with legs spread and head missing, as if the sexual gaze reduces the individual to a body stripped of character and personality. This work was not widely known in his lifetime. When compared to Picabia's *Naked Woman in Front of a Mirror* (1943), Duchamp is more graphic and less sentimental in his portrayal of the nude.

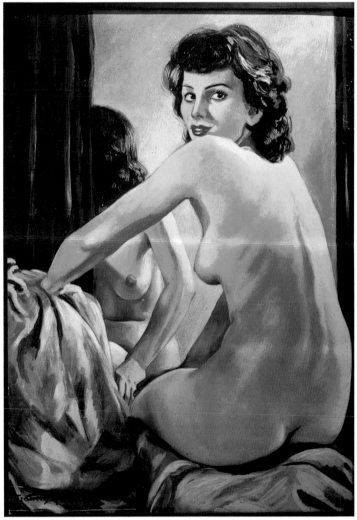

Francis Picabia (1879–1953) ***Naked Woman in Front of a Mirror, 1943***
Courtesy of Topham. (See p. 74)

PABLO PICASSO (1881–1973)
Girl in a Chemise, 1905
Courtesy of the Tate Gallery

*P*ICASSO painted *Girl in a Chemise* some 10 years before his development of Cubism. The picture's clear debt to the Symbolist movement of the late nineteenth-century places it as an early Surrealist work.

Prompted by the death of his friend Carlos Casegemas, Picasso painted a number of pictures of outcasts, impoverished musicians, and beggars, later calling this gloomy period of his youth his "Blue Period." This sad and tender portrait of a young woman, thin, underfed, yet beautiful despite her poverty, is a late Blue-Period work. In *Weeping Woman* (1937) Picasso had lost this tenderness and realism. There is a compassion and melancholy in this work evoked by a backdrop of cool blue, the delicate modeling and the artist's supreme skill. The face is slightly exaggerated, much in the manner of Toulouse-Lautrec, though its serenity also recalls the faces of Classical Greek and Roman art. The elongated limbs and metallic light are reminiscent of sixteenth-century Spanish Mannerist painters such as El Greco. Picasso does not experiment with the forms of painting but strives to create emotional pathos.

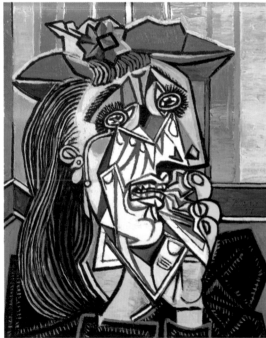

Pablo Picasso (1881–1973)
Weeping Woman, 1937
Courtesy of the Tate Gallery. (See p. 60)

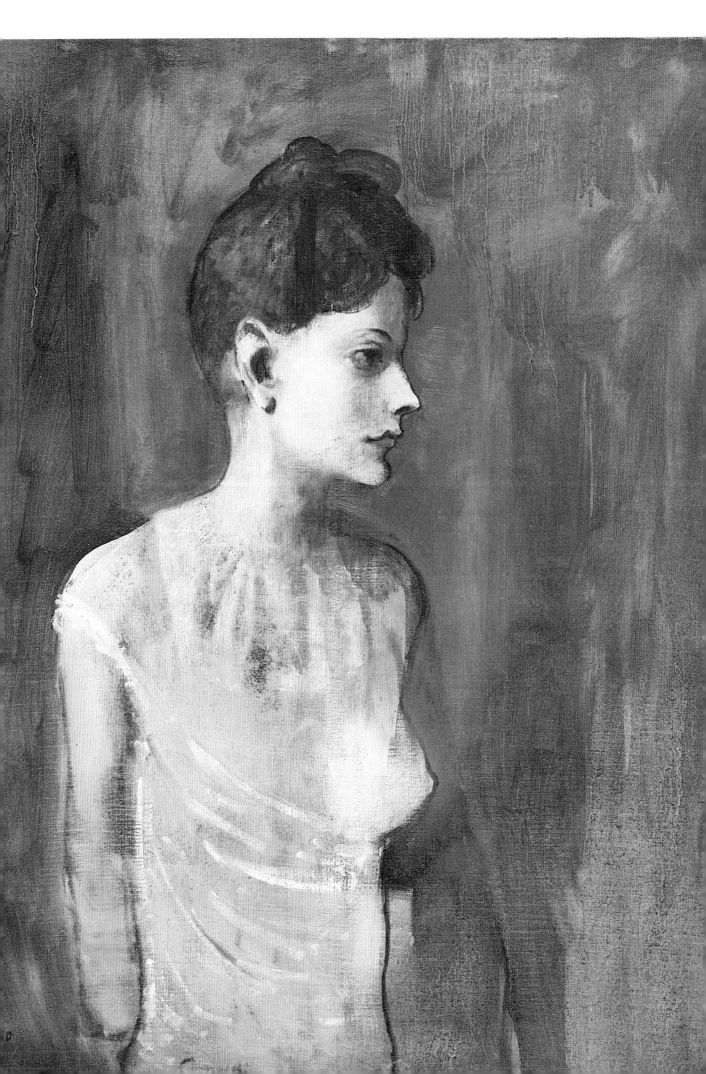

PABLO PICASSO (1881–1973)
Seated Nude, 1909
Courtesy of the Tate Gallery

*T*HIS painting is typical of the first years of Cubism, which is generally recognized as the most important and influential art movement in the first half of this century. Cubism spread widely and rapidly throughout Europe from France, finding fertile ground in Italy, Russia, and Holland. Picasso used abstraction and simplification to reduce painting to its fundamental characteristics of tone, plane, and light. Color, on the other hand, is often almost non-existent. This reduction allowed Picasso to include what he knew to be there as well as what he saw. He used a dense sequence of facets and intersecting planes to mark out a space which is both flat and deep. Here he keeps this tension by treating the canvas with an even "all-over" patterning, and as a result the painting shifts between illusion and material reality.

Cubism was never a static, fixed style; it raced through many experiments with form and ended with collage—the pasting of various objects onto the surface of a canvas. The movement came to a dramatic end in 1920 when Picasso changed to a more Classical style.

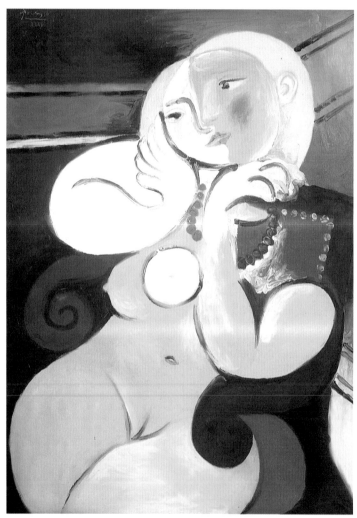

Pablo Picasso (1881–1973) *Nude Woman in a Red Armchair, 1932 Courtesy of the Tate Gallery. (See p. 59)*

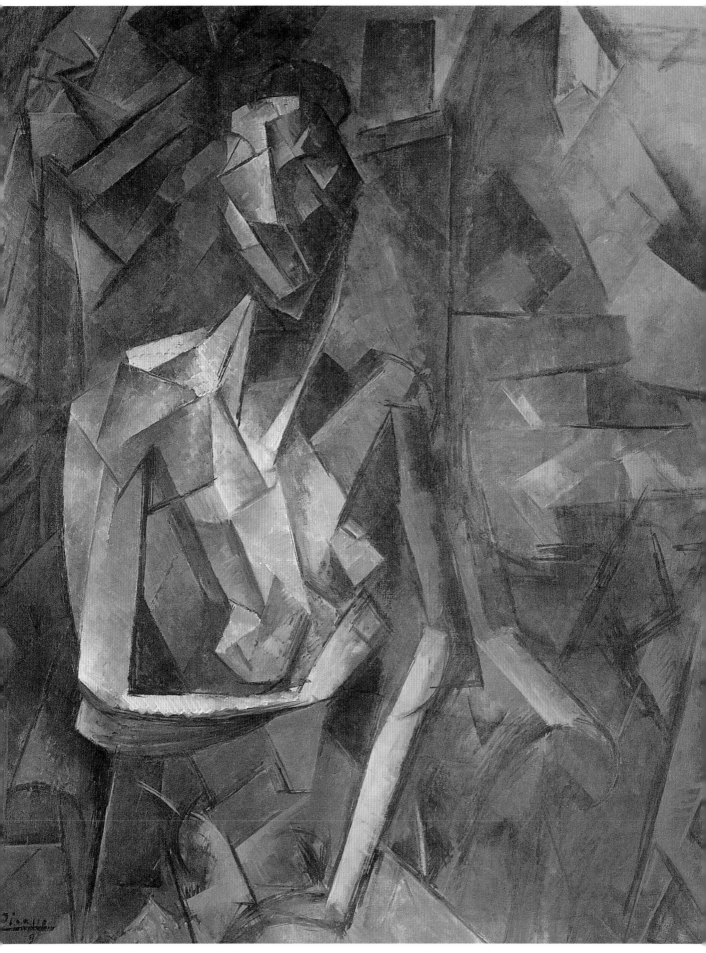

PABLO PICASSO (1881–1973)
The Three Dancers, 1925
Courtesy of the Tate Gallery

*P*ICASSO, whose Cubist pictures made him the most famous painter in France, was a welcome but reserved member of the Surrealist movement. He made several half-length portraits of André Breton, including a very Classical etching with a disconcerting twist: an erect penis rising from below the hem of his jacket. It was two years after their first meeting that Picasso produced his first Surrealist painting, *The Three Dancers*. For both scale and style, it highlights the interest Picasso was taking in the work of Joan Miró.

Picasso's painting is based upon the Classical theme of the Three Graces, yet he has replaced the usual gracefulness and serenity with a frenzied dance of death. The central figure recalls a crucified Christ and may relate to the recent death of Casagemas. Some critics see a reference to a Spanish dance at its most powerful and exhausting climax in this work, but the wallpaper and the balcony hint at a domestic location. The large, jagged planes of color and macabre gestures of the life-size figures make this monumental work a shocking contrast with Picasso's earlier years of calm Classicism.

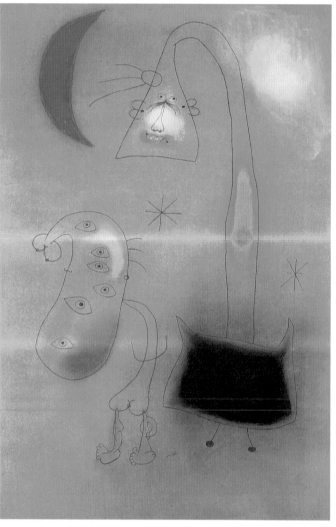

Joan Miró (1893–1983) *Persons in the Night (undated)*
Helsinki Atheneum. Courtesy of Giraudon. (See p. 130)

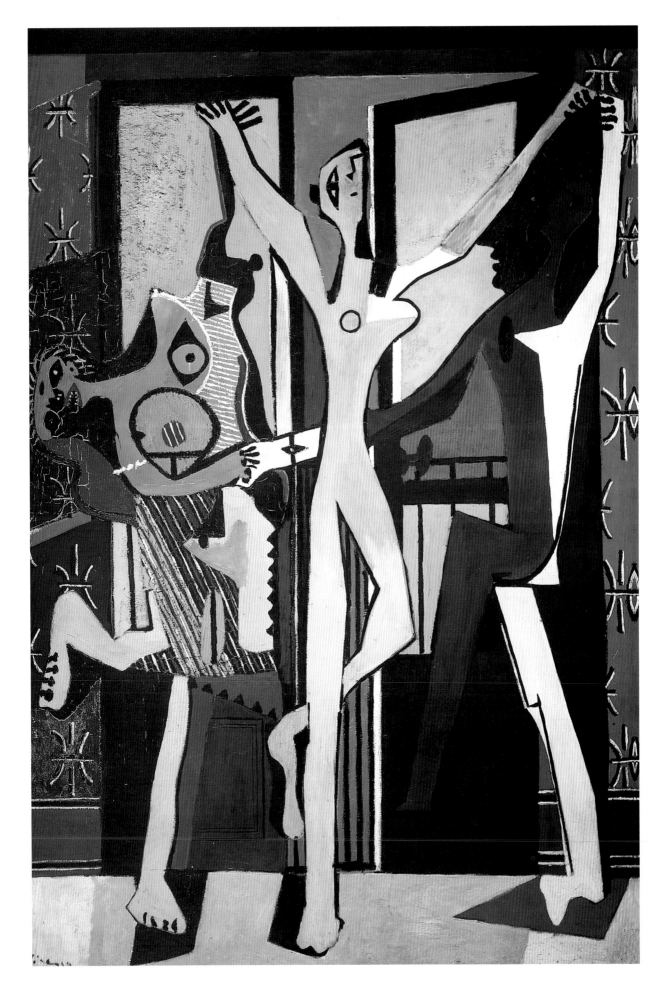

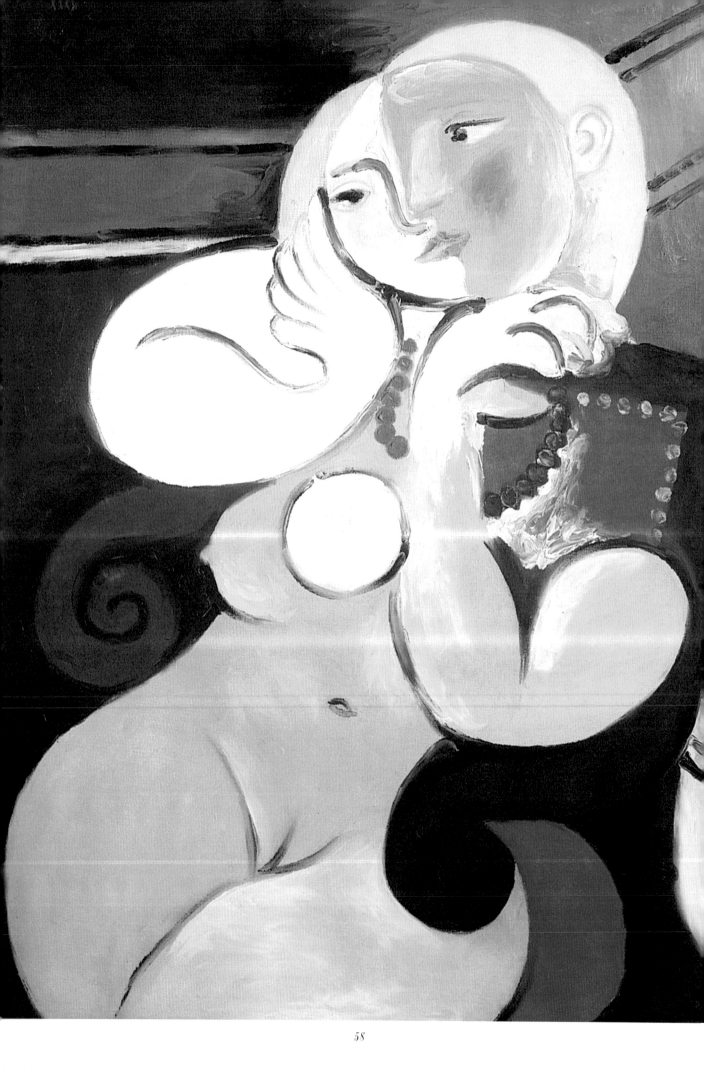

PABLO PICASSO (1881–1973)
Nude Woman in a Red Armchair, 1932
Courtesy of the Tate Gallery

*A*T the end of the First World War, Picasso abandoned his Cubist style for a more traditional, almost Classical style. However, during the 1920s and 1930s he did produce some paintings which clearly belong to the Surrealist movement, even if the majority of his work did not. Picasso enjoyed the company of the Surrealists, looking to them for ideas and energy. Above all, he made many Surrealist erotic etchings, some recounting the adventures of a lusty minotaur. This seated nude seems to be influenced by his ideas of nymph-like women who arouse the minotaur's curiosity, tenderness and violent passion.

Picasso has used the rounded forms found often in Jean Arp's work, such as *Vegetal Torso*, rather than the crisp straight lines of his Cubist canvases. To this, he has added a flat, pale blue to indicate shadow and rounded form. He used his wife as the model for this dream woman; the sensuous curves of her form, the linear arabesque of the chair handles, and the flat planes of color demonstrate his technical mastery. Some critics have noted a creeping decadence and excessive luxury in his work that were not in keeping with Picasso's reputed left-wing politics.

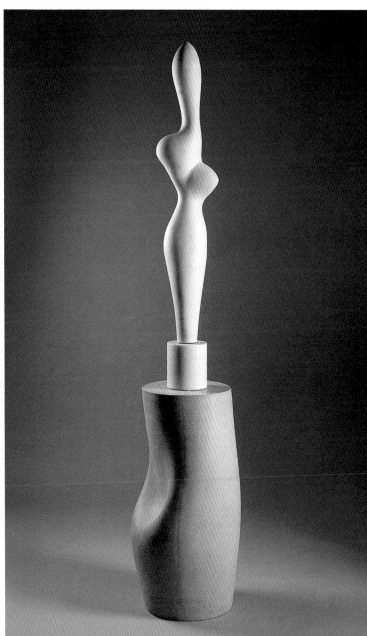

Jean Arp (1887–1966)
Vegetal Torso, c. 1935
Courtesy of Christie's Images. (See p. 150)

PABLO PICASSO (1881–1973)
Weeping Woman, 1937
Courtesy of the Tate Gallery

PAINTED in the same year as his famous *Guernica*, *Weeping Woman* was a study in grief and tragedy. Picasso was deeply moved by the civil war raging in his native Spain, and applied himself to creating a monumental record of its barbarity. Out of a sense of solidarity with the victims, he has painted the twisting of forms and shattering of lives inflicted by one of the first-ever bombing raids. He shows the woman flattened out in a grotesque distortion, as if a Cubist sculpture had been squashed. The heavy, black lines create a tense rhythm across the face and hand, while vertical yellow stripes sit calmly behind. Around the mouth, the bold, garish colors become white, suggesting the passage from hysteria to death.

While this painting is closely linked in style and content to *Guernica*, Picasso may be making a counter-point to the calm, sensuous style of *Nude Woman in a Red Armchair* (1932). In depicting this attack of weeping, he may be reflecting on his own domestic experiences.

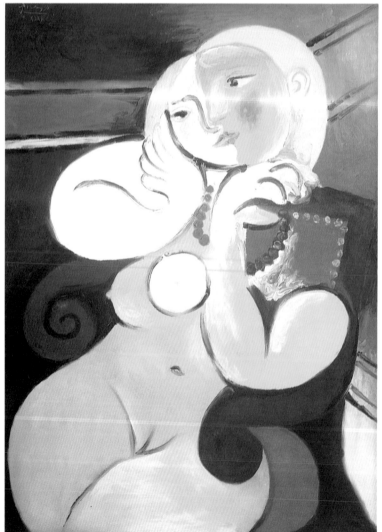

Pablo Picasso (1881–1973) *Nude Woman in a Red Armchair, 1932*
Courtesy of the Tate Gallery. (See p. 59)

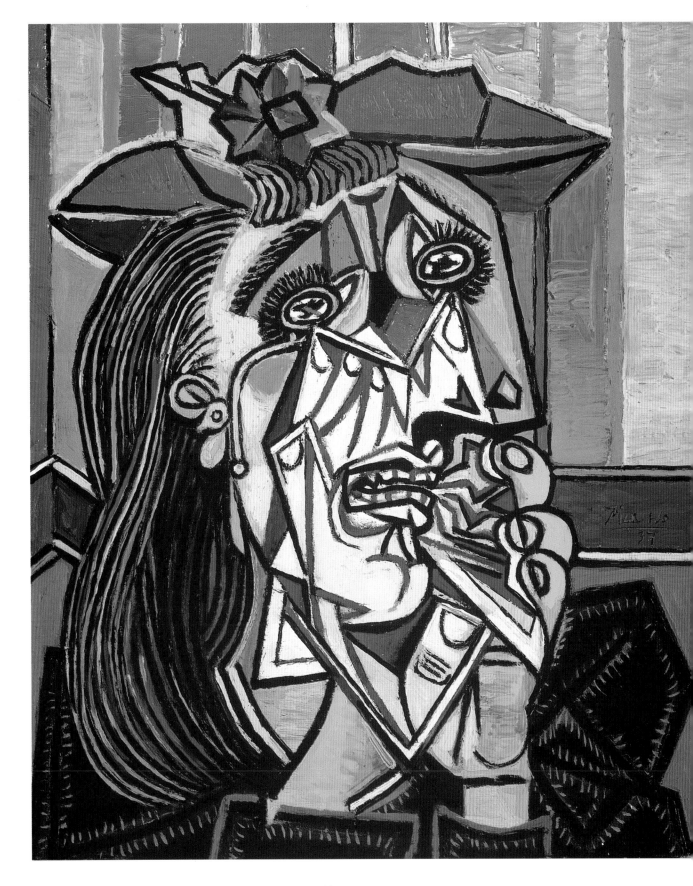

FRANCIS PICABIA (1879–1953)
Parade Amoureuse, 1917
J.L. Stern Collection, New York. Courtesy of Giraudon

FRANCIS Picabia was slightly older than most other members of the Surrealist group, having already had a successful career as an Impressionist painter before he joined their ranks. By 1912, he was a fervent member of the Dada group and went to America for an important exhibition of contemporary work, where he remained to influence and encourage Dadaist tendencies in New York. Upon his return, Picabia traveled around Europe helping to promote Dada as a truly international movement. During this time he also started to paint his machine pictures, which were regarded by some critics as copies of engineering drawings, and by others as the first truly abstract paintings.

These erotic machine pictures strike a note of irony about the modern artist's desire for something "new" in art. They compare a man's most powerful and humane feelings with the mechanics of biological reproduction. Although this may have been a defensive view of sex, it was important to Picabia's own sense of self-irony. While he defended Modernism, he also remarked that love was what a man enjoyed most, but that it was hardly modern or new. Some of his machine women were portraits of those he admired or loved, such as the painter Marie Laurencien, who was depicted in the form of an air ventilator because her presence was like a fresh breeze on a hot Spanish afternoon.

Nothing in this machine suggests erotic activity, and it is made in such a way that it cannot work. A pressurized piston seems to drive a grinding machine, a set of swinging pendulums, and a regulator. This is an engine of passion without its driver; a machine whose function, like love itself, will never be fully grasped. The artist shows us an image of love as something mechanical, unavoidable, and automatic.

Picabia continued to experiment with a vast array of styles throughout his painting life, as can be seen in *Spanish Night* (1922) and much later, in *The Happiness of Blindness* (1947).

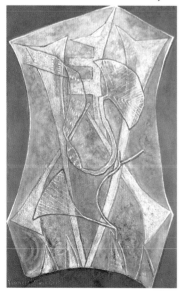

Francis Picabia (1879–1953)
The Happiness of Blindness, 1947
Courtesy of Topham. *(See p. 76)*

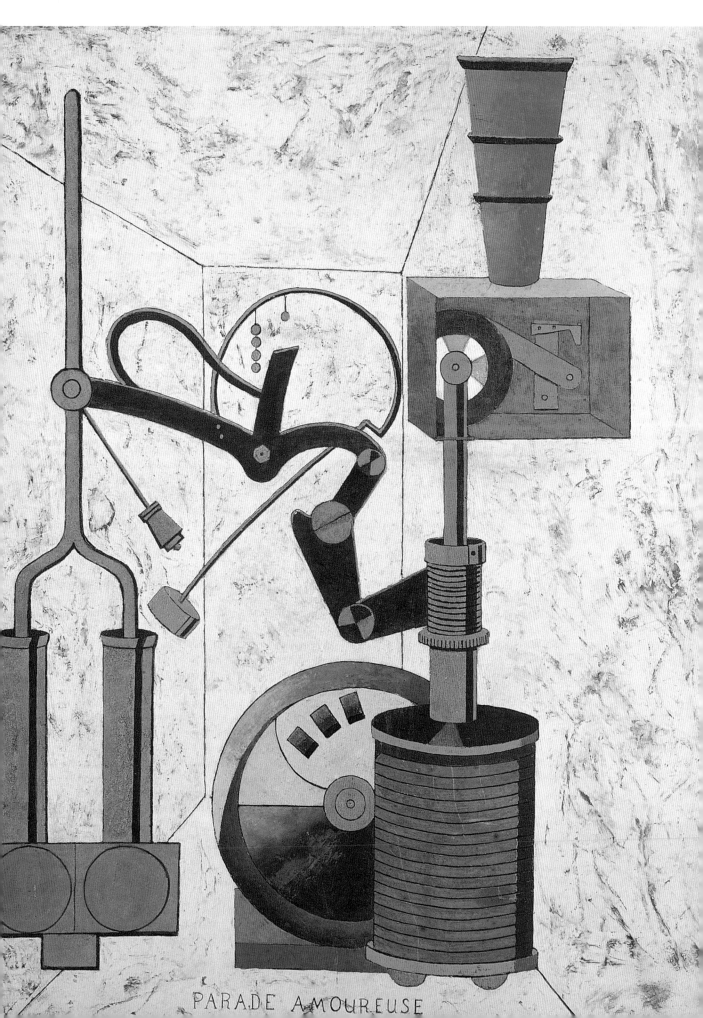

PARADE AMOUREUSE

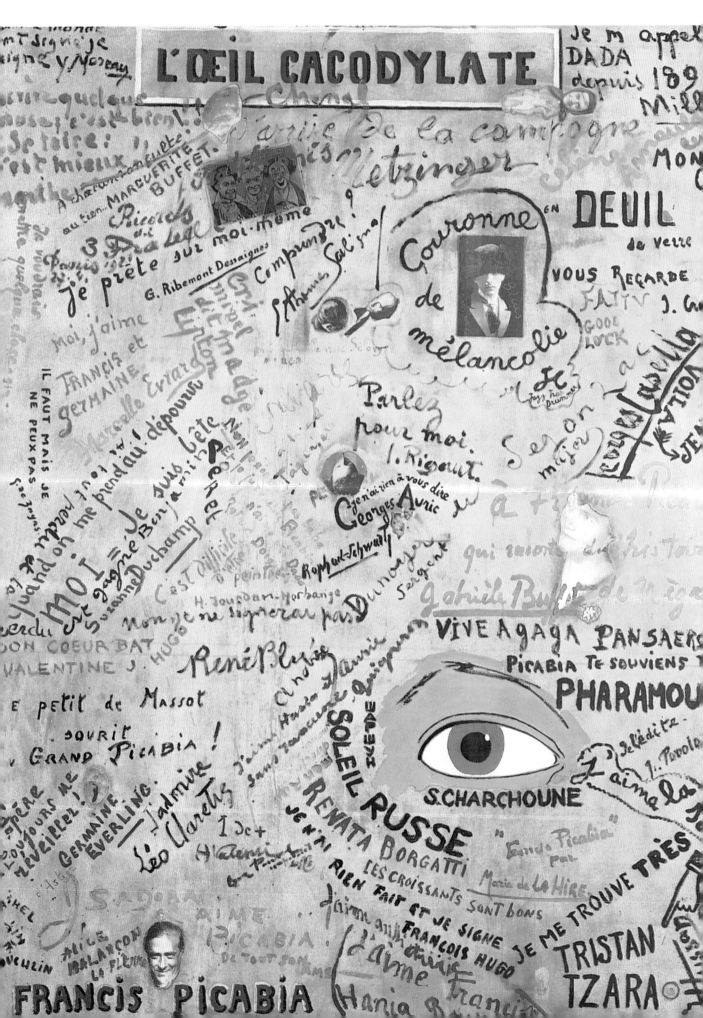

FRANCIS PICABIA (1879–1953)
L'Oeil Cacodylate, 1921
National Museum of Modern Art, Paris. Courtesy of Giraudon

FRANCIS Picabia's *L'Oeil Cacodylate*, in which the signatures of many writers and poets are incorporated, symbolizes the fluidity in art movements in the period immediately following the First World War. It appears to be merely the arbitrary jottings and sketches of a series of well-known contemporary personalities, with little or no immediately recognizable structure. During the dark years of the Second World War, however, Picabia adopted a safe, almost kitsch style of painting, seen in the nude *Naked Woman in Front of a Mirror* (1943), probably because of the Nazi destruction of Abstract art and the Communist rebuttal of Surrealism.

Having been a fervent Dadaist, Picabia joined André Breton in criticizing the movement openly when its followers gathered in Paris in 1922, and encouraged them to regroup into the new Surrealist movement. This sounded the final death knell for Dada, and Picabia was subsequently quick to embrace the experiments and techniques of painting suggested by Breton's readings and understanding of Sigmund Freud's theories of psychoanalysis.

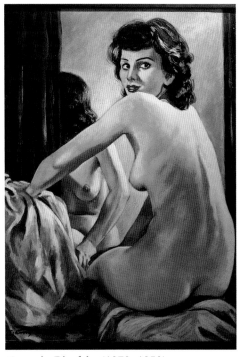

Francis Picabia (1879–1953)
Naked Woman in Front of a Mirror, 1943
Courtesy of Topham. (See p. 74)

FRANCIS PICABIA (1879–1953)
Spanish Night, (1922)
Private Collection. Courtesy of Giraudon

THIS image was used as the cover of the review magazine *Littérature*, published in November 1922. Picabia made a considerable contribution to the formation of Surrealism at this time, partly through his attacks on the Dada movement. Along with André Breton (whose work was also published in *Littérature*), he sought a more serious and less anarchic art. While Dada celebrated freedom, it was seen to be useless in bringing about real social change. It had become a noisy protest movement while what was wanted following the war was a serious force for altering art and society. Picabia's claim that Dada was dead, with Surrealism its successor, was a claim to which many listened with interest and respect.

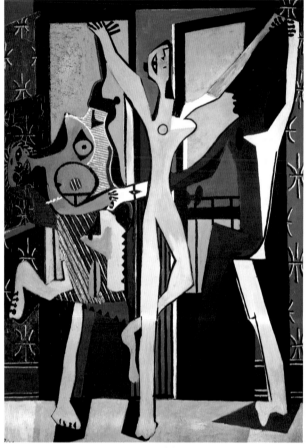

Pablo Picasso (1881–1973)
The Three Dancers, 1925
Courtesy of the Tate Gallery. (See p. 56)

In his painting, Picabia sought to create a controlled form of drawing, based upon recent work by Picasso, which some have called "Surrealist Classicism." Elements of this are still evident in Picasso's *The Three Dancers* (1925). He used the simple, geometrically sharp style of this drawing in his designs for ballet costumes used by the experimental group Ballets Suédois, whose performances featured music by Erik Satie.

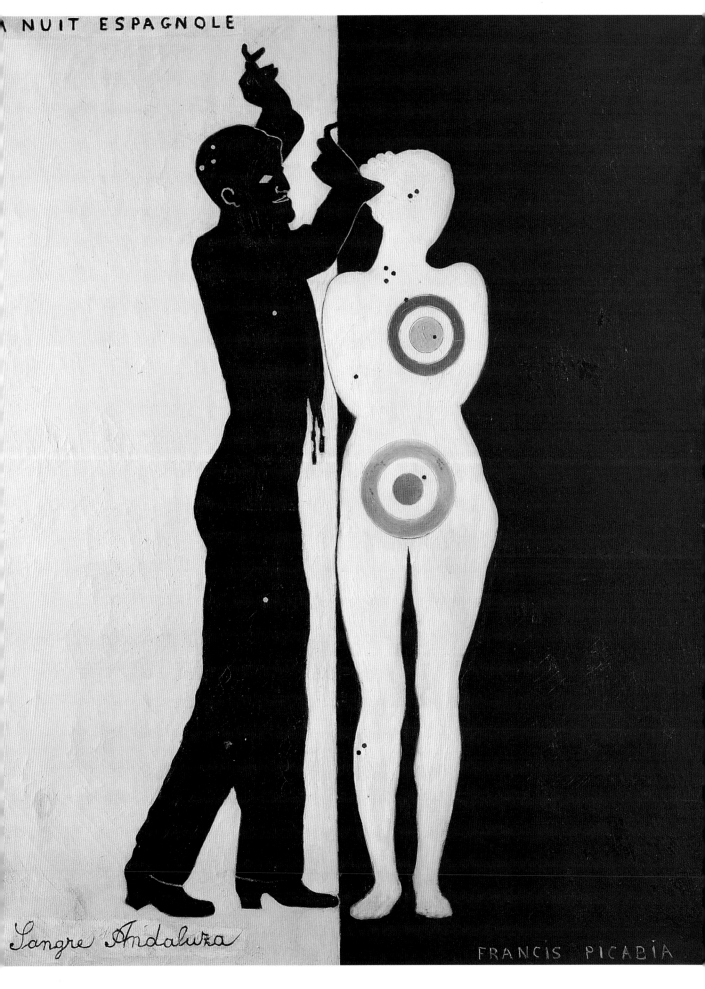

FRANCIS PICABIA (1879–1953)
The Match Woman, 1924
Private Collection. Courtesy of Giraudon

*P*ICABIA once remarked that painting was like the game of love, and to this extent he has given us a portrait of his affection. He made several images of women out of paint and matches, taking from Picasso the technique of "collage" – the pasting of real objects onto the surface of the canvas. These works were part of his general interest in reducing the female figure to a machine. Picabia has used the matches to imitate the look of parted hair. Although the eyes are closed, this woman's individuality can be divined in her face, suggesting a dangerous power that can burn if rubbed the wrong way. Similarly, the painting also has on its surface the seeds of its own destruction. To make matters more pointed, Picabia has given the woman a necklace of real coins. André Masson's *Still Life in Front of the Sea* (1924) shares similar aggressive undertones.

The whole painting is built up of very simple planes of color, making the work seem restrained and refined in its handling of line. The combination of elegance, danger, and money all suggest Picabia's play-boy image, that of a man who dashed around Europe and America, drove fast cars, and worked with many different modern artists.

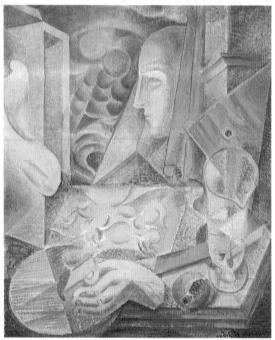

André Masson (1896–1987)
Still Life in Front of the Sea, 1924
Courtesy of Christie's Images. (See p. 80)

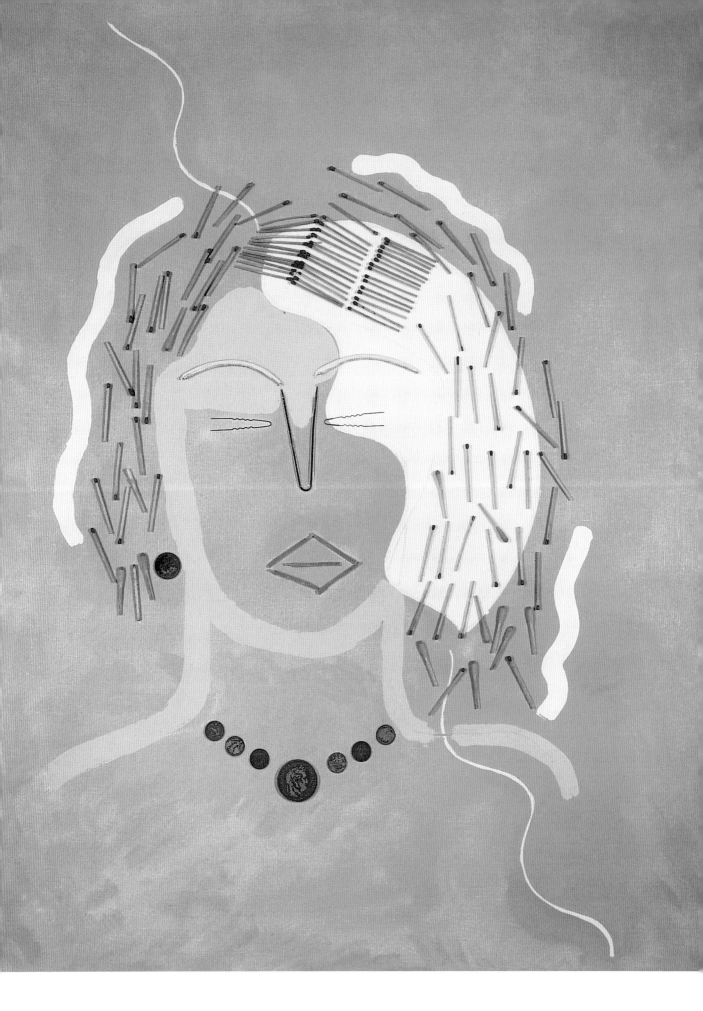

FRANCIS PICABIA (1879–1953)
Head and Winged Horse, 1928
Courtesy of Christie's Images

FROM 1924 until 1936 Picabia lived in the south of France. By leaving the bustle of Paris, he found the time to concentrate on developing a fully Surrealist technique and it was during this time that he worked on a large group of paintings which he called *Transparencies*. These works used images laid one over the other as if seen through glass. Compared to Magritte's use of transparency in *The Red Model* (1935), Picabia did not seek to create a sense of unity between thought and object. The combination of images causes the painting to become increasingly abstract. In one image, a Classical figure takes fruit from a large bowl protected by a griffin. In another, the face of a Spanish dancer appears, and mixed in is a primitive medieval image of an angel with folded wings. Picabia was using a new means of exploring the chain of visual and verbal associations which Freud described as the basis of dream meanings.

René Magritte (1898–1967) *The Red Model, 1935*
National Museum of Modern Art, Paris. Courtesy of Giraudon. (See p. 221)

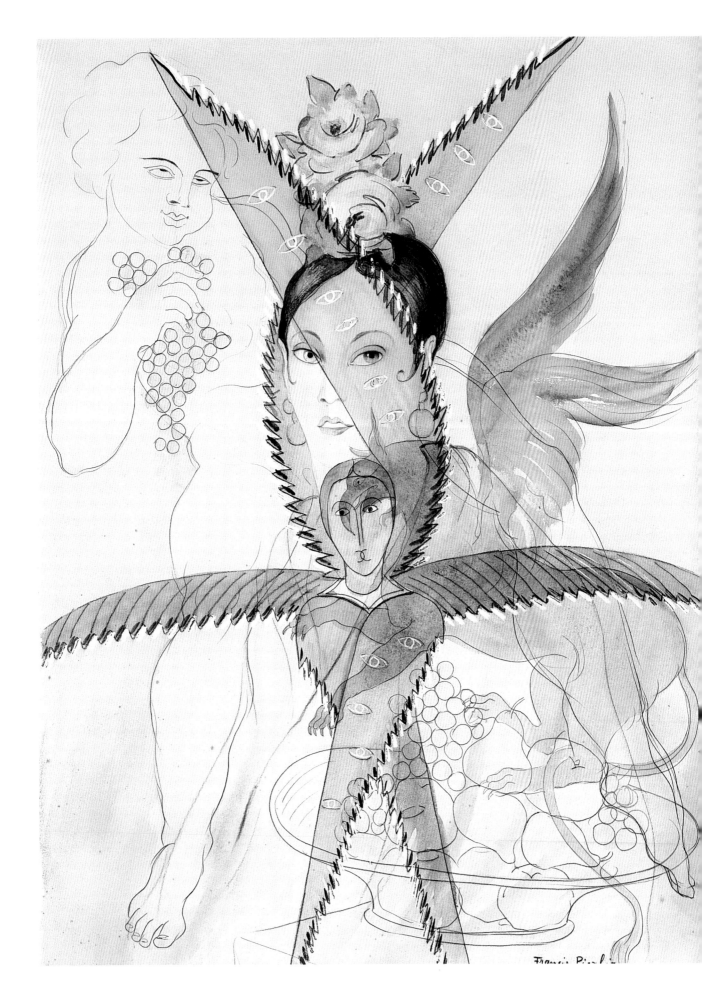

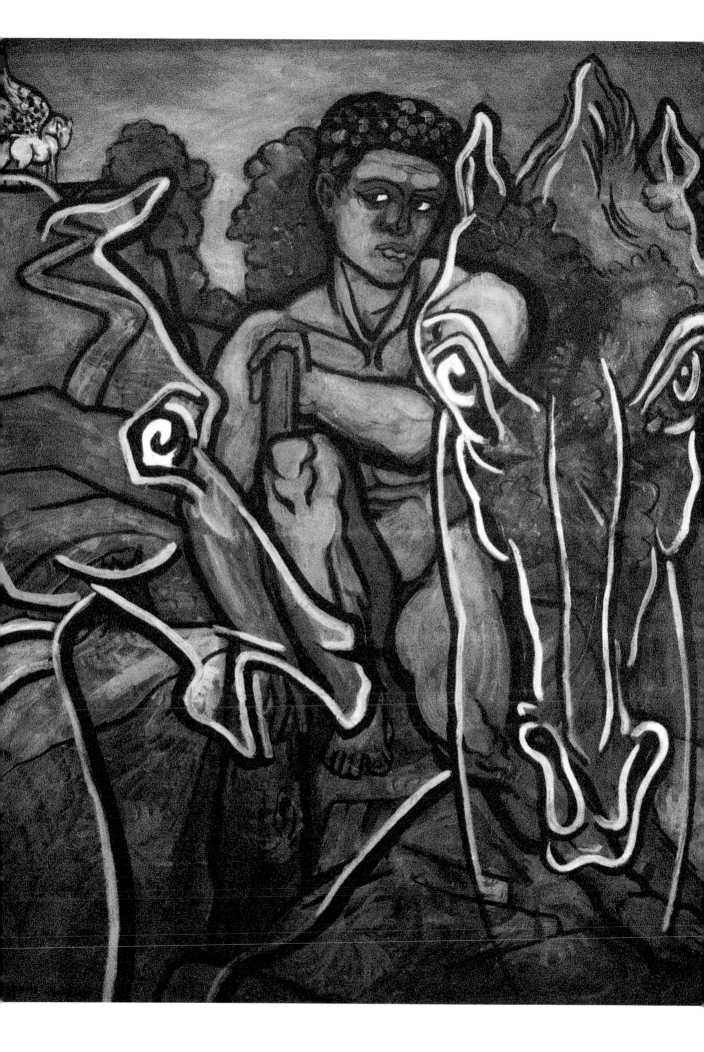

FRANCIS PICABIA (1879–1953)
Apollo and his Messengers, 1935
Courtesy of Topham

*T*HIS work was painted during the peak of Picabia's Surrealist activities, when he had left the Dada movement well behind. *Apollo and his Messengers* uses firm simplified line and limited darker colors. In this piece, the artist was striving to adapt Classical art, with its sense of order, to the Surrealist aim of exploring the deepest recesses of the mind. While in one sense the work has an heroic tone, almost like a myth reduced to its most basic elements, there is also a disturbing confusion typical of Picabia's transparency paintings, such as *Head and Winged Horse*.

A friend observed in Picabia's magazine *391* that he did not regard the knowledge of an object to be of primary importance. What the artist valued most were the varied reactions that occur between objects because of their form, and the variety of mental states felt by a spectator looking at the reactions between those forms. Between the worlds of ideas and objects there was a strange relation of resemblance and correspondence.

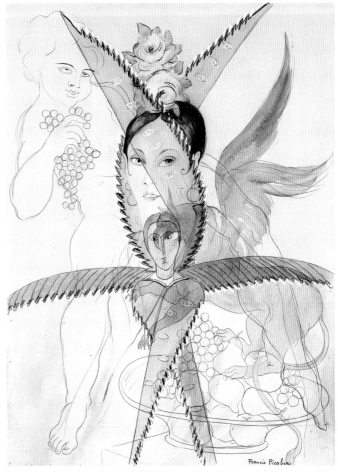

Francis Picabia (1879–1953) *Head and Winged Horse, 1928*
Courtesy of Christie's Images. (See p. 70)

FRANCIS PICABIA (1879–1953)
Naked Woman in Front of a Mirror, 1943
Courtesy of Topham

*P*ICABIA did not fight in the Second World War but roamed around North Africa and Spain instead, quite cut off from the other Surrealists, many of whom had fled to America. During this time his painting took an extraordinary turn and he made a series of almost kitsch images of female nudes. This was an extremely "safe" style of painting, given that the Nazi government had publicly burnt Abstract paintings, and the Communists had since separated themselves from the Surrealist movement.

These highly finished nudes convey a number of conflicting concerns. In one sense, they were "bread and butter" paintings made to earn money. Yet they were also a sarcastic type of painting in which art is raped by advertisement and repressive politics. Picabia sought to invest his work with vulgarity and repression, particularly by using popular imagery framed by large areas of black. Some critics have considered this work to be Fascist in its tendencies, and it is true that Picabia liked the writings of Nietzsche, and made sporadic anti-Semitic comments.

Nevertheless, he organized an exhibition with Jewish painter Michel Sima, and befriended painters who were using Fascist academic realism to make biting anti-Nazi commentaries, and made a series of explicit anti-Nazi photomontages before the war.

André Masson (1896–1987) *Antille, 1943*
Cantini Museum, Marseilles. Courtesy of Giraudon. (See p. 88)

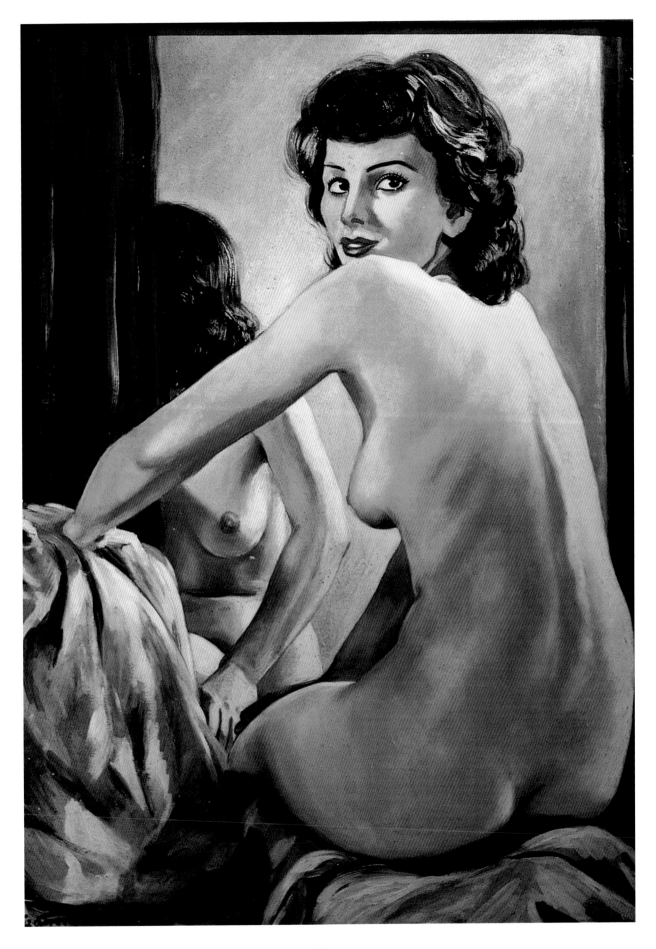

FRANCIS PICABIA (1879–1953)
The Happiness of Blindness, 1947
Courtesy of Topham

AFTER the war, Picabia continued to experiment with a wide range of styles. He returned to Paris, re-established old friendships and began to paint with intense vigor. His wife remarked at this time that he gave himself totally to painting and, in a frenzy of activity, transposed his ideas onto canvas in a deep, creative anguish. Compared to the war-time *Naked Woman in Front of a Mirror* (1943), he abandoned realism for the opposite style of complete abstraction. Here Picabia uses biomorphic forms, geometric abstraction and colors of Impressionism. He produced a large body of abstract works during this time, and, like this example, they often used thick paint built up on a broad abstract background. In the post-war period, Picabia became associated with the Existentialists and the philosopher Jean-Paul Sartre, who was aligned to Communism. He later left this circle because of its pessimism, preferring the circle around Surrealist writer Georges Bataille, with its revival of interest in Nietzsche. At this time he

Francis Picabia (1879–1953) *Naked Woman in Front of a Mirror, 1943*
Courtesy of Topham. (See p. 74)

swung between fits of gloom and periods of intense creativity and production. He became an Officer of the *legion d'honneur* in 1951 and died in 1953. As Marcel Duchamp remarked, Picabia was a tireless worker who possessed the perfect tool: an indefatigable imagination.

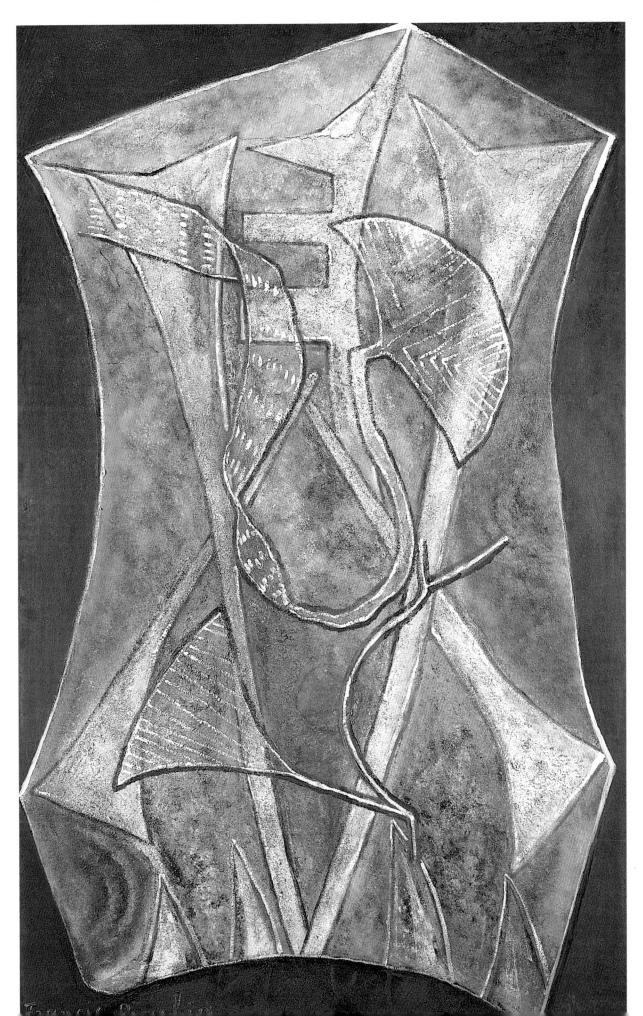

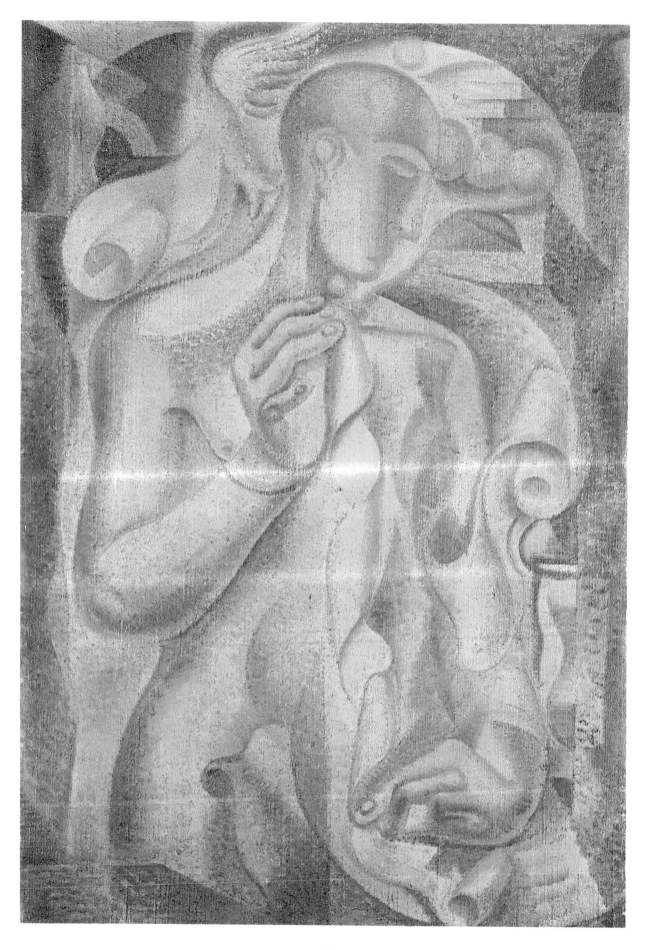

ANDRÉ MASSON (1896–1987)
Underground Figure, 1924
Courtesy of Christie's Images

*T*HIS early work of Masson's still used the flat, prism-like planes and limited color of Cubism typical of Picasso's early Cubist work such as *Seated Nude* (1909). Straight and curved lines establish a structure that appears to be in space and, yet, at the same time lies flat on the surface. The regular dot patterns also play with deep and flat space by suggesting shaded, curving planes as well as decorative pattern. Some of the dynamism of the painting lies in the tension between the deep space of representation and the flat surface of the painting. While the painting is restrained by tenets of Cubism, an element of symbolism makes this work an important stage in the formation of Masson's more wholly Surrealist paintings.

To understand the symbolism of the painting, it is helpful to turn to the notes Masson made at this time for his autobiography. "Gatherings of men: gamblers, drinkers, sleepers: memories in part, of peasant or military life ... A few still lives: views of monuments of France or Italy seen through transparent objects, appearance of the pomegranate and the flame ... Then the figure of the man makes its solitary entrance, surrounded by a constellation of emblematic objects, in a mental space: Man in a tower, Man in a vault .."

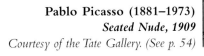

Pablo Picasso (1881–1973)
Seated Nude, 1909
Courtesy of the Tate Gallery. *(See p. 54)*

ANDRÉ MASSON (1896–1987)
Still Life in Front of the Sea, 1924

Courtesy of Christie's Images

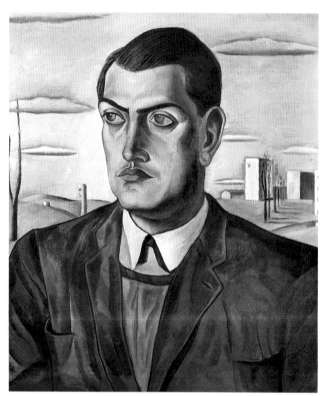

Salvador Dalí (1904–1989)
Portrait of Luis Buñuel, 1924
Luis Buñel Collection, Mexico. Courtesy of Giraudon.
(See p. 168)

DURING the First World War, André Masson was badly injured; this experience directed his energies toward a new, committed revolutionary stance. His rages against the insanity of the war were sometimes so frightening and intense that at one time he was confined to an institution. His release was only secured after the intervention of his mother.

Masson joined the Surrealist movement on the invitation of André Breton. Although he accepted, he was never deemed officially a member, being by temperament an anarchist. Masson did not find membership of the movement easy, due to the demands of the group for orthodoxy and conformism, but just as Breton recognized his gift as a painter, Masson was strongly attracted to Breton's dynamic and persuasive personality. Dalí, who produced *Portrait of Luis Buñel* the same year, was also working closely with Breton on film projects. Despite his reluctance to become a dedicated member of any specific group, Masson viewed Surrealism as the only artistic movement in France worth joining, because of its liberation from tradition. By the end of the 1920s, Masson had broken with the Surrealists, only to join them again in the early 1930s.

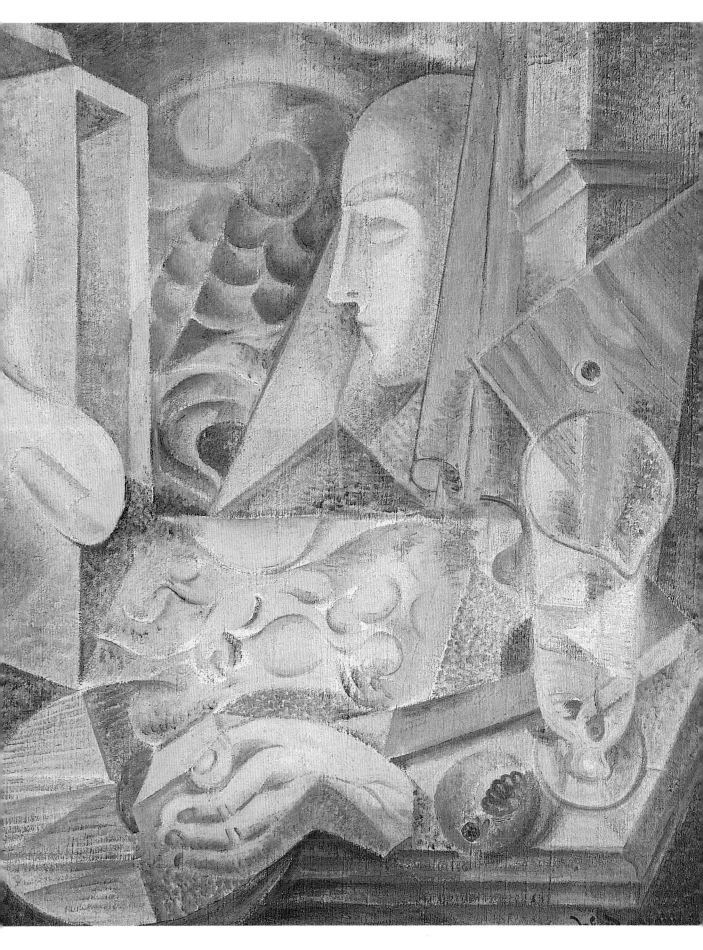

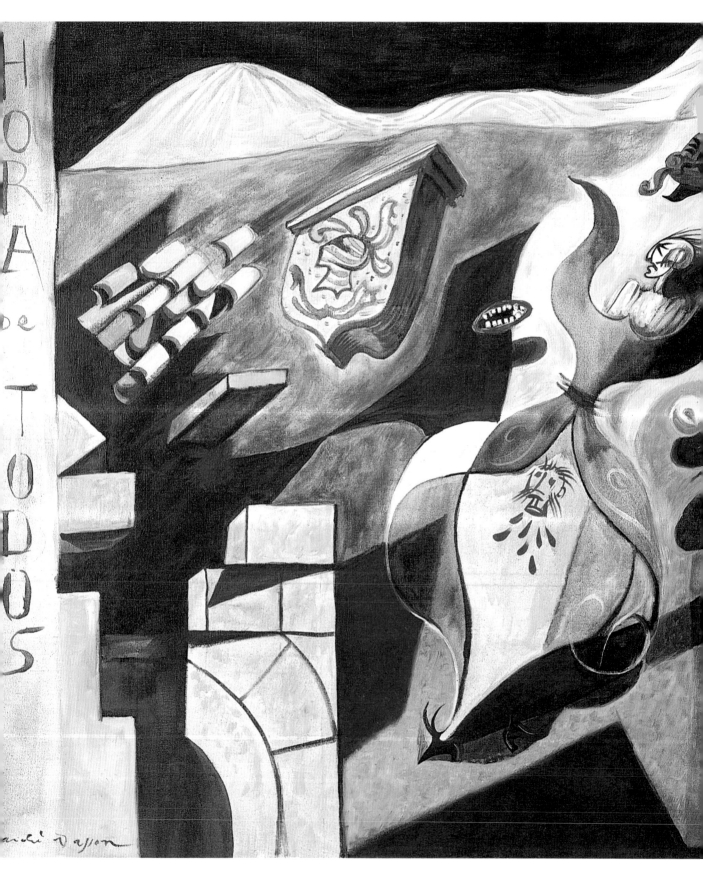

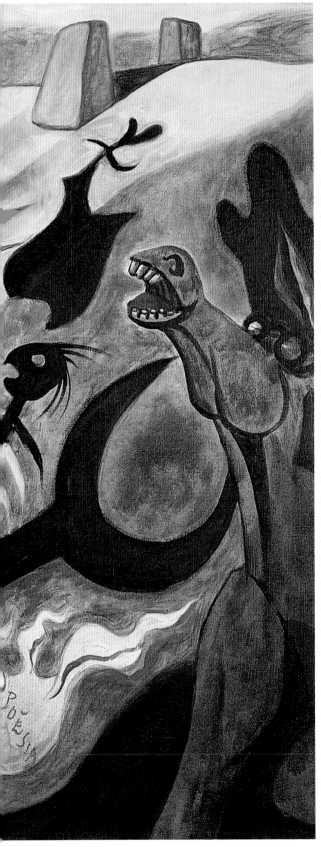

ANDRÉ MASSON
(1896–1987)
Hora de Todos, 1937
Courtesy of Giraudon

IN 1934, Masson moved from France to make his home in Spain. He loved the culture and threw himself into the study of Spanish literature, music, dance, and bull fighting. During this time he suffered from a dread of his own instincts for violence and disaster. He anticipated another war in France and was desperate to escape before it started, but ironically he moved to a country that would soon be ravaged by civil war. This bitter dispute caused Masson to produce many satirical drawings of General Franco and the Fascists, although he did not become directly involved in combat. It was during this time that he drew closer to the Surrealist writer Georges Bataille, whose celebrations of the ecstasy of violence provided an alternative backdrop to Surrealism. Masson lived in a paradox: he was fascinated by human violence yet constantly haunted by a sense of horror and disgust. In its treatment of biomorphic figures, *Hora de Todos* recalls the work of Joan Miró, while in its horror of war and its use of gray and black, the work echoes Picasso's monumental *Guernica* (1937), also painted as a protest against war.

ANDRÉ MASSON (1896–1987)
There Is No Finished World, 1942
Courtesy of Topham

MASSON was one of the first Surrealist painters to experiment with the process called "automatic drawing." He was very close to Breton, with whom he shared a passion for reading and intellectual pursuits, and soon heard of his interest in Freud's practice of free association. Automatic writing and drawing developed as a way of dictating thoughts and fantasies without the control of the mind. Through relaxation techniques, hypnosis or other artificial states of the mind, the thoughts were allowed to flow onto the paper or canvas.

Masson described the process of automatic drawing as follows: "physically, you must make a void in yourself; the automatic drawing taking its source in the unconscious must appear as an unforeseen birth. The first graphic apparitions on the paper are pure gesture, rhythm, incantation, and as a result, pure scrawl. This is the first phase. In the second phase, the image that was latent reclaims its rights."

Breton proposed that free association and automatic drawing could provide an avenue to otherwise repressed thoughts. The technique has resulted here in an image of an unconscious battle between two figures, each carrying a pomegranate. On the right, the battle is watched by the figure of a minotaur, emblematic of death.

ANDRÉ MASSON (1896–1987)
Untitled, 1942
Courtesy of Christie's Images

MASSON embarked for America early in 1941, stopping on the way in Martinique with Breton. The lush tropical plants enchanted him. He started this painting with an automatic drawing, which was then developed into an image of female fertility by rubbing in greens and pinks, then painting in the forms of leaves and flowers. Masson wrote in 1941: "the real power of an imaginative work will derive from the three following conditions: (1) the intensity of the preliminary thought; (2) the freshness of the vision onto the exterior world; (3) the necessity of knowing the pictorial means most suitable for the art of this time ... The unconscious and the conscious, intuition and understanding must operate their transmutation on the mind in radiant unity."

If this comment was an endorsement of Surrealism, he also knew its limits. By 1944, he remarked that "the meeting of the umbrella and the sewing-machine on the operating table happened only once. Traced, repeated over and over again, mechanized, the unusual vulgarizes itself." Masson continued to use the method of automatic drawing, but avoided the juxtapositions of Magritte and Picabia's layering of images.

Francis Picabia (1879–1953)
Head and Winged Horse, 1928
Courtesy of Christie's Images. (See p. 70)

ANDRÉ MASSON (1896–1987)
Antille, 1943

Cantini Museum, Marseilles. Courtesy of Giraudon

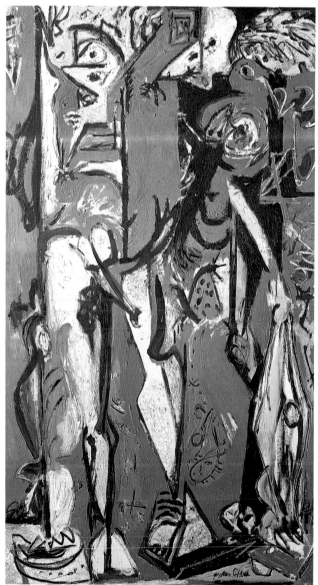

THIS painting also reflects Masson's visit to Martinique during his escape from Europe to America. He toured the small French island, drawing the steep landscapes and lush tropical vegetation. The figure of a woman dominates this composition, and appears to arise directly out of the earth. This effect was made more tangible by mixing sand directly into the paint. The artist shows the body as it absorbs the tropical forest, whose fruits and flowers appear in and around the torso. The lyrical, erotic quality of this painting is enhanced by the smooth, rolling line of the initial automatic drawing. The deep, rich variety of colors recalls the visual excitement of a jungle, while the dark under-painting unifies the composition. Masson's work at this time, was becoming more and more abstract. In this respect, the female torso becomes transparent in places, and is lost among the vegetation. Forms and colors take on a life of their own. The contours of breast and hips stand out clearly, while the shoulders and head are tangled in a torrent of biological activity. Masson's work helped to set the stage in America for a busy "all-over" painting surface that had no single focus to the composition. The comparison with the work of Jackson Pollock is interesting.

Jackson Pollock (1912–56) *Two, 1945*
Guggenheim Museum, Venice. Courtesy of Giraudon. (See p. 252)

ANDRÉ MASSON (1896–1987)
Panique, c. 1920s
National Museum of Modern Art, Paris. Courtesy of Giraudon

MASSON was interested in the experience of "panic." The word comes from the name of the Classical god Pan, wild half-goat, half-man, who was able to cause sudden and groundless fear. Although Masson had experienced panic in the trenches during the First World War, panic is caused in this picture by nature, rather than man, and suggests the opposite of pastoral Classical landscapes. Nature is possessed of a cruelty, a wild frenzy of violence and a force beyond taming. Later work, such as *The Death of Holofernes* (1960), invoke biblical themes while experimenting with the use of calligraphy and incorporating Oriental influences.

At the bottom of the painting, Masson has used one of his most highly charged motifs—the pomegranate. In French it means "grenade," which also means hand-grenade, thus making the fruit redolent with associations and symbolism. The seeds suggest life, while the blood red of the whole canvas evokes the red of pomegranate juice as well as death. When split open, the fruit suggests the sexual organs of a woman. Masson wrote of the pomegranate: "all the pomegranates that I have drawn or painted these 20 years are erased and with them the association of the burst skull: a soldier somewhere in Champagne ... I open the fruit. Unequal separation of the two parts, trickling as of a translucent wine which is also repulsive ..."

André Masson (1896–1987)
The Death of Holofernes, 1960
Courtesy of Christie's Images. (See p. 94)

ANDRÉ MASSON (1896–1987)
La Chute des Roches, 1950
Courtesy of Christie's Images

AFTER the war ended, Masson moved back to France and settled near Mont St.-Victoire, the mountain made famous by Cézanne. He started to use Cézanne's colors, the browns, greens, and yellows of the local landscape. He described Cézanne's work in terms similar to his own, saying "anguished contradictions can be the source of great riches." He saw in this painter's work the tension between tradition and experiment, Classical calm and explosive violence, self-denial, and eroticism.

While Cézanne stirred Masson's interest in landscape painting, he also referred to Chinese landscape paintings, which he first saw in quantity when visiting Boston in the U.S.A. Masson admired Chinese painting for its exclusion of man; the vast panoramas used only two or three brushstrokes to denote a human presence. He also read about Zen practices, and came to feel that Western culture was misguided in its attempts to control nature. This discovery of Zen allowed Masson to revive the idea of automatic drawing without using Freudian theory. Rather than finding heady conflicting passions, he looked within himself to find a void through which to express himself.

ANDRÉ MASSON (1896–1987)
The Death of Holofernes, 1960
Courtesy of Christie's Images

*A*FTER 1957, André Masson embarked on the creation of a "semiography." According to the writer Roland Barthes, Masson was using the Chinese and Japanese concept of the ideogram—a written notation of an idea that captures some of its visual form. Oriental writing is more pictorial than Western roman letters, allowing the artist to devise a system of spontaneous calligraphic signs. Masson attempted to combine quick spontaneous marks with a mastery of the paint and canvas.

However, his painting style remained in transition for much of his life. As he once commented: "no taboo can intervene to drive me to the fixity of one style." Here he has vigorously brushed out a dark green background on which to start drawing his depiction of the death of the Assyrian general Holofernes, whose army was besieging the Israelites. The beautiful widow Judith visited Holofernes pretending to be a traitor. When he fell asleep after a drunken banquet, during which he attempted to seduce her, she cut off his head. Returning with it to the Israelites, she called on them to scatter the leaderless Assyrians. Some critics have interpreted the hexagonal shape in the middle of the painting as a severed head.

MAX ERNST (1891–1976)
Elephant of Celebes, 1921
Courtesy of the Tate Gallery

*P*AINTED in Cologne on the eve of his departure for Paris, Ernst has used a four-legged African grain storage basket for the shape of his "elephant." It is an enormous beast, which to modern eyes looks like an over-sized vacuum cleaner topped by a colorful collection of objects. Ernst has used de Chirico's style of clear simple modeling, low side lighting, crisp shadows, and steep perspective to create an other worldly space of imagination and fantasy. The fish that swim by, and the dissolving black plume, create the impression of a liquid space in which movement is slow and deliberate. A headless woman seems to dominate the tremendous physical power of this beast, as if it were being directed in a circus act by a mannequin. The scene hints at a mindless sexual drive, an automatic response to the sight of the woman's body that leads toward the viewer.

This was one of Ernst's first large-scale Surrealist paintings, with its deceptively simple composition dominated by a single centrally placed element. Its meticulous brushwork allowed him to render sensuous surfaces that are disturbingly empty inside, very much like de Chirico's mannequins.

**Giorgio de Chirico
(1888–1978)**
Hector and Andromaca, 1924
Courtesy of Christie's Images.
(See p. 32)

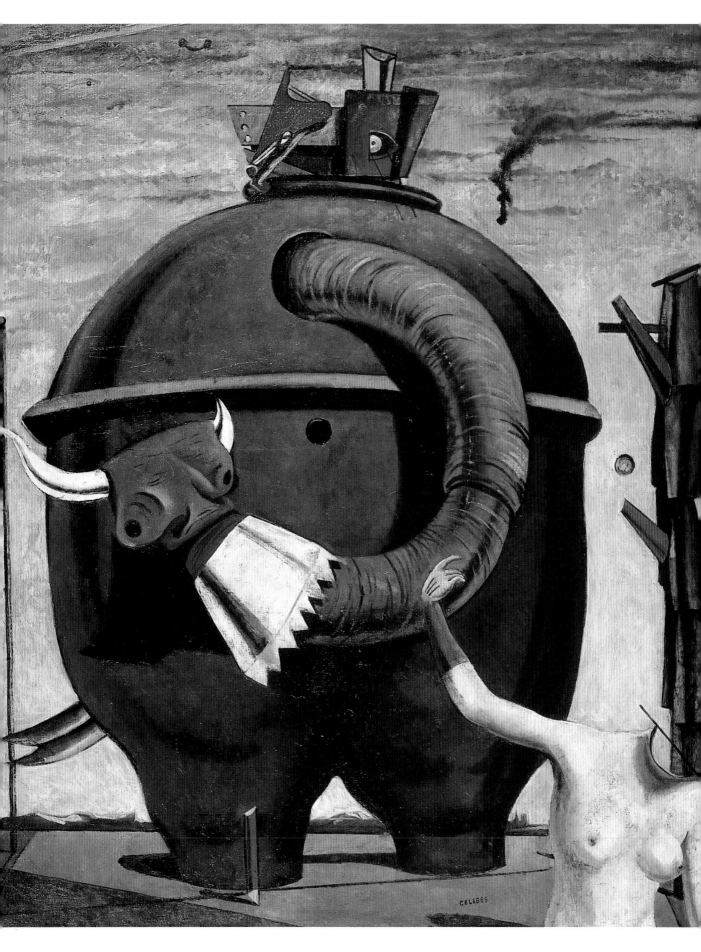

Max Ernst (1891–1976)
Perturbation my Sister, 1921
Victor Loeb Collection, Berne. Courtesy of Giraudon

IN 1936, Ernst commented on the mechanism of collage that "one Readymade reality (a canoe), finding itself in the presence of another and hardly less absurd reality (a vacuum cleaner), in a place where both of them must feel displaced (a forest), will, by this very fact, escape ... into a new absolute value, true and poetic: canoe and vacuum cleaner will make love." He continued by saying that "the complete transmutation, followed by a pure act, as that of love, will make itself known naturally every time the conditions are rendered favorable by the given facts: the coupling of two realities, irreconcilable in appearance, upon a plane which apparently does not suit them."

In *Peturbation My Sister*, Ernst has used collage elements to create an image of a woman. Like a mannequin from one of de Chirico's paintings, she stands in an open space. The image is full of erotic hints however, especially in the interpenetration of rings and circles. Shown without a face, the torso itself suggests a face looking at the viewer. Eyes are suggested on the shoulders and the nipples in a game of erotic, flirtatious gazes.

Giorgio de Chirico (1888–1978)
The Seeker, c. 1930s
Courtesy of Christie's Images.
(See p. 36)

MAX ERNST (1891–1976)
The Meeting of Friends, 1922
*Lydia Bau Collection, Hamburg. Courtesy of
Giraudon*

THIS group portrait brings
together many of the founders
of Surrealism. It represents the
group of friends Ernst joined when he
moved from Cologne to Paris in 1922.
Many of the group were writers and his
arrival signaled the growing value the
Surrealists placed on painting. Ernst is
dressed in a green suit and above him
stands the artist Jean Arp, who also used
methods of chance and randomness in
his work. The poets Paul Eluard and
Louis Aragon gesture to each other
using sign language, but the most
dramatic figure is of the critic, writer,
and founder of the movement, André
Breton, who sweeps onto the scene
wearing a red cape. Behind him,
Giorgio de Chirico stands dressed
as a fluted Classical column.

As a group, the Surrealists were
interested in politics, but often fought
with each other. Ernst gives some hint
of the internal wranglings of the group
by showing Arp with his hand resting
on a miniature stage on which men
prepare to wrestle. This wrestling
match disrupts the otherwise frozen
landscape in which the group is seated.

11 Benjamin Péret
12 Louis Aragon
13 André Breton
14 Baargeld
15 Giorgio di Chirico
16 Gala Eluard
17 Robert Desnos
Décembre
1922

MAX ERNST (1891–1976)
At the First Clear Word, 1923
Courtesy of Giraudon

THIS remarkable work was rediscovered many years after it was painted on the wall of poet Paul Eluard's house. While a guest there, Ernst painted many of the rooms, including the bedrooms. In working directly onto the walls, he recalled the ancient Roman technique of fresco painting. Of all Ernst's Surrealist paintings, this one is perhaps the most sensuously suggestive of seduction. Ernst uses the hand gestures of the deaf, as in *The Meeting of Friends* (1922), only this time using a more direct, flirtatious language of the hands. The crossed fingers become legs and are openly suggestive. Like a lover filled with ardor and desire, these fingers await an opportunity to make love. They are unabashedly filled with desire and are illuminated by the warm Mediterranean sunlight. Even the other objects in the mural seem to beg for our consent and to be as engorged with passion as the waiting lover.

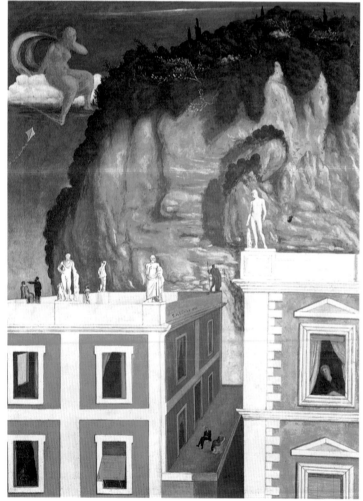

Giorgio de Chirico (1888–1978) *The Roman Villa, 1922*
Collection Casella, Florence. Courtesy of Giraudon. (See p. 30)

Compared to de Chirico's work from this period, there is far less nostalgia and melancholy, and more sexual energy and tension. Ernst presents a more libidinous sentiment, which has strong links with the art of many ancient civilizations, including Greece and Rome.

MAX ERNST (1891–1976)
The Teetering Woman, 1923

Nordrhein Westfallen Art Museum, Düsseldorf. Courtesy of Giraudon

HE teetering woman of this painting is dressed as a trapeze artist. Her outstretched arms suggest a balancing act, while the rising hair makes it seem as if the performer were hanging upside down. Set on a tilt to give a sense of unsteady forward movement, she balances between two sturdy Classical columns in a landscape which recalls the work of de Chirico, such as *Piazza d'Italia.*

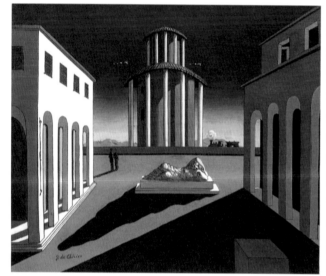

Giorgio de Chirico (1888–1978)
Piazza d'Italia, c. 1930s
Courtesy of Christie's Images. (See p. 35)

Ernst used influences from nineteenth-century illustrated magazines in his work, and in this painting he uses a picture of a machine to calm the surface of rough seas. The machine, which spurts slippery, heavy oil, has trapped a leg and sprouted metal bars that block the trapeze artist's vision. Ernst may also have drawn on ancient Roman images of the goddess of luck in making his image of danger and instability.

The drama of the scene, the sense of danger and suspended time, is portrayed in a calm and simple style. It offers a temptation to take a risk, to bet on fortune, or "lady luck." In this sense the painting uses the chance placing of objects, such as the machine and the circus performer, to conjure up the excitement of risk.

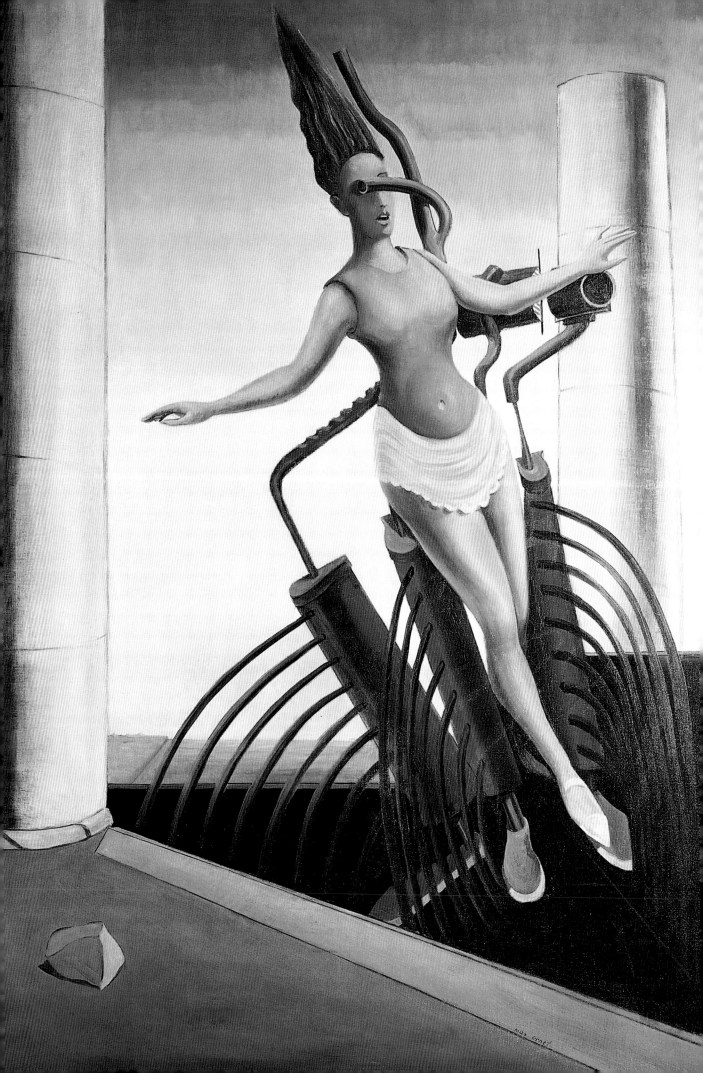

MAX ERNST (1891–1976)
Pietà (Revolution by Night), 1923
Courtesy of the Tate Gallery

THERE is a long tradition of representing the Virgin Mary with the body of the dead Christ across her lap, the best-known being by Michelangelo. In making his contribution to this tradition, Ernst has chosen a brown base on which he has laid flat areas of color. In replacing Mary with a well-dressed bourgeois man, Ernst was not taking an anarchic potshot at the middle classes, but a more focused attempt at revolution. From Karl Marx the Surrealists took the motto, "to transform the World." Although the movement may have arisen from the nihilism of Dada, it moved toward the far-left to embrace Communism, which produced tensions within the group, given that Ernst was himself from a middle-class family. The young man in this picture rests in the arms of the bourgeoisie, but remains alert and awake. The style is almost childlike, in its simple rendering, flat color, and crude drawing, yet the effect is of sophisticated opposition.

Joan Miró (1893–1983) *Book Cover for French Aid to Republicans in Spanish Civil War, 1937*
Courtesy of Topham. (See p. 136)

The tradition of Surrealist agitation had a lasting effect on many younger artists and writers, and has today become a standard language.

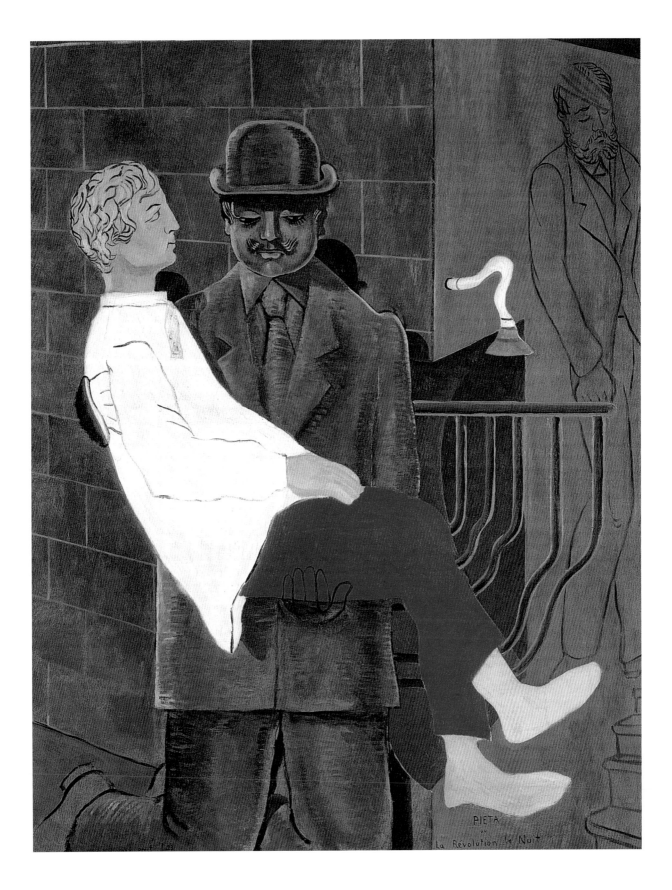

MAX ERNST (1891–1976)
Men Shall Know Nothing of This, 1923
Courtesy of the Tate Gallery

BRETON praised Surrealist images for what he called their "convulsive beauty." Above all, he sought to encourage an exploration of the limits of the mind. He felt that art could simulate various extreme mental states, and in so doing chart the true nature of man's inner consciousness. As a guide, Breton took the writing of the founder of psychoanalysis, Sigmund Freud. In seeking to use art to exceed the normal boundaries of thought and experience, Breton encouraged the study of dreams and the use of free association. He also helped develop the technique called automatic drawing, in which the artist let his or her mind go blank. In setting conscious thought to one side, he sought to gain access to the desires of the unconscious mind.

In this painting Ernst has created a landscape reminiscent of the work of Tanguy, on which he has placed a series of planetary orbits and forces of gravity. He has added a crescent moon and the legs of a copulating couple. In the center, a hand covers a glass eye, suggesting that the working of night-time dreams gravitate toward pleasure, but are always forgotten on waking.

Yves Tanguy (1900–1955) *Hope at 4:00 am, 1929*
National Museum of Modern Art, Paris. Courtesy of Giraudon. *(See p.158)*

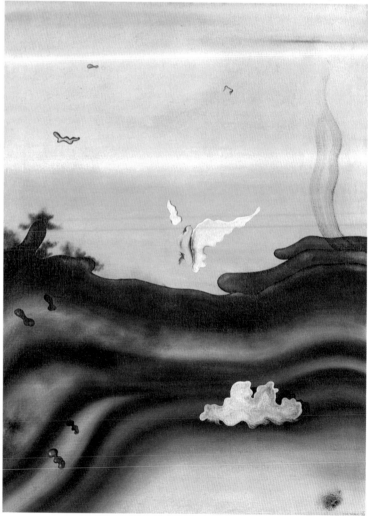

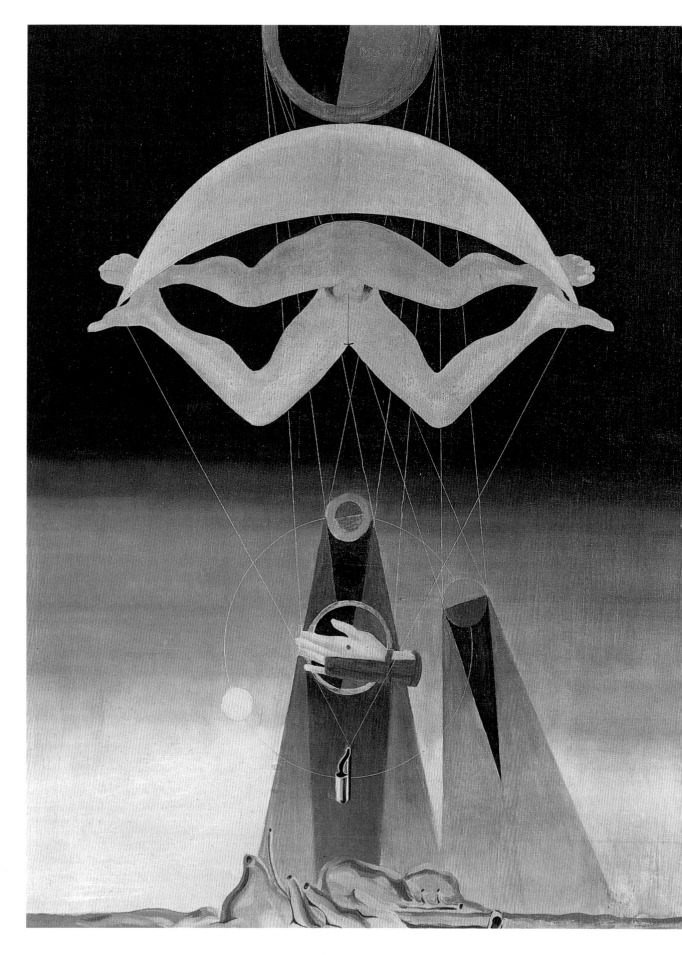

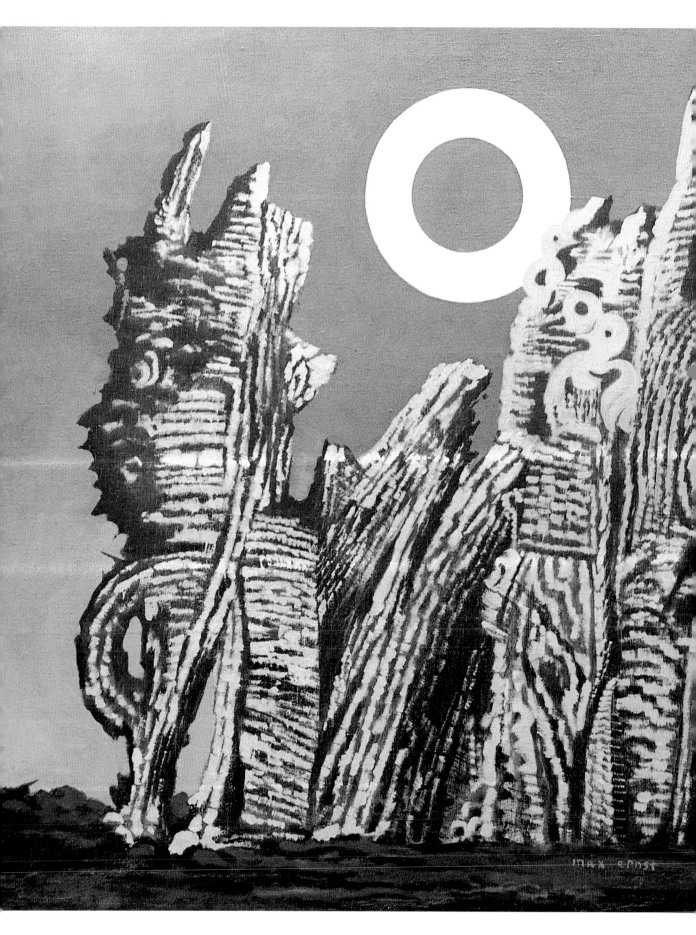

MAX ERNST (1891–1976)
Gray Forest
Courtesy of Christie's Images

ERNST achieved the dense, rich and dark colors of this painting through a method he called "frottage." This involved placing the canvas or paper over rough surfaces and rubbing. In this case he has used a worn wooden floor. The random results were then studied while allowing for a free association of images. When an image was seen in the rubbing, it would be enhanced by further painting. This method made Ernst very aware of the textures around him, and led to experiments with a variety of surfaces. Having assembled a number of frottages, he then embarked on a series of forest paintings, of which this is an example.

For the Surrealist magazine, *Minotoaur*, he wrote a poetic statement about these paintings: "What is a forest? A supernatural insect. A drawing board. What do forests do? They never retire early ... What is summer for the forests? The future: that will be the season when masses of shadows will be able to change themselves into words and when beings gifted with eloquence will have the nerve to seek midnight at zero o'clock." Hidden in the branches of this moonlit forest is a group of birds related to "Loplop Bird Superior," a character which Ernst developed in a book of his collage images.

HANS BELLMER (1891–1976)
Max Ernst au Camp Des Mille, 1940

Landeau Collection, Paris. Courtesy of Giraudon

ANDRÉ Breton was the gifted leader of the Surrealist movement. He was primarily a writer and poet, although he sometimes made art works. He also attempted to lead the Surrealists into politics by aligning with the Communist party, because he disliked the Nazi party and wanted to help stop its threats to human liberties. The German Nazi party, which was led by the ex-artist Adolph Hitler, preferred a sentimental, realist, and populist style of painting. To demonstrate his views on the matter, Hitler staged an exhibition of modern art and then burnt the paintings. In the later phases of Surrealism, being on the wrong side of a paintbrush could land an artist in a labor camp—or worse.

Hans Bellmer painted this picture of Ernst while working with him in a French labor camp. After being arrested due to their German origin, both men were put to work making bricks. Ernst is shown as if made of bricks, with a crisp profile against a somber background. In 1938 Man Ray had made a similar portrait of the notorious Marquis de Sade, reflecting Surrealism's fascination with violence and pain.

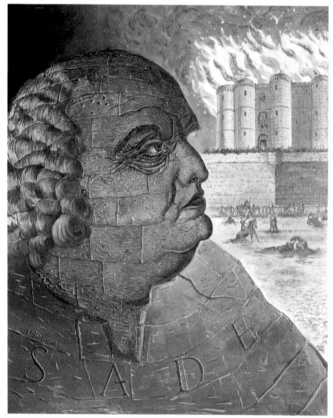

Man Ray (1890–1976) *Portrait of the Marquis de Sade, 1938*
Private Collection, New York. Courtesy of Giraudon. (See p. 179)

MAX ERNST
(1891–1976)
Lonely and Conjugal Trees, 1940
Courtesy of Giraudon

*T*HE first years of the Second World War were difficult for Max Ernst. After his arrest and the time he spent in a labor camp, the French authorities had planned to deport him to work on the railroads in North Africa, but he managed to enter Spain and escape to the U.S.A., where he married and settled.

In this painting he used a method called "decalcomania," which involved putting pigment on the canvas, laying sheets on top and removing them quickly. He began a series of such works in France, finishing them while living in the U.S.A.

Artists have often depicted fantasies, usually drawing on a shared image and using accepted visual styles. These fantasies can then be shared by society, so that although they depict the strange and fantastic, they are not strange as works of art. Ernst continued this tradition of recording fantasies, but worked with ones that were profoundly private in content and novel in style.

MAX ERNST (1891–1976)
The Eye of Silence, 1943-44
*Washington University Gallery of Art.
Courtesy of Giraudon*

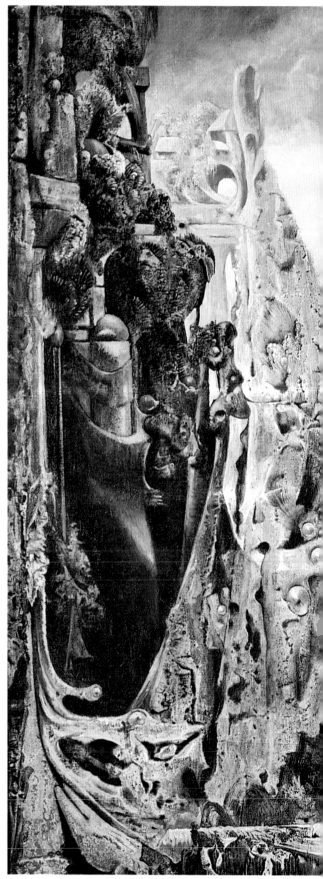

*E*RNST continued using the "decalcomania" technique, particularly during the years of the Second World War. At this time he made landscapes imbued with a sense of disaster, tragedy, and collapse. On the horizontal format of this painting he has picked out a broad sky and pool of reflecting water; a strange landscape of vertical rocks rises, worn by years of erosion; pearly balls rest in small pockets of rock and glint in the sunshine like silently watching eyes. The overall effect is one of paranoia, of being watched by hidden, inert agencies in nature.

Psychoanalyst Jacques Lacan, who was affiliated with the Surrealists, wrote about the structure of paranoia at this time. Paranoia was a very real concern for Ernst—in America he moved from a seaside house inland to avoid accusations that he was acting as a German U-boat spy. This painting also suggests an erotic grotto, marked by the hint of architecture along the left side. The only human presence is a small female figure tugging wistfully at a fruit growing on the water's edge. Critical opinions of these war-time paintings vary widely; some see them as Ernst's greatest work, others as slick melodrama more typical of Dalí.

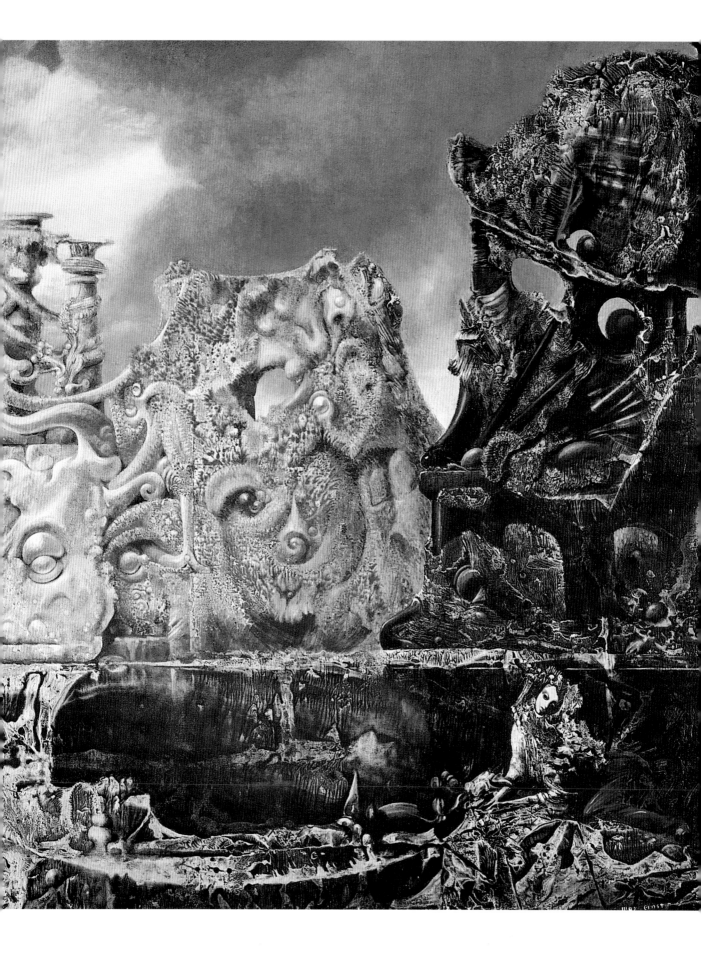

MAX ERNST (1891–1976)
Euclide, 1945
D. and J. Menil Collection. Courtesy of Giraudon

ERNST often experimented with new techniques, as in this "portrait" of the Greek mathematician Euclid. The background was created by swinging a punctured paint can over the canvas. Its repeated passes left traces of an eccentric orbit. The space between these lines was then filled in to create a regular mathematical grid of extreme complexity. Opposed to this eccentric geometry Ernst placed a portrait of Euclid, the historical master of regular planar geometry. The old philosopher is posed in a traditional portrait composition, yet rendered in the manner of de Chirico. The triangular head and planar geometry invite nostalgia at a moment in history when the new science of atomic physics rendered Euclid obsolete.

In 1942, when Ernst exhibited a series of drip paintings that were not heavily repainted, the American artists Robert Motherwell and Jackson Pollock asked him about the technique. They liked the delicate tracery of lines that could be built up by swinging a series of colors over the horizontal canvas. Although Pollock was to try this method himself, he preferred the greater control that came with holding the can in his hand. Unlike Ernst, Pollock used this control to suggest veiled figures within a mesh of lines.

Jackson Pollock (1912–56) *Alchemy, 1947*
Courtesy of Giraudon. *(See p. 254)*

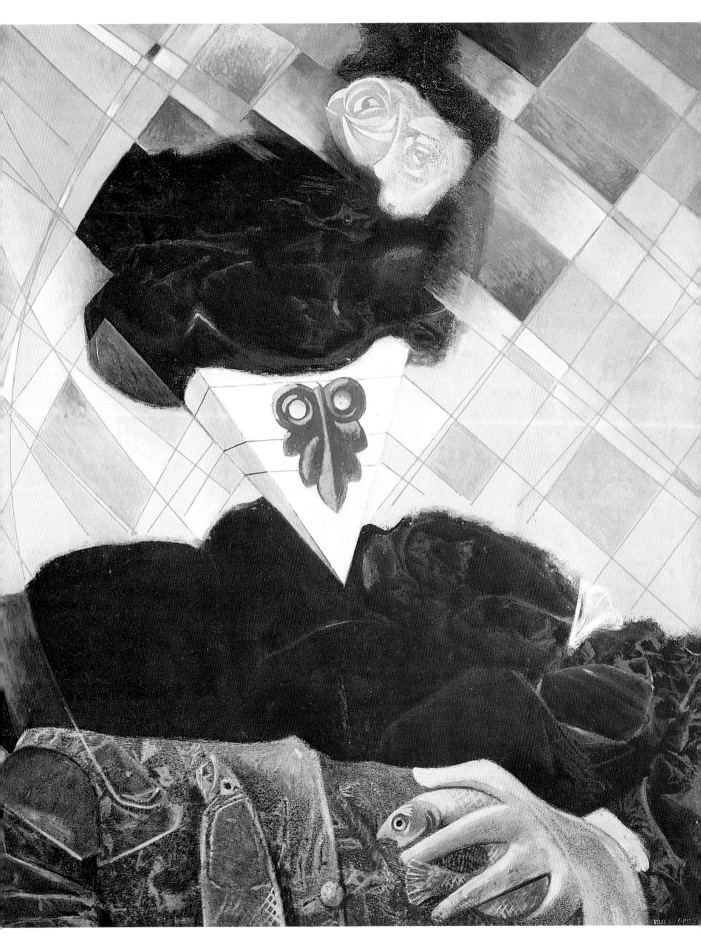

MAX ERNST (1891–1976)
An Anxious Friend, 1957
D. and J. Menil Collection. Courtesy of Giraudon

*T*HIS bronze sculpture catches the experience of having to beg a friend for a favor. The simplified forms and block-like shapes render the gesture that remains in one's memory after the friend had departed. There is a loss of dignity in this begging man, a violation of friendship, to which Ernst responded with compassion and pity. He had experienced life on the edge of destitution and knew what it was like to be forced onto the mercy of his supporters. After the First World War, he moved to France and took refuge in the home of the Surrealist poet Paul Eluard, a man he had once unknowingly faced on the other side of a war-time trench. It was only a decade after the end of the Second World War, during his second flight to the U.S.A., that Ernst could create an image of the desperation experienced by the millions who sought refuge from the war, violence, and savagery which marks the history of twentieth-century Europe. The strange columns in Yves Tanguy's *From Green to White* (1957) share a similar haunted mood of desolation and loneliness with Ernst's cowering sculpture.

Yves Tanguy (1900–1955)
From Green to White, 1954
Courtesy of Giraudon. (See p. 167)

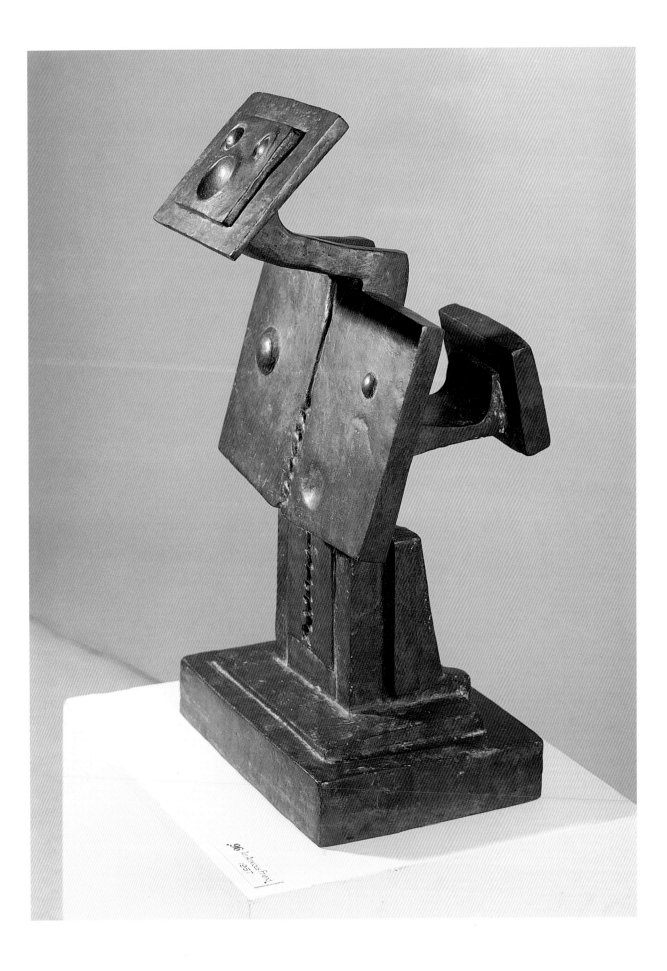

DOROTHEA TANNING (1912–TO DATE)
The Birthday, c. 1940s
Private Collection, Paris. Courtesy of Giraudon

THE American Dorothea Tanning began working as an artist convinced that art school had nothing to offer her. She left her native Illinois for New York, where she saw an exhibition of Surrealist work. Overwhelmed, she began to paint in this style, and then traveled to Paris. During the Second World War, many Surrealists, including Duchamp, Arp, Breton, and Tanguy, stayed with her in Arizona. Both before and after her marriage to Max Ernst, she worked in a meticulous style which was similar to Paul Delvaux. *The Birthday* is typical of her work in the deep perspective space seen through a sequence of doors. A female in a state of undress invites us into these chambers, which reflect Tanning's interest in realism. The garments this enigmatic female figure wears are a marvel of invention. One consists of a bundle of gnarled roots, while the other is of wrinkled violet velvet with gold hems and lace cuffs. She has at her feet a rather tame fantastical creature similar to a griffin. Like Picabia, Tanning also designed costumes for the ballet, including work for Balanchine, so perhaps the garments in this picture reflect her work for the stage. The large mirror on the left of the painting suggests a rehearsal room used by dancers.

Paul Delvaux (1897–1994)
The Visit, 1939
Courtesy of Giraudon.
(See p. 232)

JOAN MIRÓ (1893–1983)
The King's Madness, 1926

Private Collection, Paris. Courtesy of Giraudon

WHILE some critics have been of the view that Miró's paintings were primitive and childlike, the work of a simple mind, others have argued the opposite view—that his work was extremely complex. If his work seems childlike it is because he attempted to express basic levels of human sensibility.

In the year that he painted *The King's Madness*, Miró wrote: "I escaped into the absolute of nature. I wanted my spots to seem open to the magnetic appeal of the void, to make themselves available to it." The "spots" in this picture were made by pushing paint across the canvas with a rag. He expressed a fascination with the idea of a void, a "perfect emptiness." The shapes painted on the top of the void were symbolic of his dreams. Later in his career, in 1962, Miró said that he "painted without premeditation, as if under the influence of a dream." He wrote of his attempts to combine "reality and mystery in a space that had been set free."

The King's Madness owed much to the Dadaists. It was painted at a time when Miró's work was still deeply influenced by his dreams; this was reversed in his later work.

JOAN MIRÓ (1893–1983)
Dutch Interior, 1928
Guggenheim Museum, Venice. Courtesy of Giraudon

IN early May 1928 Miró traveled through Belgium and Holland, where he saw many masterpieces of northern European art. On his return to Spain, he started a sequence of paintings of interiors inspired by his travels. Miró was quite capable of painting in the detailed realistic style of traditional Dutch painting, but chose to turn these interiors into poetic ideograms. Drawing from his memories, Miró used the technique of automatic drawing, letting his unconscious urges and fantasies assert themselves. This first stage of pure automatism was then followed by a second stage of careful calculated addition and adjustment. Later work such as *Woman and Bird in Moonlight* (1949) took automatism further into the pysche.

Miró's use of color grew in mastery throughout the 1920s, and here he has used strong primary colors against luminous earth colors.

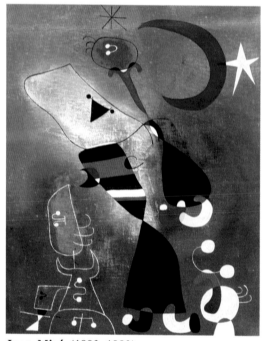

The paint has been applied in thin coats onto an absorbent surface. The thinness and flatness of his shapes of color draw attention to an optical space that only the eye can enter. This gives his forms a lightness that complements their floating in space. The painting deliberately avoids texture and thick paint so we can focus on the illusion of space. The fantastic figures and animals that appear are the result of the curving biomorphic line which wanders and expands to fill the calm interior with suggestive and animated activity.

Joan Miró (1893–1983)
Woman and Bird in Moonlight, 1949
Courtesy of the Tate Gallery. (See p. 144)

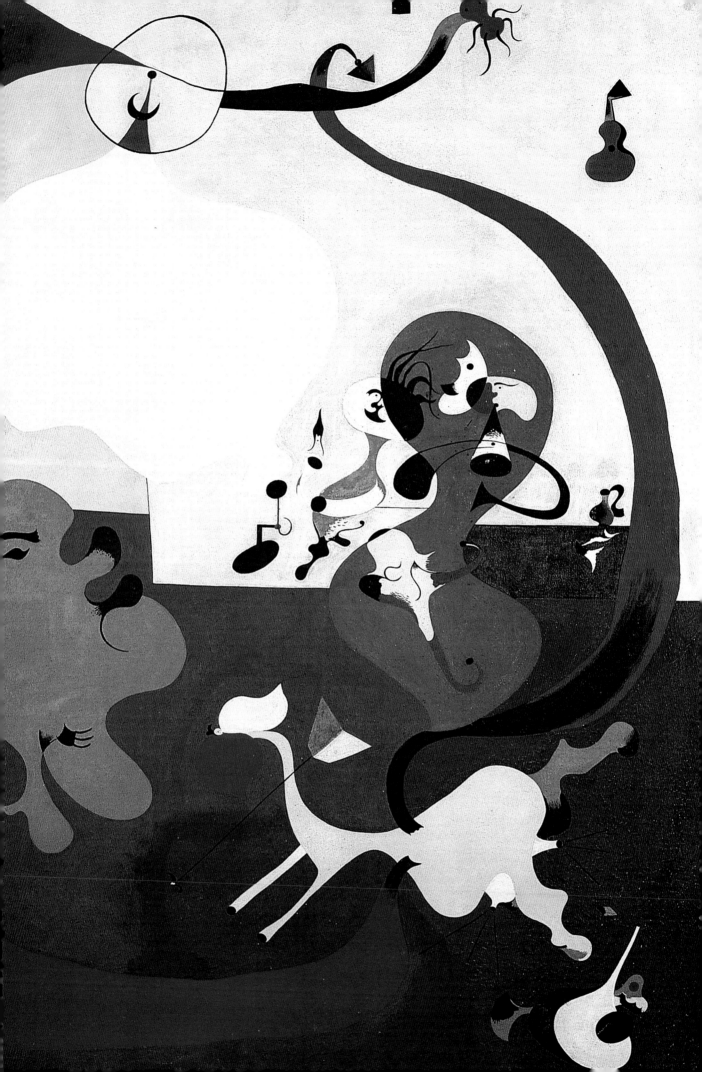

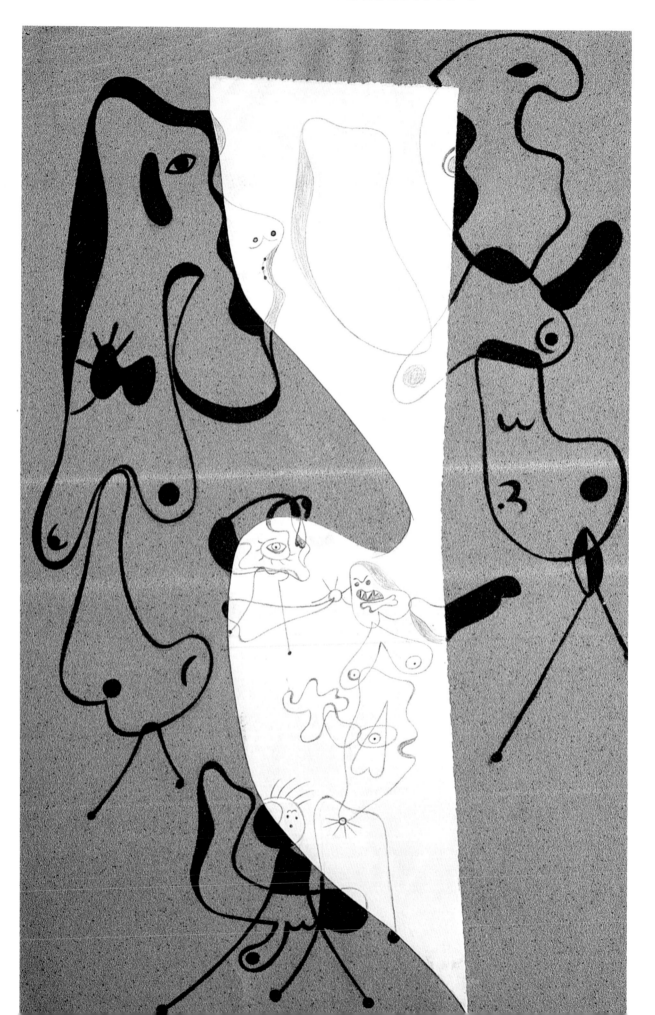

JOAN MIRÓ (1893–1983)
Collage Painting, 1930
Courtesy of Christie's Images

*I*N 1930, after painting his Dutch interior, Miró abandoned painting for collage. He dispensed with rich color and deep space, and started to paste together a series of images of a flatter world of reduced color and thin lines. This flat, inner, mental world was a denial of and withdrawal from the outer world around him. Yet, in making his collages he only used objects he found in the world, and like Kurt Schwitters, as seen in *Opened by Customs* (1937–38), these objects were often cast-off and worthless. This collage, for example, is one of a series done on sandpaper.

Miró placed great faith in the power of dreams, hallucinations, and trances, even though, unlike other Surrealists, he spent little time reading the works of Freud. He was aware that his automatic drawing allowed access to an unconscious part of the mind, which was filled with sexual and aggressive drives. These drives were understood to be generally found in all people. In tapping into unconscious forces and animal instincts, he would begin a painting by setting aside all personal responsibility. Some of these instincts took a remarkable pleasure in the brutal and savage. In order to heighten his state of mind he sometimes undertook long periods of fasting.

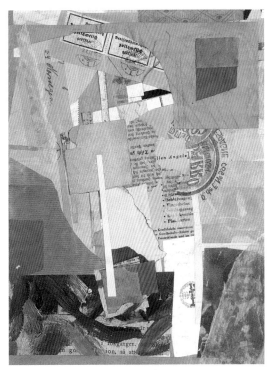

Kurt Schwitters (1887–1948)
Opened by Customs, 1937–38
Courtesy of Christie's Images. (See p. 190)

JOAN MIRÓ (1893–1983)
Persons in the Night (undated)
Helsinki Atheneum. Courtesy of Giraudon

*T*HE Surrealist writer Georges Bataille commented that in
Miró's work, reality disintegrated into "sun-shot dust." One
form migrates into another, triggered, by the earth and dust.
His work is often filled with themes of life and death, birth and decay,
in prehistoric and primal settings. While he inflicts a type of violence
on the image of his objects, he draws them into a drama of human
conflict and love that began long before man ever painted or wrote.

In simplifying the forms of his women, birds, and other recurrent
characters, his paintings have an ambiguity that has been compared to
children's drawings. Each object can have more than one meaning, each
new one destroying the last. Putting them together on the same canvas
produced an intense effect that was likened to a religious experience.
This is seen in his taste for earthly pleasures, the bodily experiences of
sun, landscape, bright color, and
animated form. Yet Miró was
engaged in a spiritual search, looking
for something that went beyond what
can be touched or seen. He shared de
Chirico's interest in the metaphysical,
a theme which the latter explored in
Metaphysical Interior (1917). Miró
commented that "what really counts
is to strip the soul naked. Painting or
poetry is made as we make love; a
total embrace, prudence thrown to
the wind, nothing held back ..."

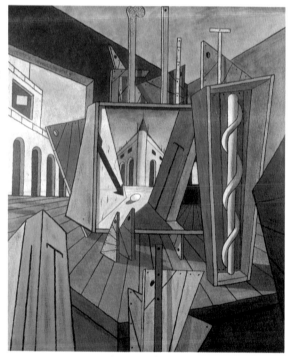

Giorgio de Chirico (1888–1978)
Metaphysical Interior, 1917
Van der Heyt Museum, Wuppertal.
Courtesy of Giraudon. (See p. 26)

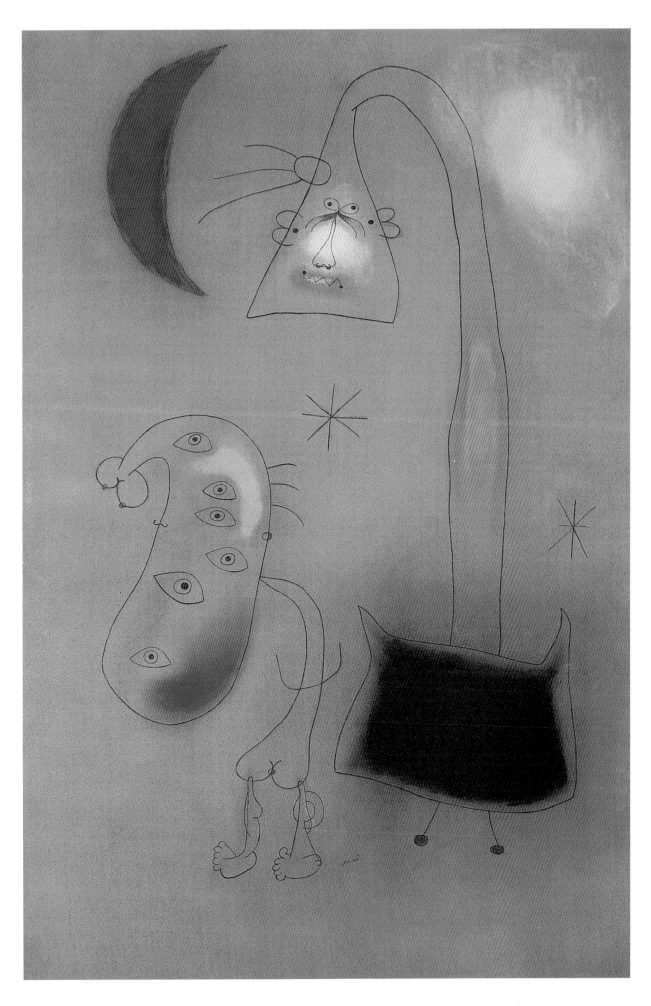

JOAN MIRÓ (1893–1983)
The Lovers, 1934
Courtesy of Christie's Images

*T*HIS painting is a complex mix of tradition and innovation. In his depiction of the pleasures of love, the artist has also sought to disintegrate the image. Some objects are so disintegrated that they become totally abstract, forcing the making of images back to its most fundamental point: the stain on the canvas. In allowing this breakdown, Miró fulfiled his violent desire to "kill painting by its own means." He remarked: "antipainting was a revolt against a state of mind and traditional painting techniques that were later judged morally unjustifiable." He also claimed that painting was his way of expressing himself through a variety of media: "bark, textile fiber, assemblages of objects, collages and so on". As Miró experimented with disintegrating images, Magritte was exploring the strange relationships between familiar objects, which can be seen in *The Red Model* (1935).

René Magritte (1898–1967)
The Red Model, 1935
National Museum of Modern Art, Paris.
Courtesy of Giraudon. (See p. 221)

Miró always claimed to be Catalan by birth and temperament, saying of himself, "we Catalans believe that you must always plant your feet firmly on the ground if you want to be able to jump in the air. The fact that I come down to earth from time to time makes it possible for me to jump all the higher."

JOAN MIRÓ (1893–1983)
Catalan Farmer Resting, 1936
Courtesy of Christie's Images

ON the eve of the Spanish Civil War, Miró was achieving a level of professional recognition in the U.S.A. that secured his reputation. During this time he started to work with new materials on which to paint. This small work was executed on a smooth sheet of copper used for printmaking. The highly polished surface made it impossible to hide the brush strokes in the oil paint.

Just as British Surrealists painted landscapes familiar to them, such as Paul Nash's *Landscape from a Dream* (1936–38), Miró repeatedly depicted the subject of the Catalan landscape and its agricultural workers. He enjoyed the countryside for its stable traditions, yet it often provoked his most daring experiments. This peasant seems to get little rest from his labors, as a beast with an elongated mouth and legs is pursuing him. Above the peasant an image of a stomach or internal organ appears, suggesting that the farmer is about to be eaten by the animal he rears as food. This reversal of roles is partly sexual fantasy, partly political comment, but remains cohesive because Miró has used repetitive lines and colors to suggest alternatives and role reversals, and has divided the painting on a vertical axis to suggest two different types of landscape.

Paul Nash (1889–1946)
Landscape from a Dream, 1936–38
Courtesy of the Tate Gallery. (See p. 240)

JOAN MIRÓ (1893–1983)
Book Cover for French Aid to Republicans in the Spanish Civil War, 1937
Courtesy of Topham

*T*HIS work was first produced as an etching and later a poster. As in *The King's Madness* (1926), the images appear childlike at first. The poster features the raised-fist salute of the Spanish Republicans. Miró, along with Picasso and sculptor Julio González, helped support the Republicans against the nationalist forces of General Franco during the Civil War. During this time Miró lived in France and was safe from persecution. He helped the Republicans by contributing to their art exhibitions, such as at the Paris Exposition Universelle of 1937, where Picasso showed *Guernica* (1937). The end of the war resulted in defeat for the Republicans and occurred just months before the outbreak of the Second World War, which forced Miró to flee France for Spain. Had he been caught at the border, he could have been imprisoned or even executed. He spent much of the Second World War on the island of Mallorca, where his wife and grandmother were born.

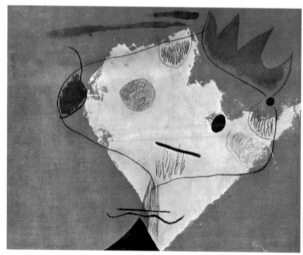

At the bottom of this image is Miró's prophecy for the near future: "in the current struggle I see the antiquated forces of Fascism on one side, and, on the other those of the people, whose immense creative resources will give Spain a drive that will amaze the world."

Joan Miró (1893–1983)
The King's Madness, 1926
Private Collection, Paris. Courtesy of Giraudon. (See p. 124)

JOAN MIRÓ (1893–1983)
The Black Sun, c. 1940
Courtesy of Christie's Images

IRÓ often painted on Masonite, which is a type of hard board, as he liked humble materials that suggested human suffering and vulnerability. Calling them his "savage paintings," his work from this period swarms with oppositions and conflicts; a black sun on a hazy yellow and blue background illuminates the painting. "Thinking about death led me to create monsters that both attracted and repelled me." Despite the continuing civil war in Spain he did not despair for long, "I understood that realism, a certain kind of realism, is an excellent way to overcome despair, whereas mistreating forms leads to mutilation and monstrosity."

The balance between figure and background became highly expressive for Miró. "The spectacle of the sky overwhelms me. I am overwhelmed when I see a crescent moon or the sun in an immense sky. In my paintings there are often tiny forms in vast empty spaces. Empty spaces, empty horizons, empty plains— everything that has been stripped bare has always made a strong impression on me." The work was made, as Miró explained, "in a state of passion and excitement. When I begin a painting, I am obeying a physical impulse, a necessity to begin. It's like receiving a physical shock."

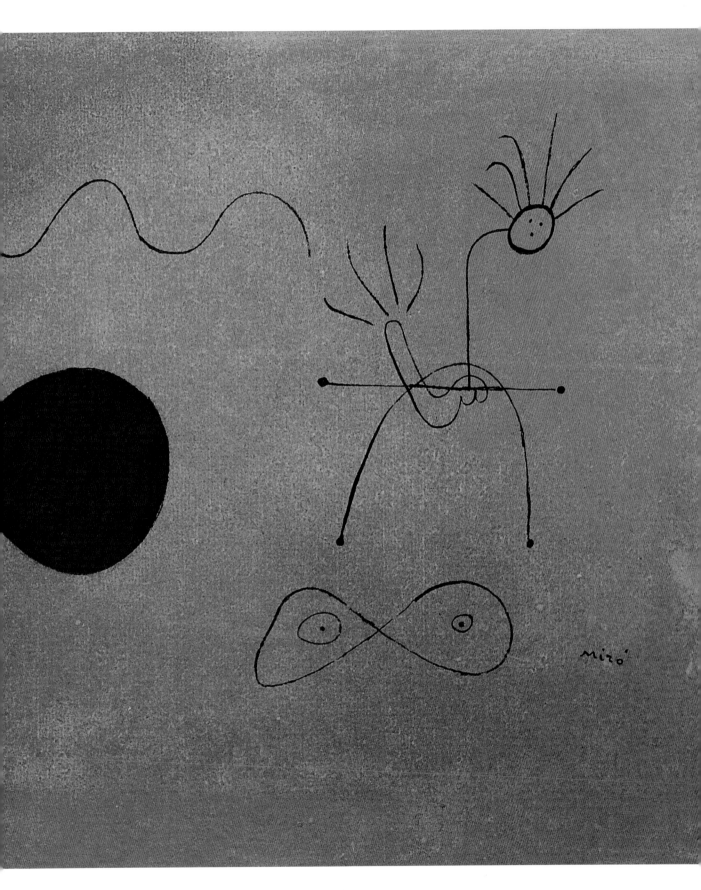

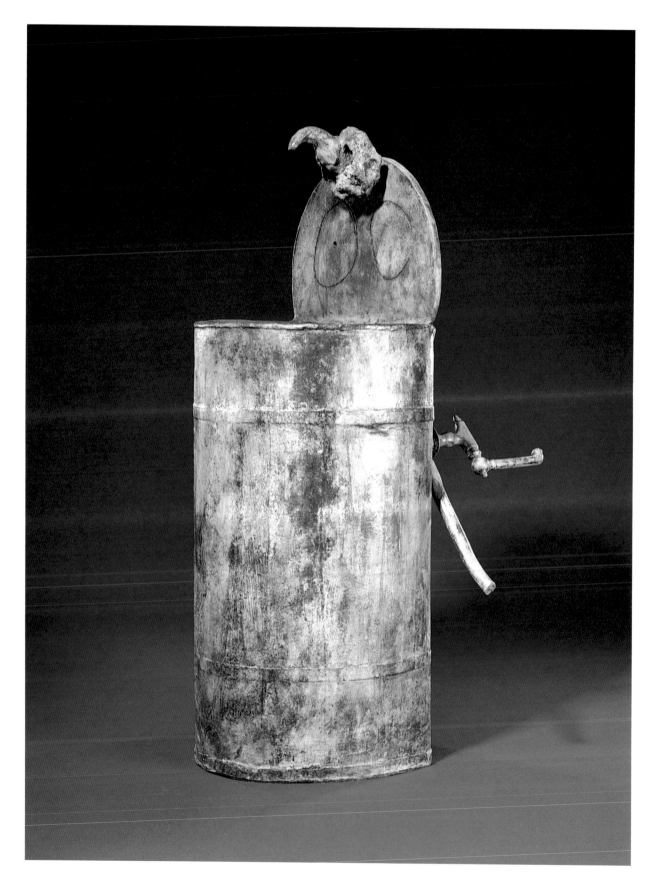

JOAN MIRÓ (1893–1983)
Woman in the Guise of a Bird, c. 1944
Courtesy of Christie's Images

MIRÓ first worked with the Spanish ceramicist Artigas in 1944. He began by painting on pre-fabricated ceramic plaques, but later developed more confidence in making sculptural forms directly in clay and other day-to-day materials. Miró employed Picasso's method of making sculpture through assemblage rather than carving or modeling. He worked directly onto his materials without making sculptures from drawings. The task was to start with a collection of objects which he found and to transform them into his favored characters of women and birds. Like Picabia, he made reference to woman as a receptacle and a machine.

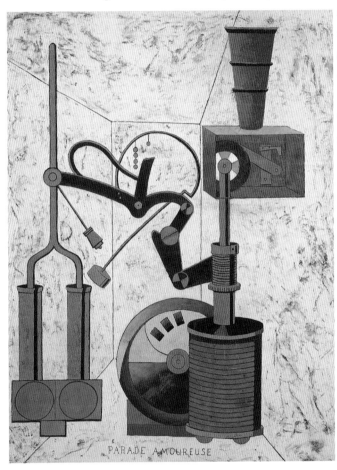

Francis Picabia (1879–1953) *Parade Amoureuse, 1917*
J.L. Stern Collection, New York. Courtesy of Giraudon. *(See p. 62)*

André Breton claimed that the entrance of Miró into Surrealism marked an important stage in its development. His work displayed an innocence and freedom that were never surpassed. The only drawback to his natural gift was his childish personality, which imposed limits on his intellect and his production. Miró did not adhere to Breton's politics, so although Breton considered Miró to be at the heart of Surrealism, he often ignored him in favor of lesser artists who agreed with his politics.

JOAN MIRÓ (1893–1983)
The Bull Race, 1945

National Museum of Modern Art, Paris. Courtesy of Giraudon

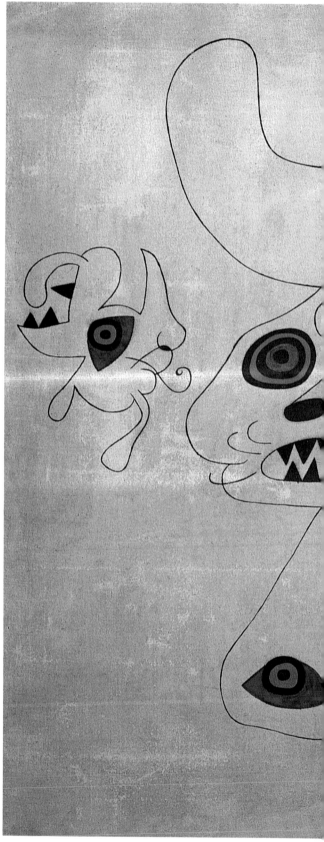

*T*HIS work started with a field of light blue paint spread thinly over the canvas. On it Miró has made a bull-fighting scene, a theme which was also popular with Picasso. The purely linear treatment of the large central bull was achieved with a great directness and simplicity. As he commented "My desire is to attain a maximum intensity with a minimum of means. That is why my painting has gradually become more spare." He liked bullfights, and many other traditional Spanish arts, for their sincerity and intensity. The simplest things gave him ideas, some of which came from Spanish folk art. In this native art "there are no tricks, there is no fakery."

Miró once said that his paintings were "like a secret language made of magic phrases, a language that comes before words themselves, from a time when the things men imagined and intuited were more real and true than what they saw ..." He recognized that this painting was slightly humorous as well as tragic. This effect was unintentional, arising from a need to escape from the tragic side of his temperament.

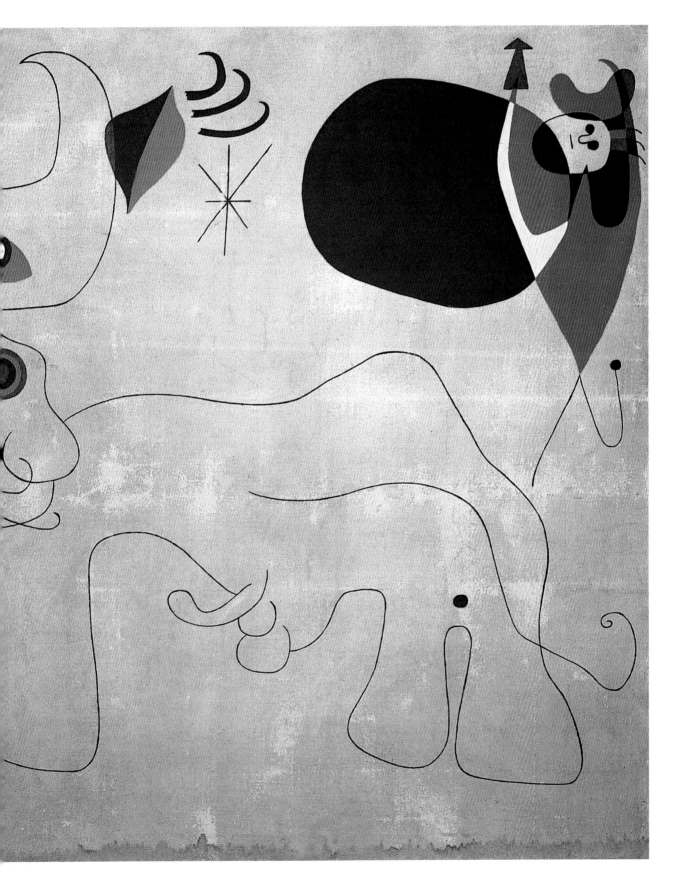

JOAN MIRÓ (1893–1983)
Woman and Bird in Moonlight, 1949
Courtesy of the Tate Gallery

*W*ORKING with psychic automatism, a human figure and a bird become visible out of the overlapping forms. Considering that this is a night-time scene, Miró was less concerned with making the figures clear in space than to evoke the personal and illogical space of a dream. It may suggest a foreboding, a "night-time of civilization" when Europe was plunged into the violence that Surrealists applied to their art and abhorred in reality. This scene, with its tangible, rough daubs of red and gray paint, followed by crisply outlined flat forms, arose from his intangible, complex inner life. Although reminiscent in subject matter of Henri Rousseau's *The Dream* (1910), the treatment of the background is of minimal importance here.

Miró believed that there were experiences in religion, dreams and art, that were beyond the life of flesh and matter. For him, the universe was split between the physical and the spiritual. He also believed that art could allow the closing of this split, if only for a moment. To experience this unity, it was necessary to step away from day-to-day identity. It required a child's simple awareness and lack of self-consciousness, and a painter's sharp eye for observation. He did not seek to escape modern life, but to enrich it with the insights of primary human experience.

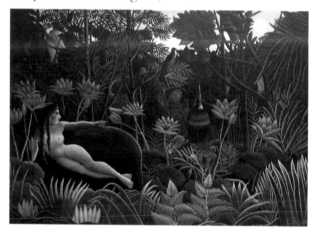

Henri Rousseau (1844–1910)
The Dream, 1910
M.O.M.A., New York. Courtesy of Topham. (See p. 16)

Jean Arp (1887–1966)
Dada Collage, 1918
Private Collection. Courtesy of Giraudon

LIKE so many Surrealists, Arp started within the Dada movement, and traveled regularly between French and German groups. At this time Arp used a technique of composition which took advantage of chance: he dropped pieces of wood or card onto a surface and fixed them where they fell. Another technique involved dropping paint-covered string onto a canvas. He then made additions to these spontaneous compositions until he was satisfied with the final result.

This collage started with a sheet of sandpaper, on which he made random daubs of red, yellow, and black paint. This scattered composition, which acts like a large frame, holds a second sheet of paper. This inner work contains several man-made bars through which we look at a series of impersonal, gray shapes on a sky-blue background. This reflected Arp's elegant self-restraint, for he believed that abstract painters had to tame violent emotions to master their art and harness the forces of chance.

**Joan Miró
(1893–1983)
*Collage Painting, 1930***
*Courtesy of Christie's
Images.* *(See p. 129)*

JEAN ARP (1887–1966)
Configuration, c. 1920s
Courtesy of Christie's Images

A S WITH many of the Surrealists, Arp began to move away from Dada after the First World War. He went to live in Paris, although he continued to keep in contact with many different European art movements, including the German abstract painters and the De Stijl group in Holland.

He experimented extensively with abstract painting and sculpture, often using cut out wood and card to build up a shallow sculptural surface. His wife, Sophie Tauber, was an abstract painter who used straight lines and geometric forms, but he preferred the natural organic line—a "biomorphic" shape. In *Configuration* Arp used irregular vertical stripes of blue-gray and black to create a background of shifting space and depth. Down the central strip oval and organic white shapes float with innocence, generated with spontaneity.

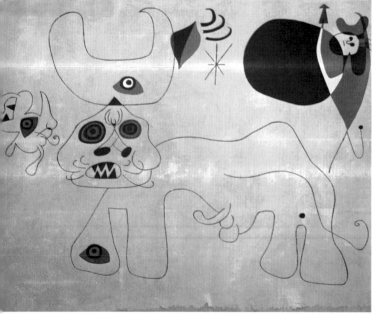

Joan Miró (1893–1983) *The Bull Race*, 1945
National Museum of Modern Art, Paris. Courtesy of Giraudon.
(See p. 142)

JEAN ARP (1887–1966)
Vegetal Torso, c. 1935
Courtesy of Christie's Images

ARP used rounded, biomorphic shapes in a number of his works. He discovered that almost any combination of such forms became representative of a plant or animal. These swelling forms were almost emblems of creativity itself and, as he commented: "we wish to produce as a plant produces its fruit, and not to reproduce." The result of this desire was a series of virtually abstract sculptures. For Arp, however, there was nothing abstract in his work. He called his style *art concret* because it was a physical manifestation of an invisible, unknown force.

In fact, Arp did not like the term "abstract art" because it implied something entirely mental and internalized. As Hans Bellmer invokes the physicality of the torso in *The Doll* (c. 1937–38), Arp also liked the physical fact of his art, and wrote statements claiming that his sculptures were solidification of mass. Thickening, growing, hardening, and maturing lumps of marble and bronze suggest the vital sustaining force that exists in all living creatures. In this particular work he used stacked stone in a style reminiscent of the Classical sculptor Brancusi. The variety of textures and colors move upward from rough and earthy to smooth and white. As they rise, the forms become less vegetal and more animal.

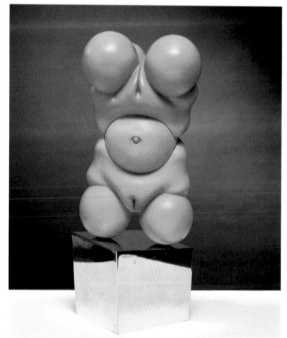

Hans Bellmer (1902–1975)
The Doll, c. 1937–38
Courtesy of the Tate Gallery. (See p. 180)

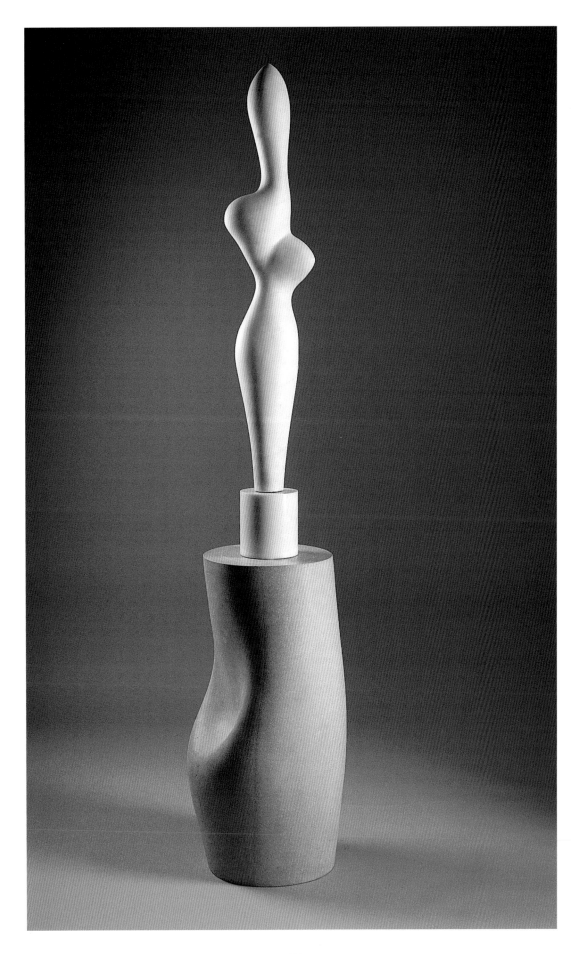

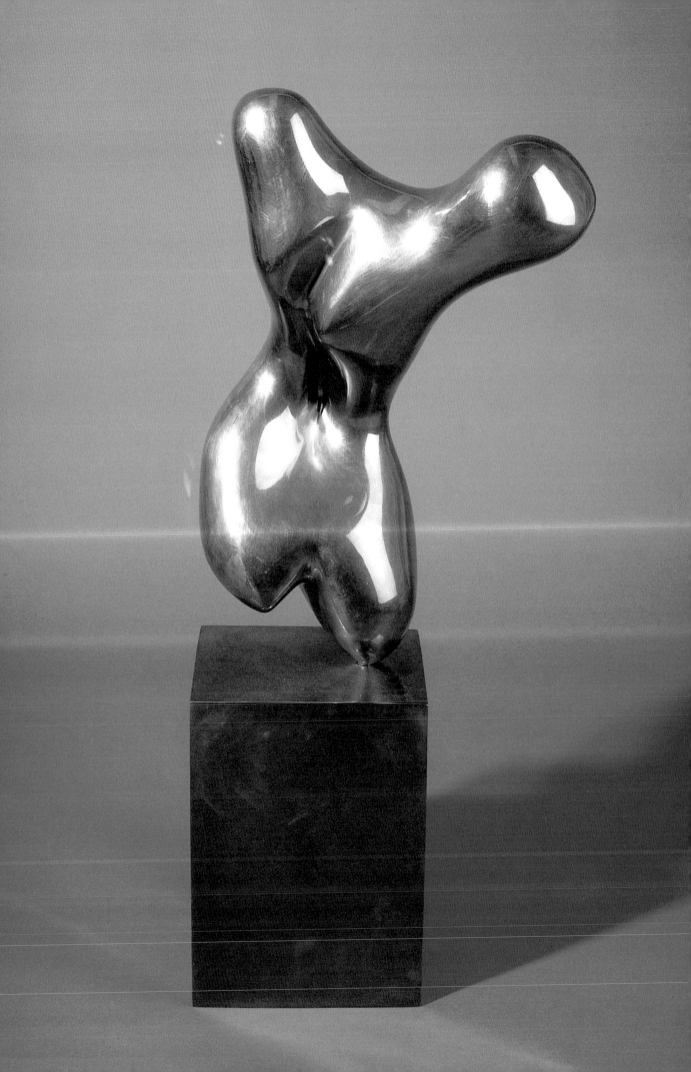

JEAN ARP (1887–1966)
Abstract Torso, c. 1930s
Courtesy of Christie's Images

IN the early 1930s, Arp began to create free-standing sculpture. This change was well received, particularly for its attention to solid mass. Many sculptors, such as Picasso and the Russian Constructivists, were opening sculpture into flat planes in space, or making assemblies of found objects. Sticking to a more traditional concept of sculpture, Arp made enclosed forms with soft curving profiles, which suggest biological creatures of many sorts. The title of a work was often decided after it was complete.

This highly polished bronze torso is delicately balanced on the edge of a heavy bronze block. It seems to leap and gesture as it fills out into our space, and is startlingly reminiscent of the torso in Duchamp's *Etant Donnés* (1945–66). The work also suggests the ways in which growth affects its environment. The finish is so smooth and polished that the work acts like a mirror that absorbs and distorts its surroundings. Strong lighting fills the work with shifting glints and deep shadows. Throughout his long career, Arp made a point of suggesting the growth and change of natural forms, such as animals and plants, without ever letting them become too specific.

Marcel Duchamp (1887–1968)
Etant Donnés (Taken as Given), 1945–66
Modern Art Museum, Stockholm. Courtesy of Giraudon. (See p. 50)

JEAN ARP (1887–1966)
Entwined Concretion, c. 1930s
Courtesy of Christie's Images

MANY of Arp's sculptures were shown in the middle of a room, rather than against the walls. This allowed the spectator to experience the work from various positions. As the viewer shifts in space the suggestions of form start to change, a torso from one angle becomes a fish or a tree branch from another angle. Full resolution of the form meant completion, yet also a type of death. This bronze is particularly direct in its relation to us, because it has no plinth. We share a single space with this work, making it tempting to insert a hand or caress the surface. Arp used a black finish on this work, and a rough texture like the skin of a citrus fruit, reflecting his remark that "art is a fruit that grows in man."

In the course of his development, Arp was single-minded in his pursuit of pure poetic forms. He called them "essential forms," and repeated them for over 40 years. This emphasis on a refined set of forms gave his work a distinctive style, but it also restricted his production. The ripe fullness of the forms contrasts starkly with the thin, vulnerable forms used by Giacometti after 1940. Arp's biological forms made him an important artist for the American abstract painters of the 1940s.

Alberto Giacometti (1901–66) *Man Pointing, 1964*
Courtesy of the Tate Gallery. (See p. 208)

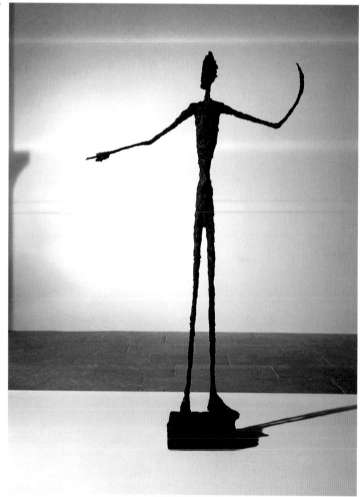

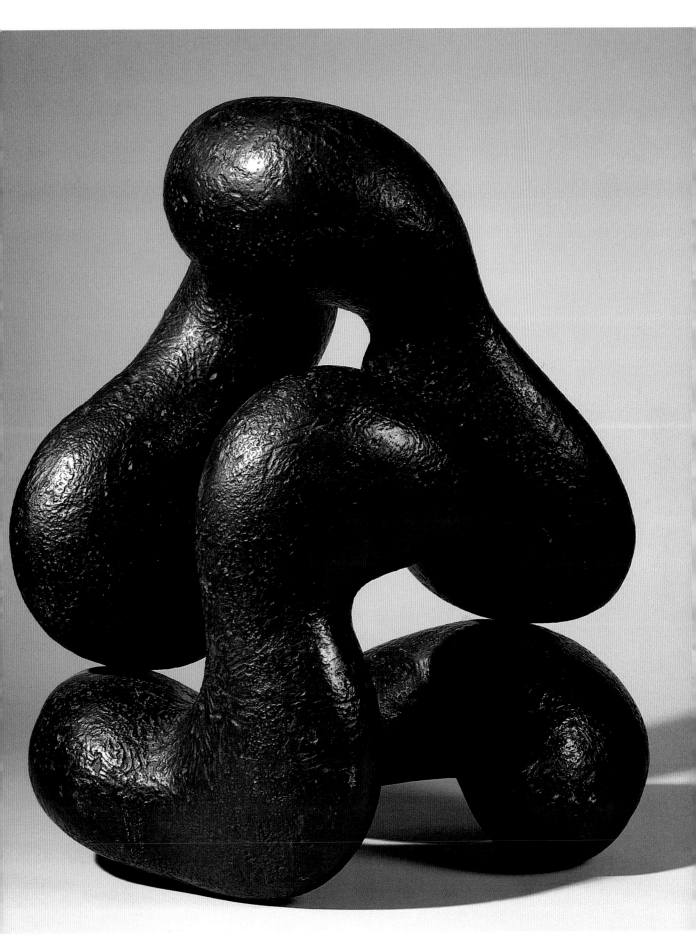

YVES TANGUY (1900–55)
A Large Painting which Represents a Landscape, 1927

Private Collection, Tokyo. Courtesy of Giraudon

ANGUY depicts a dark sea-floor, or desert, which is dotted with occasional weeds and marked by long shadows. On top of a steep rock a vaguely human figure rests in a nest, while simple organisms squirm below. The blue-green of the background is carefully calculated to suggest water or air. This proved to be an important work for Tanguy, in that it includes all the important elements of his mature style. Biomorphic forms are smoothly shaded to create depth, shown in strong light and crisp shadows. Although the forms and spaces are fantasies, their rendering is highly illustrative and realistic. Tanguy was one of the first Surrealists to use illusionistic images, opening the way for artists such as Dalí and Magritte.

Tanguy felt that painting could contribute to society. He also signed some of the Surrealist manifestos, including public statements of their political positions, and a promise to follow the orders of the French Communist Party in the event of a war between capitalism and communism. He wanted to place his energies at the service of "the revolution." In addition, he joined in Surrealist condemnation of racism and colonial exploitation.

René Magritte (1898–1967)
The Annunciation, 1930
Courtesy of the Tate Gallery. *(See p. 216)*

YVES TANGUY (1900–55)
Hope at 4:00 am, 1929
National Museum of Modern Art, Paris. Courtesy of Giraudon

*L*IKE so many Surrealist painters, Tanguy was inspired to become an artist after seeing the work of de Chirico, such as *Portrait of Apollinaire as a Premonition* (c. 1914), published in the magazine *La Révolution Surréalist*. He also counted among his friends several important Surrealist poets. Despite his lack of training as a painter, Tanguy moved to Paris in 1923 to join the Surrealists, working there for three years. In 1926, unhappy with his work, he destroyed all his paintings and began again in a new style. These new works powerfully suggested a weightless space, like the tranquility and silence of the bottom of the sea. This particular painting is unusual in its suggestion of a cliff of layered stone. The title suggests an early morning scene in which a delicate bird-like creature takes flight.

In his essays about Tanguy's paintings, André Breton, the leader of the Surrealist movement, tried to record the flashes and echoes of emotion which the paintings caused in him. As Breton stated, writing about Surrealist painting "can exist only as a form of love."

Giorgio de Chirico (1888–1978)
Portrait of Apollinaire as a Premonition, c. 1914
National Museum of Modern Art, Paris. Courtesy of Giraudon. (See p. 23)

YVES TANGUY (1900–55)
I'm Waiting for You, 1934
Courtesy of Giraudon

TANGUY shared the pictorial realism of Dalí and Magritte, yet made no reference to an observed world. His works appeared spontaneous in the manner of an "automatic" drawing, but required hours of meticulous painting. Visible brush strokes are kept to a minimum in order to hide the craftsmanship of the work. It could be said that Tanguy provides the achetypal Surrealist painting: recording a world that has never been within the highest level of photographic accuracy. Strange creatures populate his imaginary world. Here, small amoeba-like organisms prop up an object suggestive of a jawbone, while others stretch out in an elastic, oozing, purple mass. Some of these creatures make reference to the work of Arp, which is unsurprising as Tanguy worked within a similar, limited range of forms and deep atmospheric spaces. He did not experiment with different media and styles in the manner of Ernst or even Magritte.

Yves Tanguy (1900–55)
Surrealist Landscape, 1935
Courtesy of Christie's Images

*T*ANGUY was an active member of the Surrealist group and often participated in the group game *Corps Exquis*, in which people contributed sections of a drawing without seeing what the others had done. *Surrealist Landscape* is the result of one such game. It is often remarked that he combined the abstract emblematic forms of Miró and Masson, such as the latter's *Underground Figure* (1924), with a Realist style. The contemporary pyschoanalyst Jacques Lacan put a finer point on this common remark. He observed that the human subject is forced to use forms—pictures and language—to express desire. Without these forms, desire is unable to complete its circuit. Many of the forms within this landscape appear to be made out of piles of oil paint.

Lacan believed that painters lay down their gaze on canvas in order to satisfy desire and to realize "being." In this work, Tanguy paints a substance which normally remains unconscious; a substance that can transform into any shape. To help preserve the surprise of these forms, Tanguy sometimes drew and painted on canvases turned upside down. Here, he staged a scene in which oily, unformed masses begin to take on the shape of desire. He witnesses the abstract moment when desire first takes form. Because he never shows its consummation, he never requires a new style.

André Masson (1896–1987)
Underground Figure, 1924
Courtesy of Christie's Images. (See p. 79)

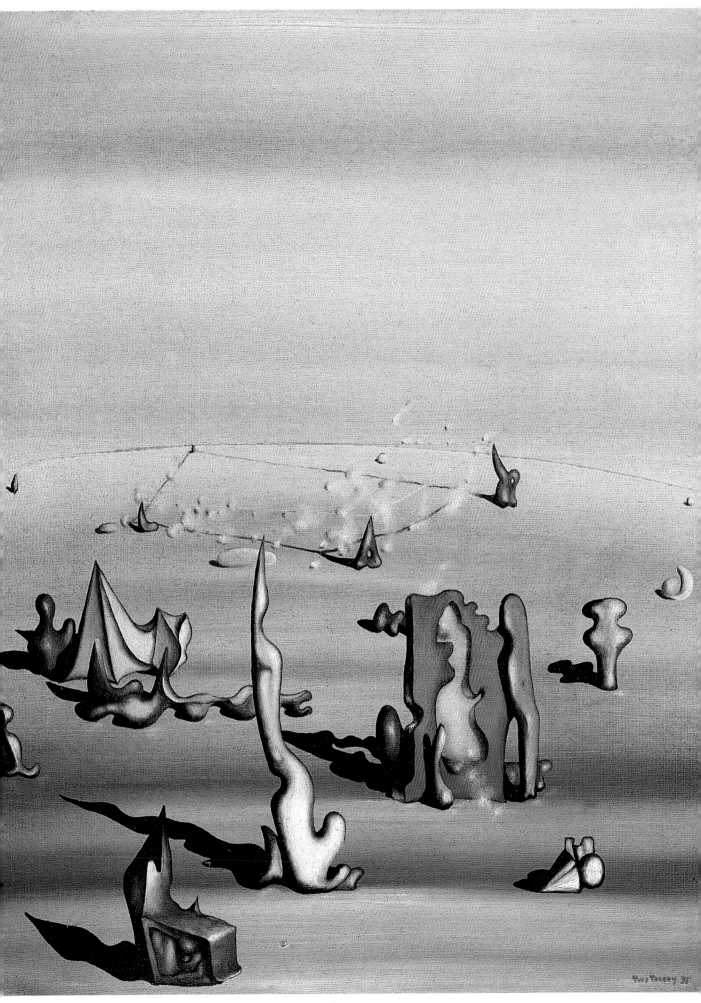

1940

Modern Art Museum, Venice. Courtesy of Giraudon

AT the beginning of the Second World War, Tanguy moved to America, where he married and settled. In joining other Surrealists in America he contributed to the strength of the movement, yet in the period after the war his absence contributed to the impoverishment of French art.

On this canvas, he presents his typical spatial vocabulary, although he has made some slight changes. The distinction between ground, plane, and sky has been blurred, in part by restricting and limiting his colors so that the horizon line is lost. Instead, it is the constructed, organic forms that have stronger colors, such as bright yellows and blues. The forms are also close to the foreground and are tightly composed into a vertical frame. Others of Tanguy's contemporaries, such as Paul Delvaux in *The Visit* (1939), were looking back to Renaissance works for inspiration for their figures at this time.

The painting includes an odd device: the dark panel on the right, which bears cryptic inscriptions or instructions. The tighter degree of composition in this painting was achieved by drawing on the canvas before painting. This allowed shapes to be moved and arranged in a process of construction and erasing. Previously Tanguy had painted more directly, using a type of automatic doodling.

Paul Delvaux (1897–1994) *The Visit, 1939*
Courtesy of Giraudon. (See p. 232)

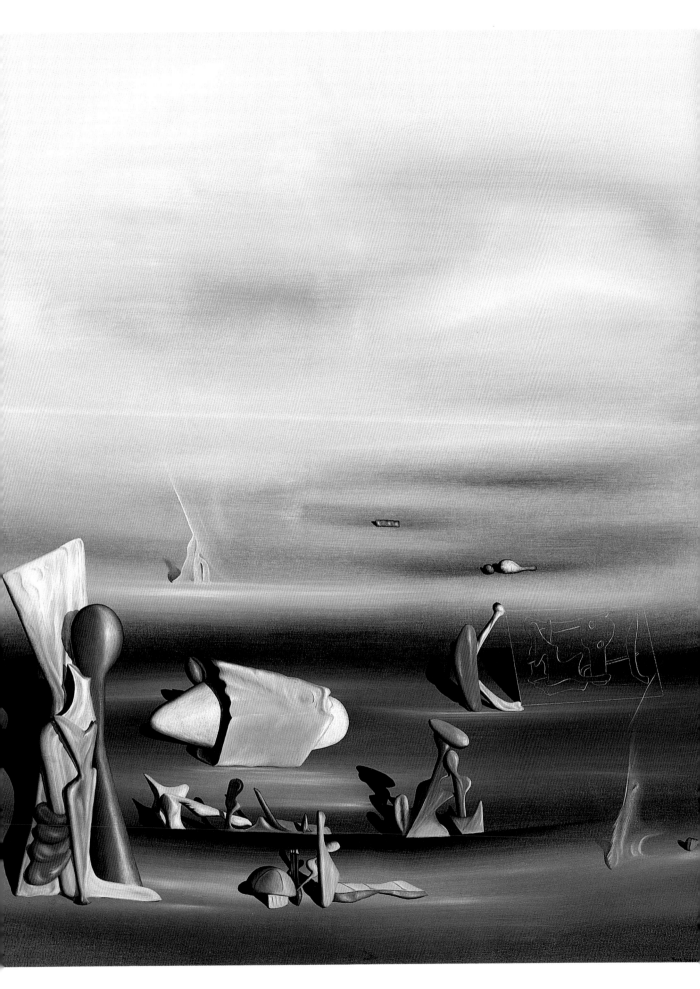

YVES TANGUY (1900–55)
From Green to White, 1954
Courtesy of Giraudon

TANGUY'S pictorial language was consistent throughout his life. It has been suggested that his adolescent trips to Brittany were one influence on his style, as was a trip to Africa, where he saw many unusual geological formations. Another suggestion is that his initial training as an officer in the merchant navy gave him a strong sense of the deep, misty spaces and loneliness of the open ocean. This is a late picture, made after many years of living in America. During this time he and the young painter Matta had considerable influence on each other's work. Here the brightly glowing forms that float in the sky are reminiscent of Matta. Below this active and swirling sky Tanguy gave a vision of an unearthly, airless architecture, which could also be read as natural rock formations.

Matta (1911–to date) *Composition, 1966*
National Museum of Modern Art, Paris.
Courtesy of Giraudon. *(See p. 239)*

Tanguy was unusual among Surrealists because his pictorial language was consistent, without ever using narrative. In this sense his pictures were abstract stories, which depended upon limited moods and actions. While many of Magritte's paintings show a similarly limited range of mood, he used more literary devices, and suggested personal biographical events.

SALVADOR DALÍ (1904–1989)
Portrait of Luis Buñuel, 1924
Luis Buñel Collection, Mexico. Courtesy of Giraudon

*D*ALÍ was fond of reading texts by Freud and Krafft-Ebing about unusual sexual perversions. Of particular interest to him was the fetishist, who cannot achieve orgasm without the presence of certain objects. Dalí also studied Freud's ideas on the meanings of dreams, and liked the suggestion that unpleasant childhood memories were pushed down from the conscious mind into an "unconscious." Dlai's civilized, meticulous, and realistic style served as a sharp contrast to his interest in repressed memories, violence, and the mind's animal instincts.

In this early painting, Dalí has made a portrait of his friend and fellow Spaniard, Luis Buñuel. He worked closely with Buñuel on several film projects, such as the notorious *Chien Andalou*. The opening sequence of this film shows a man grasping the head of a woman from behind, then slitting her eye open with a razor. Such was the "convulsive beauty" which arose out of their fascination with extreme states of mind. Dalí's showmanship helped revive a career that had been badly damaged by his sympathies for the Nationalists (Fascists) in the Spanish Civil War. Like Tanguy, he pursued a style of magic realism, but detested abstract painting.

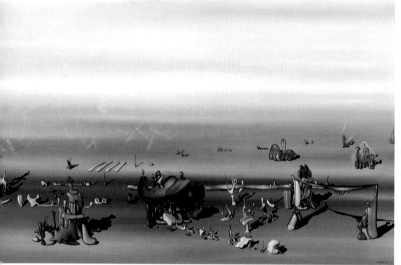

Yves Tanguy (1900–55)
I'm Waiting for You, 1934
Courtesy of Giraudon. (See p. 161)

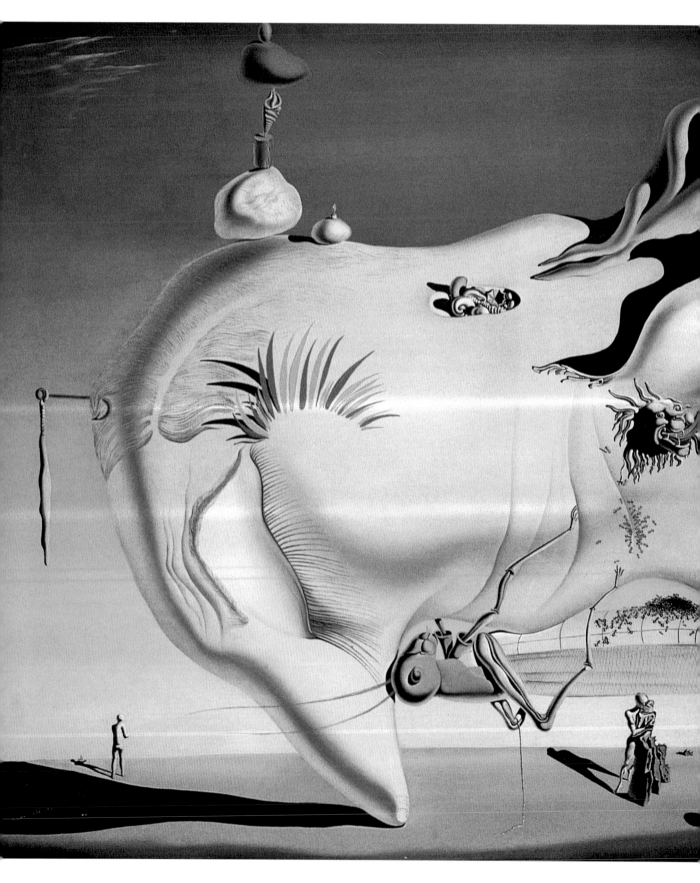

SALVADOR DALÍ (1904–1989)
The Great Masturbator, 1929
Luis Buñel Collection, Mexico. Courtesy of AiSA

*T*HE large face in this picture is a self-portrait of Dalí lying nose down. The eyes are closed while a locust clasps his mouth. As this head transforms, it reveals an erotic scene of oral sex at the top, and architectural stonework at the bottom. In a poem about this painting, Dalí drew attention to the tension in the membrane across his mouth. Dalí also wrote of his childhood fantasies of being eaten, as well as, recalling an intense childhood pleasure and disgust in eating locusts. A contemporary critic noted how the painting combined a sexual seductiveness with the voluptuousness of good food. Indeed, the theme of eating the body was a regular feature in Dalí's paintings, a gesture of imitation toward Christ, whose body is symbolically eaten in the sacrament. Whatever its personal interpretation, this aspect of Dalí's work followed an accepted psychological view: when the mind is free of all habits, pressures, and rules it produces images, many of which do not make logical sense. In dreams, the subject accepts the most extreme jumps of space, time, and forms, undisturbed by their irrationality.

SALVADOR DALÍ (1904–1989)
The Persistence of Memory, 1931
Courtesy of Topham

DALÍ is probably the closest the Surrealists ever came to creating a household name. Although critical opinion of Dalí is generally very low, public awareness of him is very high, largely because of the outrageous manner in which he invited critical disapproval. Breton took great pleasure in throwing Dalí out of the Surrealist group.

In this painting, Dalí presents a fantasy scene in a highly realist academic style. It consists of landscape forms that slowly change from one object to another. Contours may be read in different ways, spaces twist, yet the image as a whole remains unified. Some of these shifts produce freaks and distorted figures.

Dalí behaved like a paranoid megalomaniac, and perhaps he was. He visited Freud in London to show him some of his pictures. Freud agreed with Dalí: he had succeeded in painting his unconscious, and agreed that they required no further analysis. Freud also remarked, however, that he preferred paintings in which the subconscious could be discovered, rather than those in which it was laid bare.

SALVADOR DALÍ (1904–1989)
The Burning Giraffe, 1936–37
Courtesy of Giraudon

*D*ALÍ made a considerable impact on Surrealism around 1935, with the introduction of his "paranoid-critical" method. He regarded automatic drawing like that of Miró in *Dutch Interior* (1928) as too passive; inner dreams and reveries were valuable and interesting, but automatic drawing lacked the commitment and means to realize inner imagery fully. Besides this, Dalí also argued that Surrealist art should be more assertive in forming its pictures of the unconscious, to be more ordered and systematic in its methods—even the artist could not verify the meaning of an automatic drawing.

This called for a new understanding of automatism. It needed to become a lyrical and even violent vehicle for changing reality, it required the artist to avoid private art works and to make a more public display and effort. Dalí took private sexual imagery and, like an exhibitionist, went out into the public. His works raised the debate over the value of automatic drawing, which by 1935 seemed an exhausted method. Could a method so dependant on passivity and chance be made into a calculated and methodical art? Certainly Breton disagreed, and he expelled Dalí on the grounds that his fascination with Hitler, paranoid and apolitical as it may have been, was unacceptable.

Joan Miró (1893–1983)
Dutch Interior, 1928
Guggenheim Museum, Venice. Courtesy of Giraudon. (See p. 126)

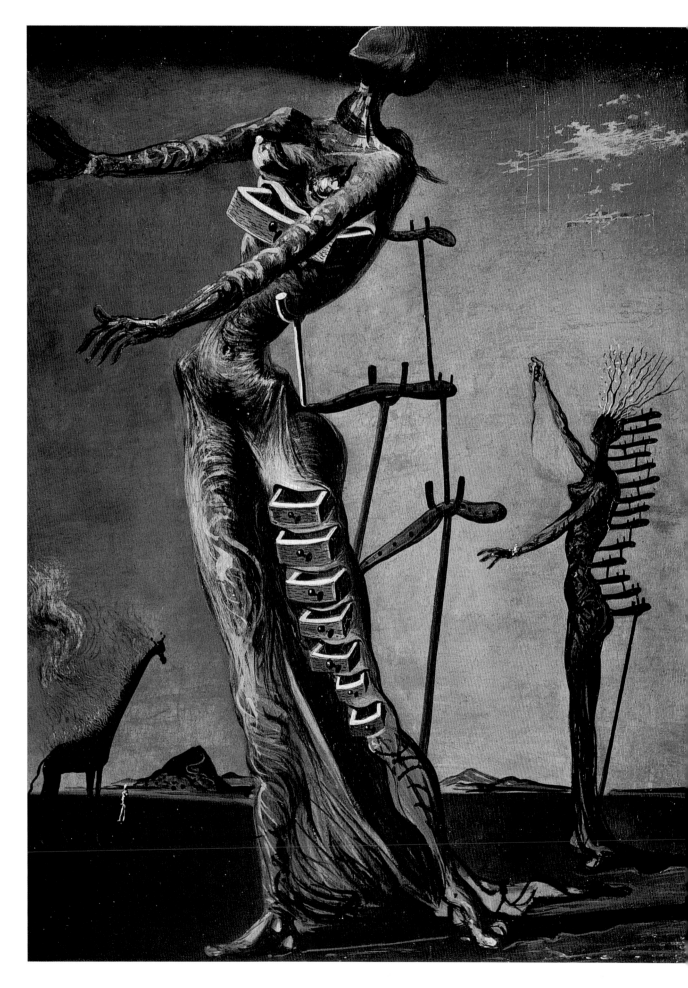

MAN RAY (1890–1976)
By Itself, 1918
Courtesy of Christie's Images

*T*HE American artist Man Ray first met Marcel Duchamp in New York in 1915. Then, in 1921, Man Ray went to Paris where the Surrealists particularly liked his wit and humor. His long residence in France, however, has led to a critical neglect of his work in America.

This sculpture stems from Man Ray's time with Dadaists. Like Duchamp, he worked through many painting styles before becoming exasperated with the theory of self-expression through paint on canvas. Under the influence of Picabia and Duchamp, he began to experiment with Dada constructions. This work, originally made of wooden slats and an iron clamp, was later cast in bronze, like Duchamp's "Readymades." Although it is composed as a form, and possesses an architectural balance and clarity, it was not meant to have pleasing aesthetic qualities. Instead, Man Ray has taken something formless, random, and

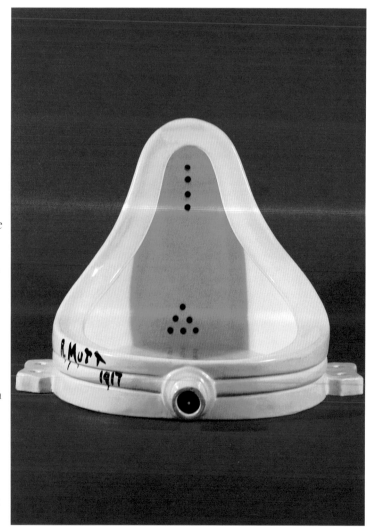

Marcel Duchamp (1887–1968) *The Fountain, 1917*
Courtesy of Christie's Images. (See p. 42)

worthless, and transformed it into art. While his many different styles warrant his inclusion in a book on the Surrealists, he was at heart a Dada artist, even after the movement had disappeared.

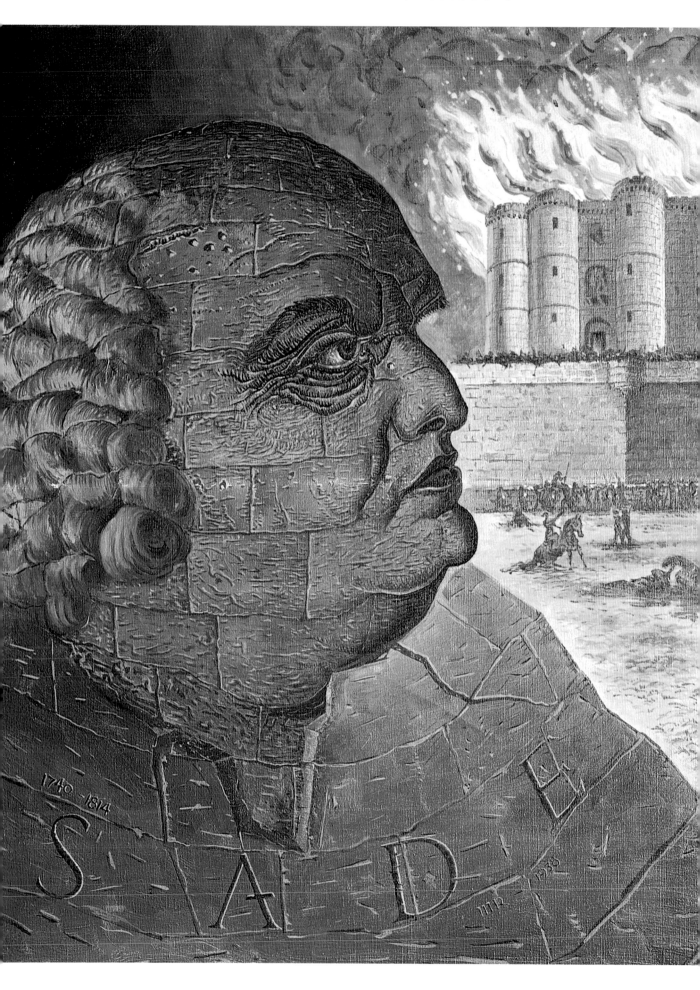

1740 – 1814

S A D E

1938

MAN RAY (1890–1976)
Portrait of the Marquis de Sade, 1938
Private Collection, New York. Courtesy of Giraudon

WHILE working on Dada paintings, Man Ray supported himself by working as a commercial photographer—his photographic portraits of the Surrealists are greatly admired. Once, when working in the dark room, he accidentally left a glass funnel and a thermometer on a sheet of photographic paper lying in developing solution. When he turned the light on the paper began to go dark, leaving only the traces of refracted light from the glass implements. He called this process, which did not need a camera or photographic enlarger, "rayography."

On the eve of the Second World War, Man Ray suddenly shifted to painting for his portrait of the Marquis de Sade. It shows de Sade beside the Bastille as it is stormed and razed to the ground. This is a scene of public violence, watched by the notorious marquis, whose exploits of crime and cruelty in the eighteenth century fascinated many Surrealists. De Sade was a master of

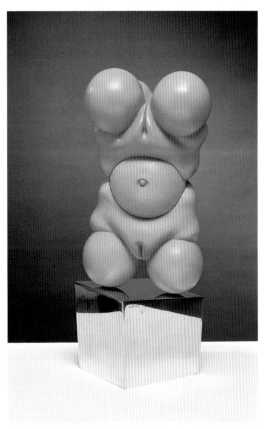

Hans Bellmer (1902–75)
The Doll, c. 1937–38
Courtesy of the Tate Gallery. (See p. 180)

deception, who preyed upon the rich and enjoyed causing pain. He disappeared while waiting for the guillotine, and changed his identity as often as he wished, becoming a phantom figure.

HANS BELLMER (1902–75)
The Doll, c. 1937–38
Courtesy of the Tate Gallery

THERE was, in the Surrealist movement, a tendency to evoke the uncanny from ordinary, everyday objects. This could be striking, shocking, and even traumatic. If the end vision is experienced as traumatic by some, this usually arises when the human body is made uncanny. In the case of Bellmer's photographs and sculptures of dolls, which he made between 1939 and 1949, the body is dismembered into a strange and wonderful collection of orifices, most of them sexual. In one sense his work is erotic, a fantasy of a body designed for no other purpose than to give pleasure. This "woman" is all sex and no head, like Duchamp's pornographic *Etant Donnés* (1945–66). Despite, or because, this fantasy violence that has been committed on the body, radical "surgery" has cut away the character and personality to leave only the automatic instincts of headless flesh. The result can be both erotic and deathly at the same time. In one sense

this doll is beautiful and full of the promise of pleasure; in another it is grotesque, dismembered, and convulsive. Perhaps this is what André Breton meant when he coined the term "convulsive beauty" to describe the works of art that he admired.

Marcel Duchamp (1887–1968)
Etant Donnés (Taken as Given), 1945–66
Modern Art Museum, Stockholm. Courtesy of Giraudon. (See p. 50)

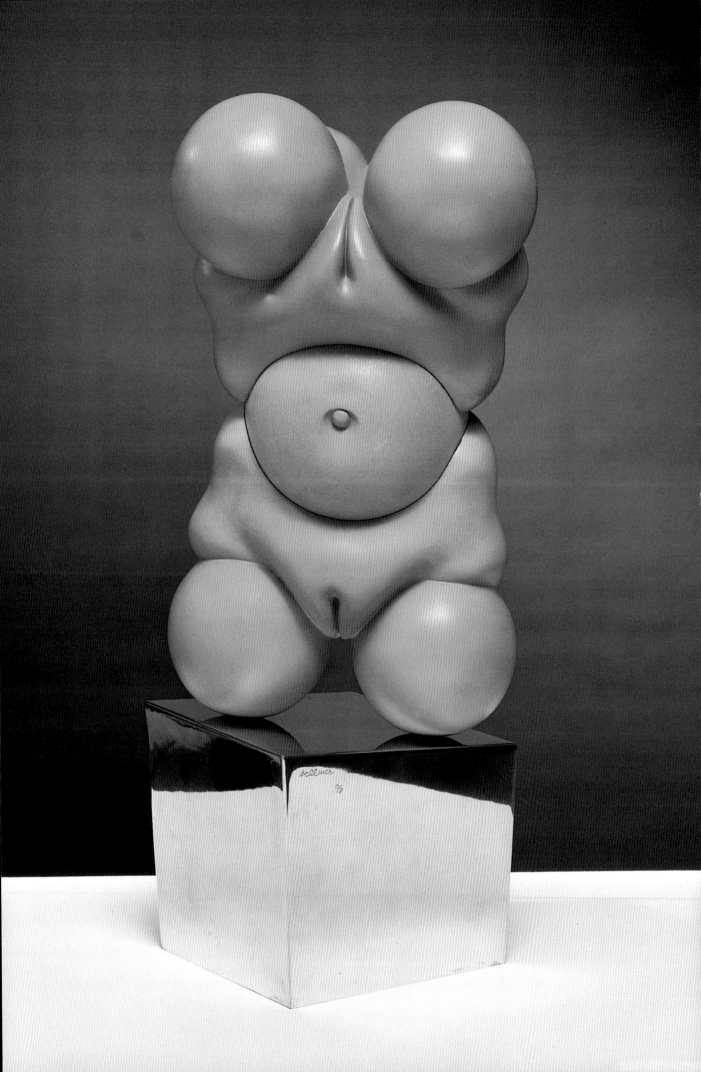

HANS BELLMER (1902–75)
La Noce (The Night), 1963
Courtesy of Christie's Images

*T*HIS delicate pencil drawing reveals Bellmer's powers as a draftsman. It subtly combines line and tone in a soft rich evocation of space and form, and the delicate style belies the pornographic content. In the drawing we see a woman's buttocks sitting on a stool, penetrated by a shaft. Above this is a woman's head, part of the face has melted into a clear liquid like tears. Hovering above this figure are fragmented scenes of lovemaking. The whole drawing is unified by a series of lines that shift between hair, stockings, and intermingling forms. Some critics see this work as sadistic, with fascist overtones in its reduction of woman to a sex machine. Similar observations have been made about the wartime work of Picabia. Others comment that these are private fantasies to be interpreted by Bellmer alone. Bellmer shows us the sexual instincts and drives of man before subjecthood has taken root.

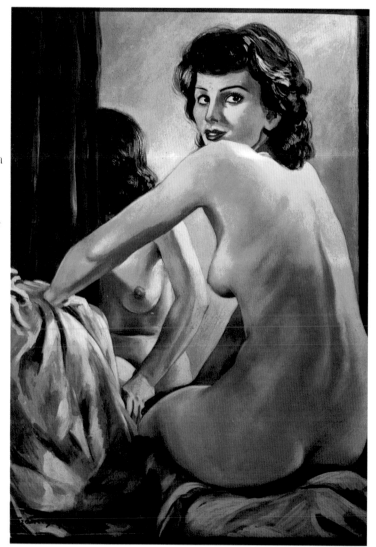

Francis Picabia (1879–1953)
Naked Woman in Front of a Mirror, 1943
Courtesy of Topham. (See p. 74)

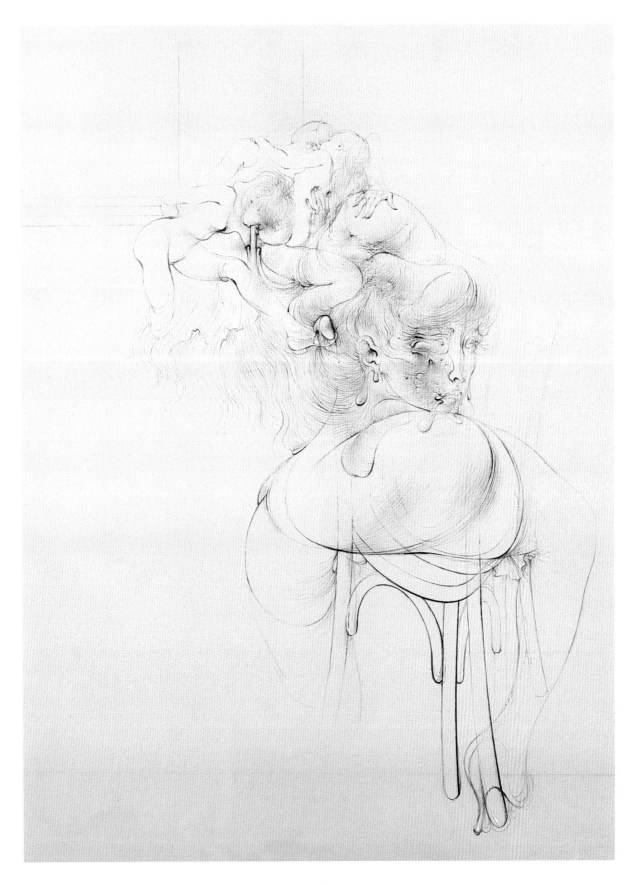

HANS BELLMER (1902–75)
Intertwined People, c. 1935
Courtesy of Christie's Images

*T*HIS small painting was done as a study for his work with dolls. Bellmer pursued this work most intensively in the period of 1934–35. During this time he commented that the work caused him a mix of pleasure and fear. It is harsh in comparison with the softness of *Girl in a Chemise* (1905) by Picasso, and some critics have interpreted this work as fetishistic, meaning that Bellmer feared the dismemberment of the body, especially his own castration. As a defense against this, he has constructed the female body as if it were a penis, so denying his castration anxiety.

Bellmer's own comments sometimes suggest the truth of this view. He has suggested that this figure, standing in an open space with its blue background, recalls his memories of an enchanted garden which he visited when a child. By placing his creations in an ideal childhood, he

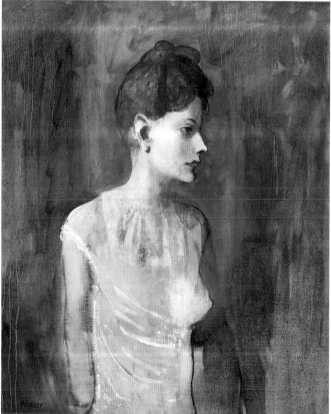

recalls a period from his personal history in which he had no sexual anxieties. If the garden was an encompassing, supportive place, it is disrupted by the classic Freudian trauma: the discovery, by a male child, of a woman's "lack" of a penis.

Pablo Picasso (1881–1973)
Girl in a Chemise, 1905
Courtesy of the Tate Gallery. *(See p. 52)*

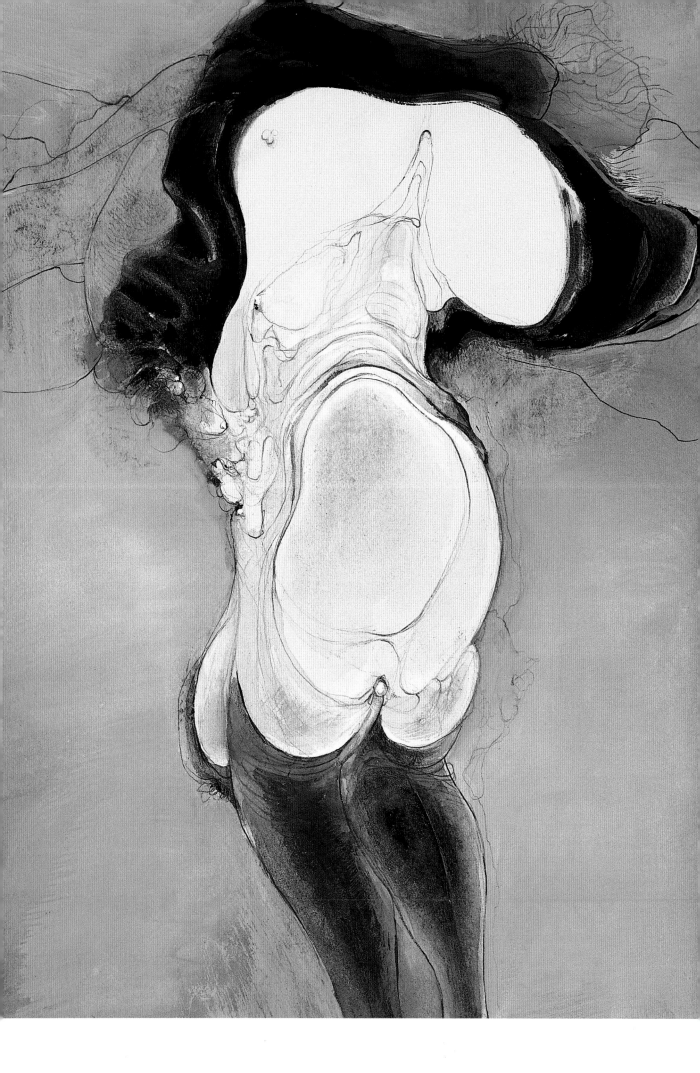

Kurt Schwitters (1887–1948)
Merz 94 Gurnfleck, 1920
Private Collection, Zurich. Courtesy of Giraudon

SCHWITTERS was close friends with many German Dadaists, despite the fact that he disagreed with some of their views. What he admired was their love of nonsense. What he defended was the value and importance of art over politics. He did not want to generate a revolution, but rather to construct a better world. His great love of art is revealed in the small scale of his works—they were highly personal and intended to be easy to own. In a calm, distanced way he worked with society's discarded objects: not impressed or frightened by these rejected items, he built them into examples of sublime human creativity. It was art and imagination, resourcefulness, and creativity that Schwitters defended from the destructive and nihilistic tendencies of Dada.

Max Ernst (1891–1976)
Perturbation my Sister, 1921
Victor Loeb Collection, Berne. Courtesy of Giraudon. (See p. 99)

Like his contemporaries, in particular Max Ernst in works like *Perturbation my Sister* (1921), Schwitters used everyday items in his works. A visitor to his studio recalled: "the interior does not strike one as being a studio, but a carpentry shop. Planks, cigar boxes, wheels from a perambulator, various tools for the 'nailed together' pictures lay between bundles of newspaper ... With great care broken light-switches, damaged neck ties, colored cheese boxes, colored buttons torn off clothes, and old tickets were all stored up to find a use in some future creation."

187

KURT SCHWITTERS (1887–1948)
Collage, 1923

Trudi Neuburg-Coray Collection, Ascona. Courtesy of Giraudon

*I*N looking at a Schwitters collage, it is the materials that the viewer first notices. In this sense style was a secondary matter. It soon also becomes apparent that the individual items of the collage have been chosen for their aesthetic beauty. The placing of the different parts was determined by each part, thus there is no underlying, predetermined structure. The coherence of each construction depended on the chance character of each piece. Perhaps for this reason one of the greatest pleasures of this collage is in imagining the process of its making. In reconstructing this process, the viewer can enjoy both the references made by each piece of paper, to tickets, letters and newspapers, and the sense of integrity in their assembly.

By 1923, Schwitters had started to move away from his associations with Dada toward the Constructivists, artists such as Rodchenko, Mondrian, and Theo van Doesburg. In this particular work his new interest was reflected

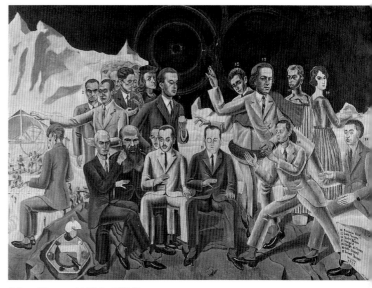

Max Ernst (1891–1976)
The Meeting of Friends, 1922
Lydia Bau Collection, Hamburg. Courtesy of Giraudon. (See p. 100)

in the more geometric edges and placement of each element. But, as before, it is interesting to look at the words in his collages. Here, there is a newspaper article on vampires and a fragment bearing the last letters of Schwitters' name.

KURT SCHWITTERS (1887–1948)
Opened by Customs, 1937–38
Courtesy of Christie's Images

SCHWITTERS incorporated into this image the labels on a package sent from his native Germany. He had taken refuge in Norway with his son, who was wanted for his anti-Nazi activity. This period of exile was difficult. Pressed by the Norwegian authorities to leave and cut off from any income, Schwitters suffered poverty and illness, but enjoyed the opportunity to live in the countryside. Despite this rural existence, the objects in this collage still recall an urban geometry and excitement, and a more curved line begins to appear. Arched shapes and obvious brushwork herald a move toward more natural materials and a collage method that becomes deeper and more sculptural—an assemblage of objects rather than a collage of flat paper.

The Dada and Surrealist movements claimed that art could be

made out of anything, and it was Schwitters' work that best-proved their point. He found a new dignity in what had been rejected and thrown away. As in *Merz 94 Gurnfleck* (1920), worn, broken, and obsolete objects were assembled into something worth looking at. In this sense he teaches a moral lesson about "rubbish," in stark comparison to contemporary Nazi campaigns for racial purity and conformist styles of painting.

Kurt Schwitters (1887–1948)
Merz 94 Gurnfleck, 1920
Private Collection, Zurich. Courtesy of Giraudon.
(See p. 186)

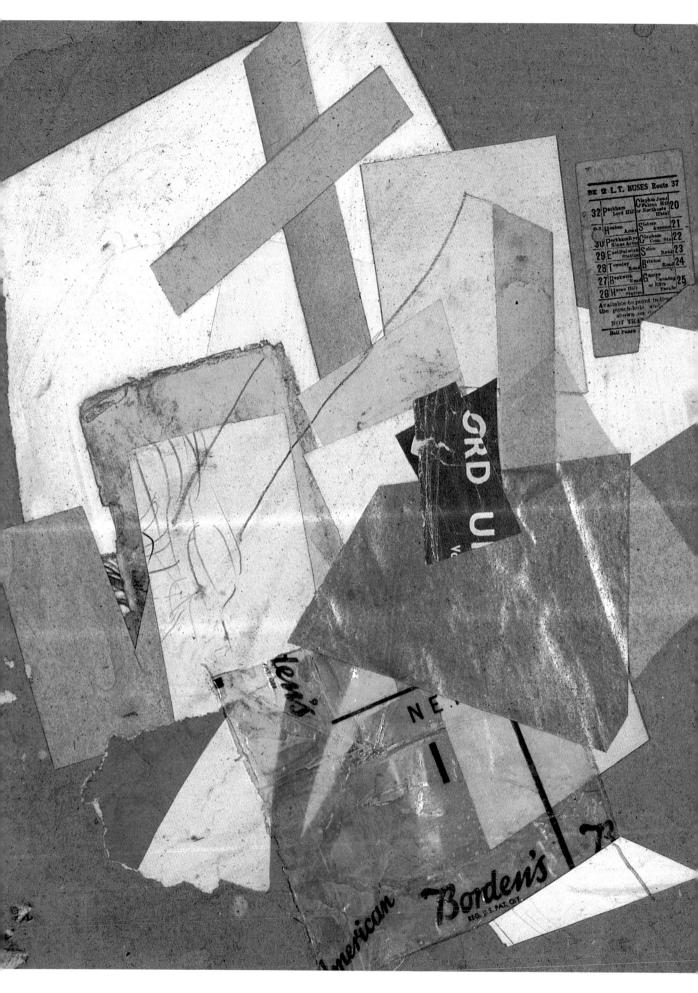

KURT SCHWITTERS (1887–1948)
Oru u, 1945
Courtesy of Christie's Images

THOSE close to Schwitters were in a position to be aware of the social and political aspects of his work. The political climate in Germany was, of course, too tense to make these views public at the time. Schwitters had turned to collage after the First World War in the belief that although the world around him lay in ruin, by using the scraps of this world, he could rebuild a better, more honest culture. The delicate construction of old materials into a whole environment had the force of a political and social statement. His beliefs led him to criticize Modernism for its slick middle-class taste.

This collage included items from his stay in England, among them a London bus ticket, as well as an American cellophane food packet. The title, like so many of his collages, was taken from words in the work. These words often have a nonsense effect. They are pure sounds and letters that can be made into whatever meaning is needed or desired. As he commented, the angled lines and jagged shapes of this work set off a composition in which, "lines fight and caress one another in generous tenderness." He maintained his interest in collage throughout his career, as *Collage* (1947) shows.

Kurt Schwitters (1997–1948)
Collage, 1947
Courtesy of Christie's Images. (See p. 194)

KURT SCHWITTERS (1887–1948)
Collage, 1947
Courtesy of Christie's Images

AS artists such as Gorky, as seen in *Year after Year*, also painted in 1937, began to experiment with Abstract Expressionism, Schwitters continued his collage work. He called the majority of his style "merz" and, like the word "Dada," its meaning was never exactly defined or fixed. On one occasion he said it came from the word "commerz," and certainly by 1947 Schwitters was a successful small businessman and property owner. However, on another occasion he said it came from the word "ausmerzen," to reject, meaning that he had accepted materials that were rejected by society.

Arshile Gorky (1904–48)
Year After Year, 1947
Courtesy of Christie's Images. (See p. 250)

On several occasions Schwitters built his materials into architectural interiors he called "Merzbau." These were made of wood and other materials and consisted of a labyrinth of different rooms. For example, one was a *Dada Grotto*, another a *Cathedral of Erotic Misery* and another a *Sex-Murder Cave*. These interiors became all-encompassing environments, complete works of art, in which one could live. In this late collage Schwitters reveals his architectural interests by using tall vertical shapes and thick card. The humble materials, however, make it clear that Schwitters did not follow other Constructivists in their belief that new machines and technology would rescue man from catastrophe and misery. At the top, a scrap of an English newspaper flies like a flag and is cut so as to give the ironic message "serve your country—DUTY IS— founded on fact; but the names used are fictitious."

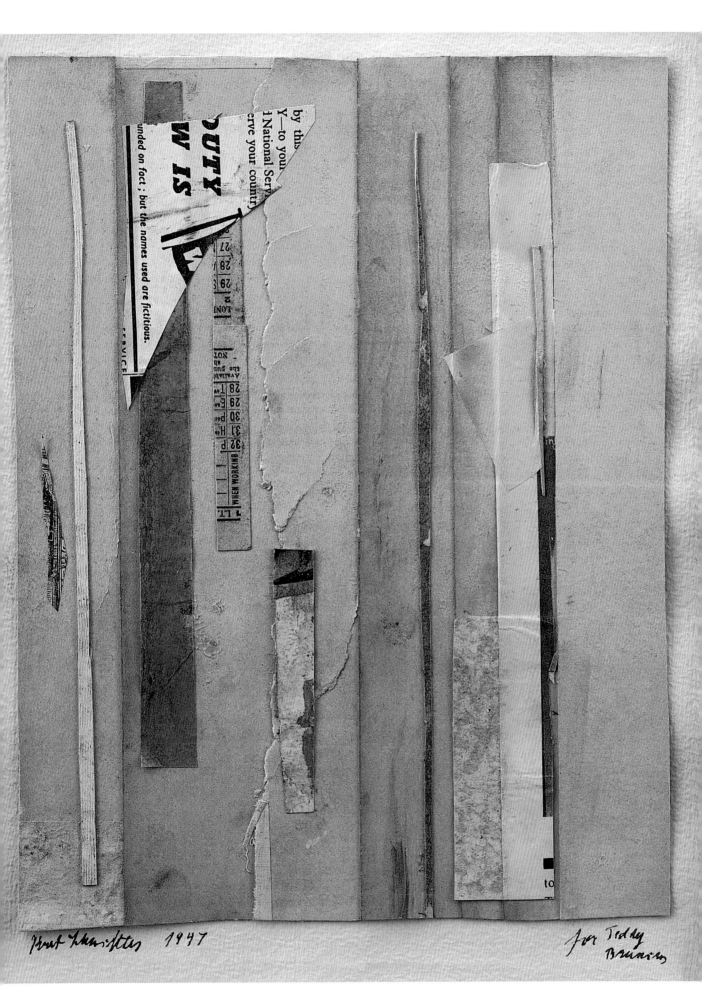

Kurt Schwitters 1947 for Teddy
 Brian

ALBERTO GIACOMETTI (1901–66)
Composition (Man and Woman), 1927
Courtesy of the Tate Gallery

*I*N the course of his life, Giacometti produced two very different bodies of work. The first was his Surrealist phase, in which the majority of the work was sculpture. In 1935, however, he changed direction; this second phase lasted the rest of his life and resulted in a second body of work.

This sculpture, from his Surrealist phase, is a curious bronze relief. It recalls the open constructions of Cubist sculpture and the love of machines typical of Picabia. It also displays an interest in primitive sculpture, such as African carvings. Although the work is cast, Giacometti has given the impression that it is carved out of wood. He made numerous Cubist-inspired works, but they differed from the work of Picasso, Lipchitz, or Laurens because they aspired to be primitive totems. He played with the rich possibilities of near-abstract figures, stacking and assembling them together. To this he added a number of symbolic and even humorous references to sex, such as the ball and cup. The rod that punctures the louvers of the grill hints at the more sexually violent sculpture which came from his studio over the next eight years.

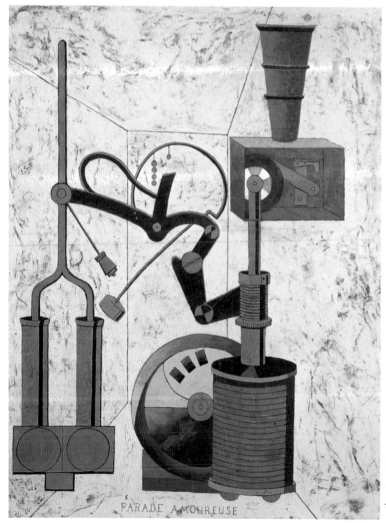

Francis Picabia (1879–1953)
Parade Amoureuse, 1917
J.L. Stern Collection, New York.
Courtesy of Giraudon. (See p. 62)

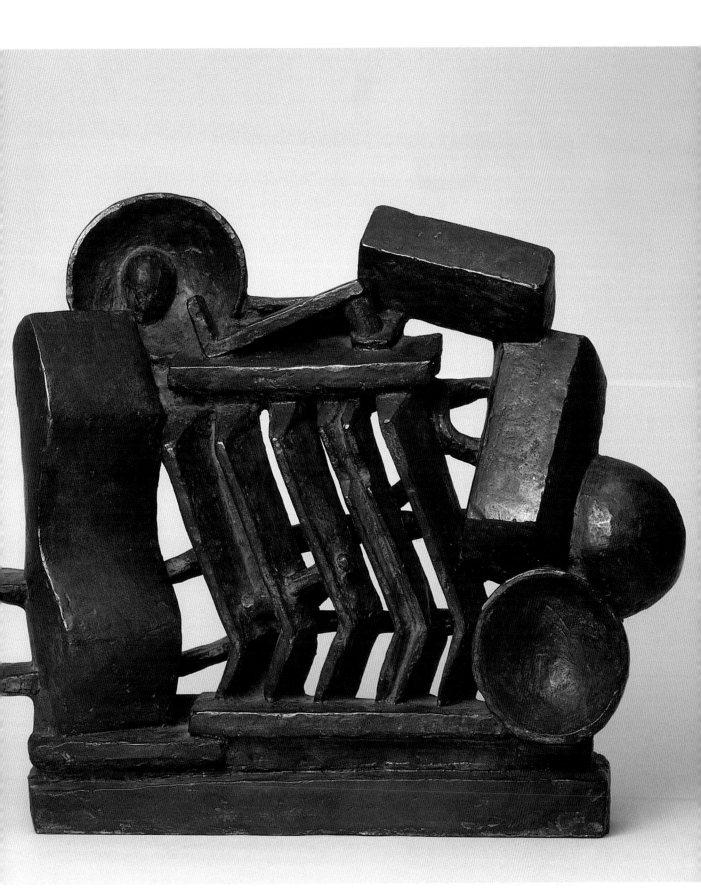

ALBERTO GIACOMETTI (1901–66)
The Cage, 1930
Modern Art Museum, Stockholm. Courtesy of Giraudon

*T*HIS wooden sculpture is full of veiled references to sex and violence. Giacometti, like the Surrealist author Georges Bataille, took an interest at this time in the sexual frenzy and sadistic blood rituals of some early civilizations, such as the Aztecs. Like Duchamp's *The Suitcase* (c. 1920), everything in the work is clearly visible in space, but the meaning remains opaque. Notice first that the cage both supports and traps a group of objects that could be understood as figures. It is also built in the manner of a bed with a canopy frame, or perhaps a chair. At the top of the cage a male figure, consisting of two balls, hovers over a group of spoon-shaped women. Movement in this space would be difficult, and in any case dangerous, given the five sharp spines that fill one corner—sexual pleasure is intensified by the risk of self-destruction. This elaborate set of associations, however, is tamed by its abstract treatment. One need only look again to see seeds instead of balls, leaves instead of spoon-women.

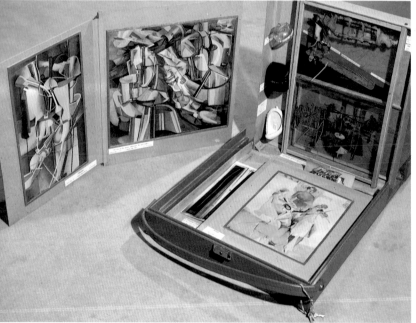

This subtle treatment of form, accomplished fully in the round, makes this a virtuoso Surrealist sculptural achievement. It allows a relatively harmless still-life to become animated by a subliminal sexual fantasy.

Marcel Duchamp (1887–1968)
The Suitcase, c. 1920
Courtesy of Christie's Images. (See p 47)

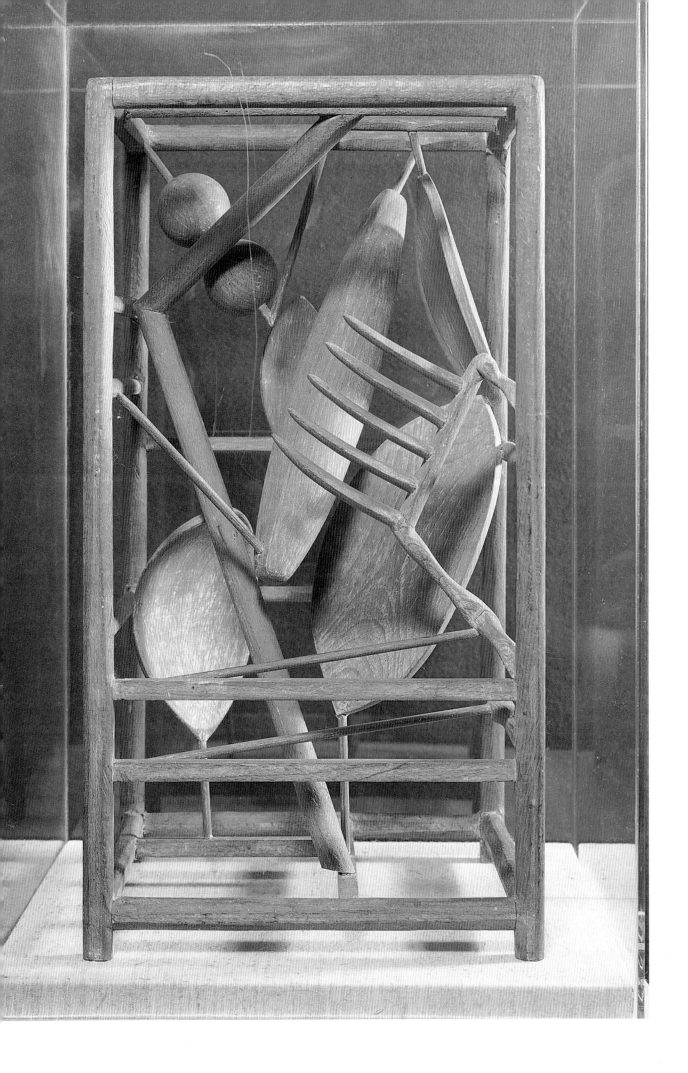

ALBERTO GIACOMETTI (1901–66)
Standing Woman, c. 1930
Courtesy of Christie's Images

SURREALISTS had a general fascination with extreme states of mind which, for a time, included an interest in pure pleasure and pure pain. This was difficult territory for many, yet perhaps a justifiable venture, given the need to face up to the horrors of the First World War. Indeed, it was after this war that Freud began to suggest the existence of a "death drive" in man. In the 1930s, however, Giacometti decided to abandon his fascinations, along with any interest in Surrealism. This turned out to be a prescient decision in that Surrealism did not survive the Second World War. Instead, Giacometti was championed by a new set of French intellectuals in the Existentialist movement, headed by Jean-Paul Sartre.

In changing his artistic concerns, Giacometti turned to a consideration of the life model in an attempt to describe his visual experience. He often painted and sculpted figures which show the space between himself and his model. In this example, he chooses the point when the sitter turns from being an anonymous person to being someone who is recognizable. Soon, however, his emaciated figures would call to mind the survivors of war-time concentration camps.

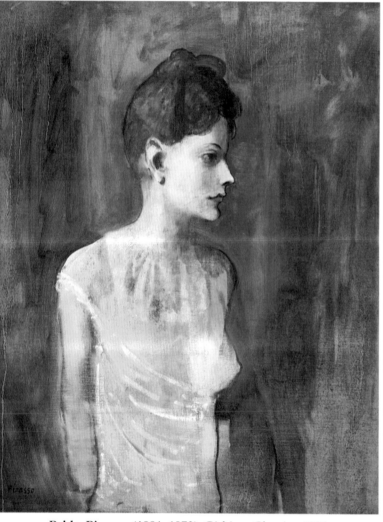

Pablo Picasso (1881–1973) *Girl in a Chemise, 1905*
Courtesy of the Tate Gallery. (See p. 52)

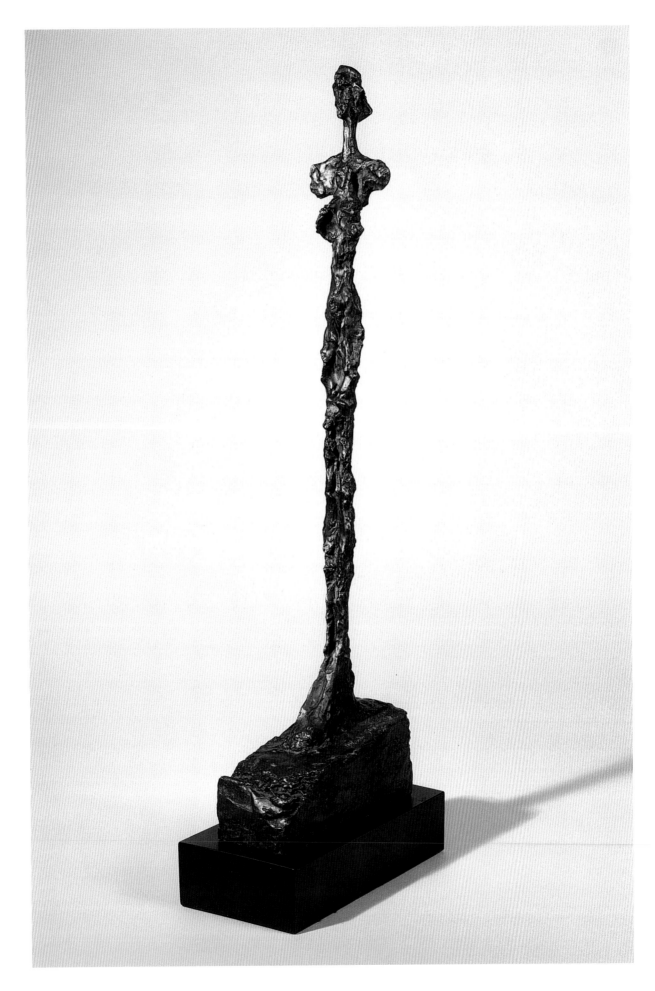

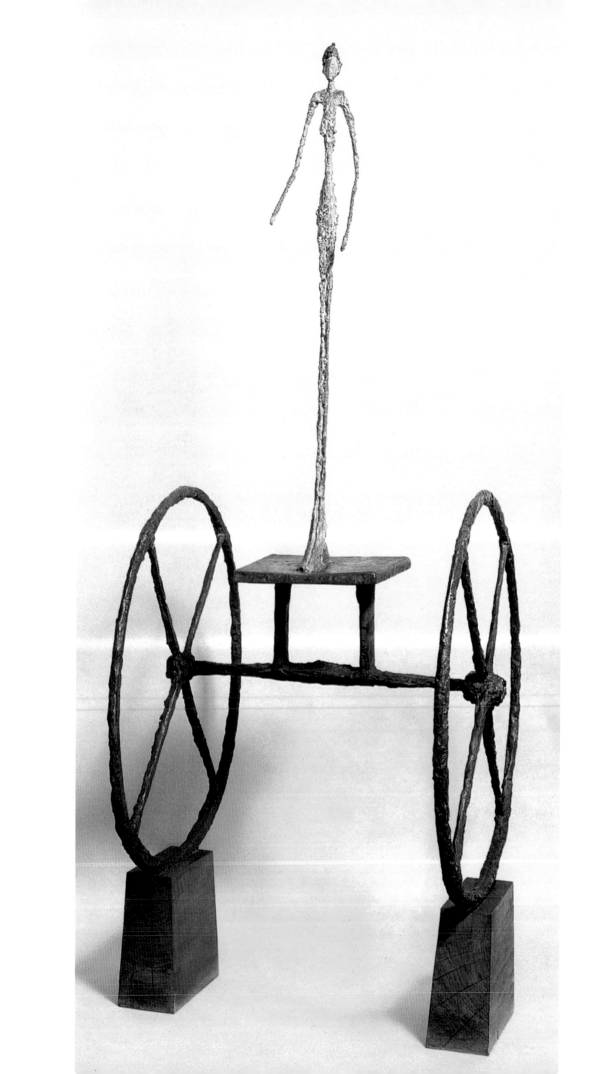

ALBERTO GIACOMETTI (1901–66)
Chariot, 1950
Courtesy of Christie's Images

GIACOMETTI'S tall, delicate, and painfully thin figures were repeated many times. In this bronze, one of his numerous standing women wears a hint of a crown and is set upon the wheels of a chariot. Her arms are raised to suggest the reins of an absent horse. So thorough was his knowledge of primitive sculpture that, at a glance, this work could be mistaken for a corroded fourth-century BC Italian casting. The woman stands like an ancient deity and appears in a serene and ceremonial mood. In preparing his sculptures, Giacometti worked with wax or clay on an armature of wood and metal, adding and removing material as he worked with his model. In many cases the clay would be removed entirely, and the work started again from the beginning. When the original was complete, the work was cast in a suitable material, such as bronze. *Chariot* is finished with a metallic patina and has been placed on wooden impost blocks to separate it from the space of the spectator. As might be expected, many Surrealist critics did not like the work. They found it repetitive, sentimental, impressionistic, and vaguely architectural. To this day opinion varies widely about Giacometti's standing as an artist. Other work from around the same time, for example, *Against Your Assassins from Palomas* (1950) by Matta, is often perceived as having lost some of the original Surrealist power and energy.

Matta (1911–to date)
Against Your Assassins from Palomas, 1950
Cantini Museum, Marseilles. Courtesy of Giraudon. (See p. 236)

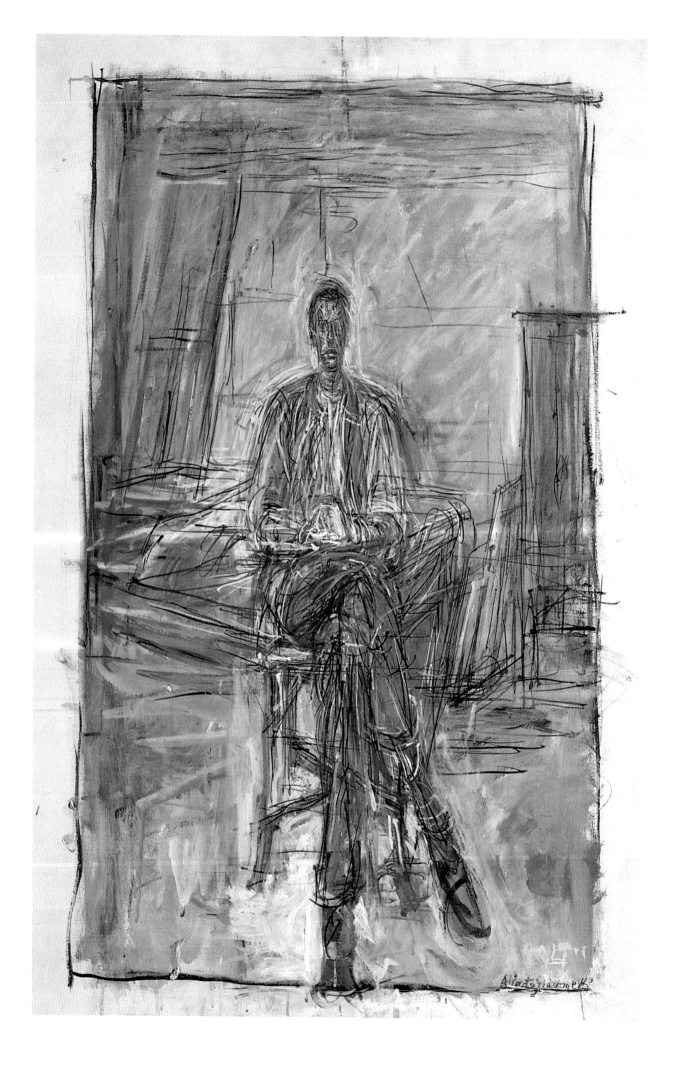

ALBERTO GIACOMETTI (1901–66)
Seated Man, 1949
Courtesy of the Tate Gallery

THE nervous active lines that make up this figure are the marks of a sculptor who paints. The lines try to capture form in space, yet also act as a record of the difficulty of really seeing another person. The frame of this tall painting establishes the sitter in an isolated space into which we can only partially enter. The forms of the figure move and vibrate with life in a way that dead mass does not. This visual experience of trembling human energy, which contains both a mysterious power and a violence, is transmitted onto the canvas. The sense of distance and barriers between men became an important theme for the artist after the war, and one he developed by painting directly from life. Sitting for the artist was itself often difficult. He would work and rework a portrait for days, often feeling lost and unable to complete it. The image would almost disappear under a network of lines, only to reappear. The artist was not satisfied until the sitter's face had a powerful presence, a sense of possessing the gaze that gives a face its humanity.

Salvador Dalí (1904–1989) *The Great Masturbator, 1929*
Luis Buñel Collection, Mexico. Courtesy of AiSA. (See p. 171)

ALBERTO GIACOMETTI (1901–66)
Caroline, 1962
Kunstmuseum, Bâsle. Courtesy of Giraudon

WHILE artists such as Chagall were using bright colors, for example in *Circus in the Village* (1966), this painting is typical of Giacometti's later work in that the color range is limited to blacks, whites, and earth tones. He commented that the only difference between painting a living person and a dead one was the presence of a gaze. This did not mean imitating the appearance of the eye, but giving the portrait the feeling that it could see the spectator. "Caroline" sees us as we look at her; her life is to be found in her face, which was given in

Marc Chagall (1887–1985)
Circus in the Village, 1966
Courtesy of Christie's Images. (See p. 247)

great detail. Her body plays a less important role. Giacometti's brush strokes repeatedly mark out the subtle movements and life in the face, circling around the eyes, building up the forehead, nose, and cheeks, in a tangle of lines that nevertheless produced a strong sculptural sense of form. While Caroline sat calmly and without moving (she had to sit for many hours) the artist has communicated great energy. The surfaces of the head and hair seem to have an activity and motion all their own, as if the artist was trying to trace the life and force of his sitter as it emerged from the still mass of her body.

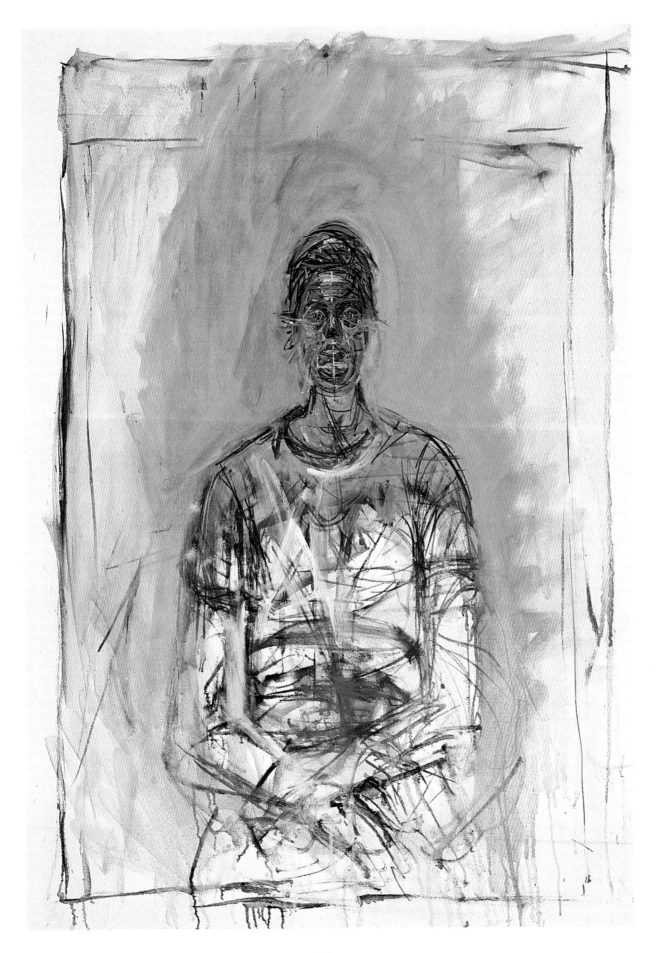

ALBERTO GIACOMETTI (1901–66)
Man Pointing, 1964
Courtesy of the Tate Gallery

*G*IACOMETTI'S Surrealist work, which almost glorified human cruelty, has been reversed in this sculpture. Instead, he has addressed our compassion, our desire for intimacy, our desire to cross the barriers of space to be with others. For some critics, the space around this figure seems to be compressing and containing it. This anonymous man appears as a survivor, someone who has endured great suffering, loneliness, and isolation, yet remains unified and admirable.

The philosopher Sartre remarked on this work, observing how man speaks with his whole body. Running, sleeping, and gestures are all a type of speech within the world. It was Giacometti's gift to find a way to record the human body without becoming caught in the conventions of sculpture that have accumulated over the centuries. It was as if Giacometti had gone back to man's first urges to sculpt. This project ignored the model's social status, seeking instead inner absolute. He particularly admired the way in which the sculpture remained the same no matter what distance one stood from it: even when seen close to, this man seems far away.

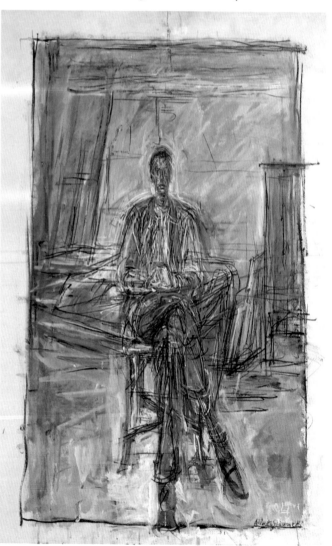

Alberto Giacometti (1901–66)
Seated Man, 1949
Courtesy of the Tate Gallery. (See p. 205)

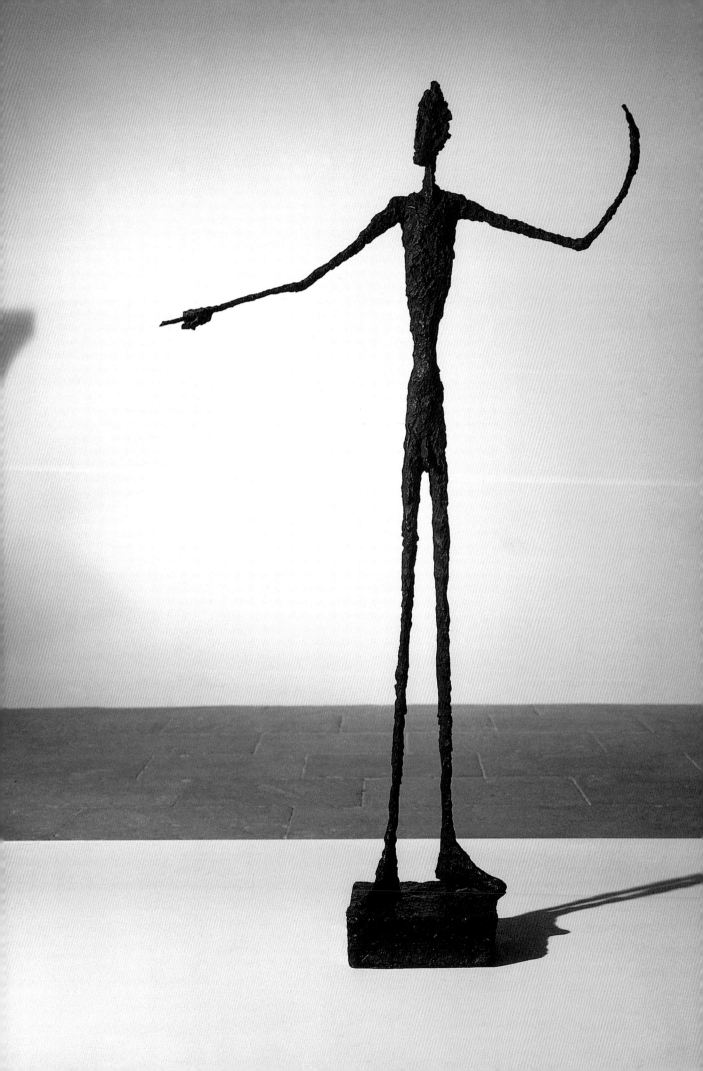

RENÉ MAGRITTE (1898–1967)
The Lost Jockey, 1926

Mrs. R. Michel Collection, Paris. Courtesy of Giraudon

*T*HIS early painting was of great importance to the Belgian painter René Magritte, as it captured for the first time his search for a poetic idea. In this work he abandoned his study of painting itself, with all its problems of creating the illusion of form and space. Instead, he turned to address the question of how a painting might produce a sense of mystery. He discovered, in effect, how to make a painting that could speak about more than just painting. The jockey has been placed in a forest made of turned wooden spindles or "bilboquet," as are typically found on stairs or tables. These strange wooden forms are full of suggestive associations: they are phallic as well as evocative of chess pieces, trees, furniture, or isolated and lonely figures.

Magritte repeatedly used the image of a jockey in his works to suggest an anxious, racing state of mind, an urgency of emotion. It also suggests risk and gambling in its tension with the background of the calm, motionless forest that watches the jockey's search. The crisp rendering of the objects suggests a clear understanding of their form and function, yet as a founder of Belgian Surrealism, Magritte has used this style to attack rational thought and painterly skill.

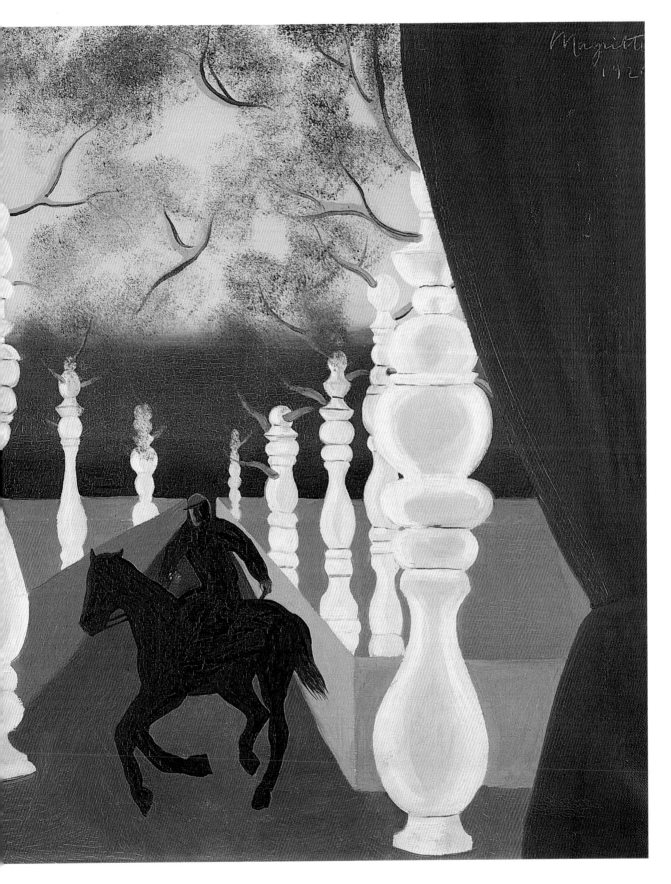

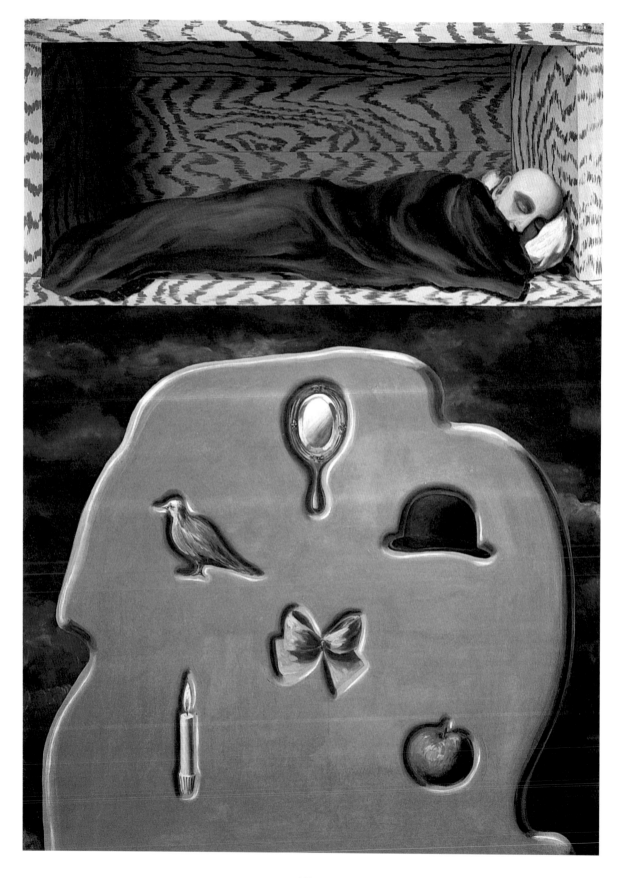

RENÉ MAGRITTE (1898–1967)
The Reckless Sleeper, 1928
Courtesy of the Tate Gallery

AGRITTE'S response to Sigmund Freud was mixed. While this painting suggests the philosopher's proposals for the interpretation of dreams, Magritte felt that psychoanalysis could never provide full answers to the mysteries of the universe. He claimed that he was not painting a dream narrative, and indeed he did not make any attempt to give significance to the items in the picture. The hat, hand-mirror, candle, and apple catch a glimpse of the dream, but they do not interpret the sleeper's repressed desires and wishes. Instead, he focuses on the mystery of the existence of thoughts and images in a sleeping brain, a preoccupation that is reflected in *Spanish Night* (1922) by Picabia. It seemed remarkable to Magritte that thoughts and desires went on even when the conscious mind was not present. As he commented, psychological theories explain thought by making use of thought, but he went further by indicating the mysterious conditions in the world that made thought possible. What Magritte found fascinating was the fundamental surprise of encountering the dormant, formless mass that surrounds these objects. He asks us to consider what this organic material is, and how it came to possess the capacity for thought. This mass thinks without being conscious, and is conscious without thinking.

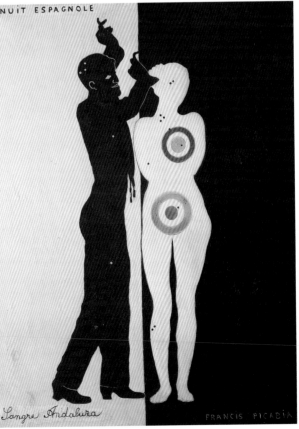

Francis Picabia (1879–1953)
Spanish Night, (1922)
Private Collection. Courtesy of Giraudon. (See p. 66)

RENÉ MAGRITTE
(1898–1967)
The Betrayal of Images,
1928–29

County Museum of Art, Los Angeles.
Courtesy of Giraudon

MAGRITTE'S picture states that this image is not a pipe. "Just try to stuff it with tobacco!." He added, "So if I had written on my picture 'This is a pipe,' I would have been lying!" After the philosopher Michel Foucault published his book, about Magritte, *This is not a Pipe*, he received several letters from the artist. They dealt with the difference between the words "resemblance" and "similarity." For Magritte, two peas in a pod are similar. Only objects could be compared for their similarity, whereas thoughts could be compared for their resemblance. This difference was important because he felt it allowed him to paint his thoughts, not what his eyes saw. Although thought was not an object, he felt it could be represented through pictures. He wanted to draw attention to the link between language and the world. Signs, such as the word "pipe" were in fact rather randomly assigned to an object. A Russian, for example, might have a very different word for this object. What then is the link between sound, word, and object? For Magritte, this link was the mysterious operation of thought itself.

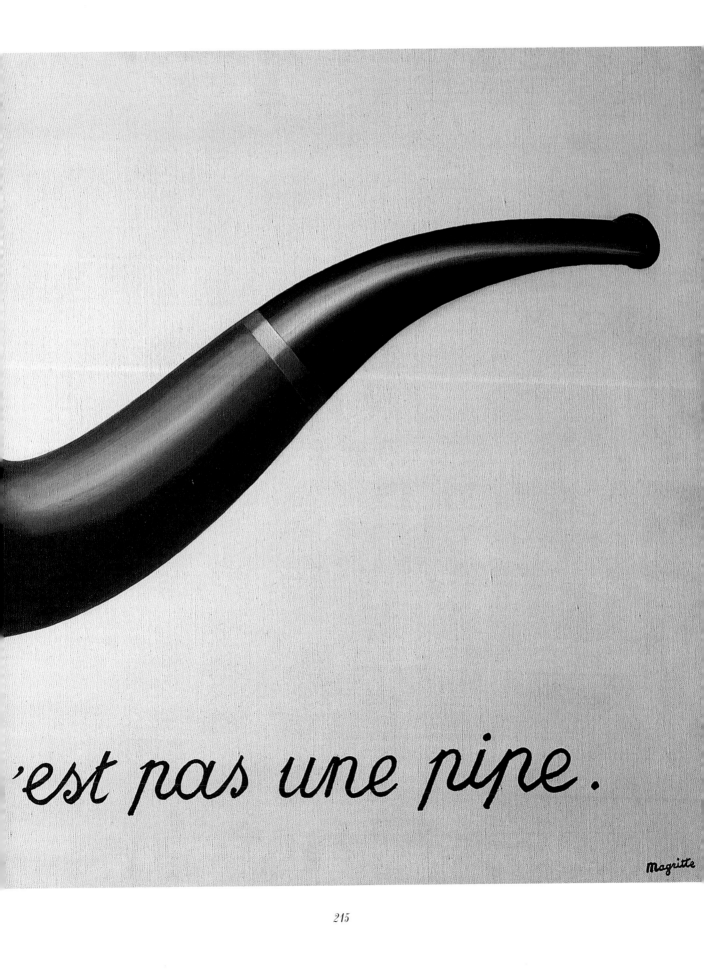

RENÉ MAGRITTE
(1898–1967)
The Annunciation, 1930
Courtesy of the Tate Gallery

IN the foreground rocks of
this picture, Magritte has
hinted at a style of religious
painting common in Italy in the
fourteenth-century. Such medieval
paintings represented miracles and
scenes from the Bible as a matter of
course. In addition, some paintings
were believed to possess special
powers to communicate prayers to
God. Instead of presenting a
traditional scene of the Virgin Mary
receiving the word of God through
the angel Gabriel, Magritte has
removed all traces of human presence.
In their place, a tall wall
of corrugated material supports an
assortment of large bells. In front of
this a delicate lace has been cut out of
an irregular piece of paper. On the
right, two tall balustrades stand like
mysterious witnesses to the scene.
The calm stillness shown here is
nevertheless filled with tension and
unanswered questions. Many have
noted a sadness in this painting which
reflected personal tragedy. In 1912,
when Magritte was aged 14, his
mother committed suicide by
walking into a river, dressed only in
her night-gown. The impressionable
teenager was there when her body
was dragged from the water, her face
veiled by her garment.

RENÉ MAGRITTE (1898–1967)
The Human Condition II, c. 1930
Courtesy of Christie's Images

MAGRITTE did a number of paintings that feature an easel holding a painting in front of a window. Here, he has used a beach scene framed by an arched door. One way to grasp this picture is to think of the door as an eye. The outer world pours through the door and into an interior space. The eye provides a flood of perceptions and visual experiences. The mind must make sense of this world of perceptions by trying to put them into categories and orders. To make sense of the world man must be able to represent the world, and in this painting he has succeeded completely. The world of the beach, and the painted image of the beach, fit perfectly. For Magritte, however, this marks the beginning of a common mistake. Language is just language, no matter how well adapted to the scene. It is the human condition to live between language and the world, between words and things, never being quite sure of the relationship between the two. Magritte felt that his paintings were unique in their understanding of the world, and bore no resemblance to those of other Belgian Surrealists, such as Delvaux in paintings such as *The Meeting* (1942).

Paul Delvaux (1897–1994)
The Meeting, 1942
Courtesy of Christie's Images. (See p. 230)

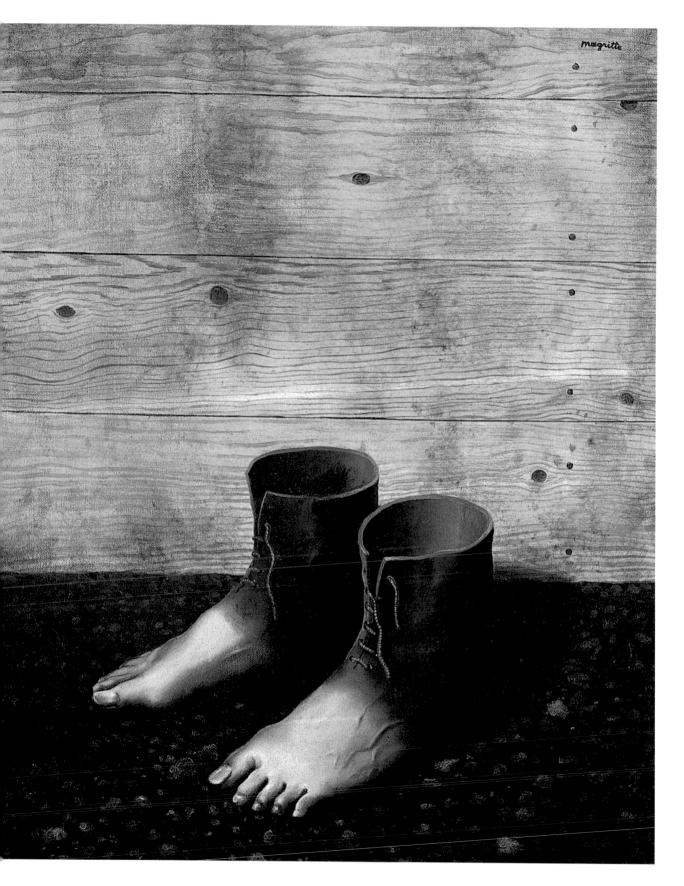

RENÉ MAGRITTE (1898–1967)
The Red Model, 1935

National Museum of Modern Art, Paris. Courtesy of Giraudon

*I*N his later life, Magritte often worked with the strange similarities between objects. This marked a change from the more common Surrealist method of placing dissimilar objects side by side. For this painting Magritte prepared drawings in order to find the best combination of subject matter. Only when the drawing was successful, did he turn to paint and canvas. What he sought in these drawings was a sense of paradox. He asked, like the philosopher Hegel, why every object exists as an idea in relation to some other object. Without rain, there would be no umbrella, without the sea there would be no ships. In this painting it would seem that the foot calls forth the idea of the shoe. Yet, in allowing the two images to penetrate each other, we can never be sure whether the foot calls upon the pure idea of the shoe, or the shoe calls upon the memory of an absent foot.

Salvador Dalí (1904–1989)
The Burning Giraffe, 1936-37
Courtesy of Giraudon. (See p. 174)

Magritte makes his exploration of the unity of thought a humble and sometimes playful one. In this case, the shoes are working-man's foot wear, and recall the sad and expressive shoes painted by Van Gogh. Around this time, Dalí was making a big impact on Surrealism with work such as *The Burning Giraffe* (1936-37).

RENÉ MAGRITTE (1898–1967)
Pan, God of the Night, 1954
Private Collection. Courtesy of Giraudon

MAGRITTE developed an illustrative style apparently typical of reference books such as encyclopedias. However, the clear expression of knowledge was subverted by his transformation of the objects he painted. Magritte would mislabel objects, replace an object with a word, and make changes in the materials of the objects which he used. These shifts and changes suggest the functioning of mysterious forces within thought. Because the displacements and changes are made to common objects, the sense of surprise through conflicting ideas is made all the greater, and reflects his systematic search for an overwhelming poetic effect.

In this painting, Magritte used his method of displacement to create a vaguely sexual sign. The hat, seen again in *The Great War* (1964), was one of his favorite images, and here is combined with a sumptuous head of hair. The two should not go together and yet they look right. Masculine and feminine are combined into a sensuous beauty, against a calm, domestic, blue wall. In their unity the two images suggest the splitting of the universe into two genders.

René Magritte (1898–1967)
The Great War, 1964
Private Collection. Courtesy of Giraudon. (See p. 229)

RENÉ MAGRITTE (1898–1967)
Painted Bottles, 1959
Courtesy of Topham

MAGRITTE, like so many Surrealist painters, also made sculptures. He did not turn, however, to the principles of collage in making this work, but to a set of associations using projected images. He started with an *objet trouvé* which excited the imagination and produced associations. In this case he selected a wine bottle, a receptacle which, when emptied, can increase desire, reverie, and fantasy.

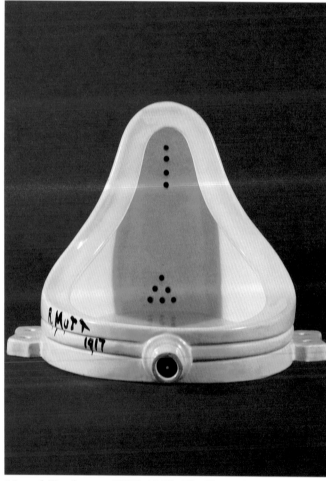

Marcel Duchamp (1887–1968) *The Fountain, 1917*
Courtesy of Christie's Images. (See p. 42)

Compared to Duchamp's *Fountain* (1917), which was transformed simply by turning its angle of presentation from the vertical wall to the horizontal pedestal, Magritte has worked hard. The sexual wit in Duchamp's transformation of a male toilet into a reclining female receptacle was made obvious and more personal by Magritte. His treatment of the nude has allowed more of the character of the woman to appear, although the image is idealized and heightened in its color. If many Surrealists appeared to remove character and personality from women, they also did so to men—all sexual drives were automatic and machine-like in their repetition. Magritte shared this fascination with sex, yet the fragility of the bottle, its brittle delicacy, and its ordinariness is oddly reassuring, calming and graceful.

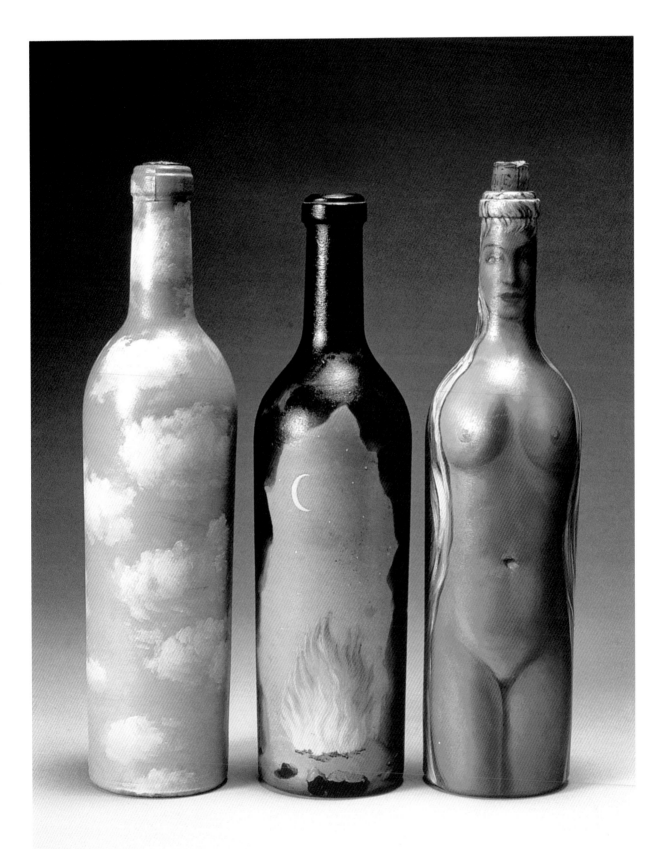

RENÉ MAGRITTE (1898–1967)
The Wells of Truth, 1963
Courtesy of Christie's Images

*I*N this sculpture, Magritte used the technique of fragmentation rather than transformation. The boot is placed so that it is not possible to see the top of the cut, which is directly at eye-level. The tailored trouser and polished shoe suggest the many middle-class, bowler-hatted gentlemen so often found in his paintings. Are we to dip into this leg as if into the well of truth? Magritte leaves this question unanswered. In that almost everyone possesses a left leg, Magritte suggests that the truth is close at hand, yet lies where we least expect it. The predicament of truth is that it is not seen even when it is present. The truth lies within man, and in cutting the leg to remove the anonymous man, he draws attention precisely to that fact. As he wrote in a letter, "in 'distinguishing' Nothingness, we already define it and

give it a form it couldn't possibly have ..." This image is sinister and thought-provoking, with none of the playful aspect of his painting, *The Red Model* (1935).

René Magritte (1898–1967)
The Red Model, 1935
National Museum of Modern Art, Paris.
Courtesy of Giraudon. (See p. 221)

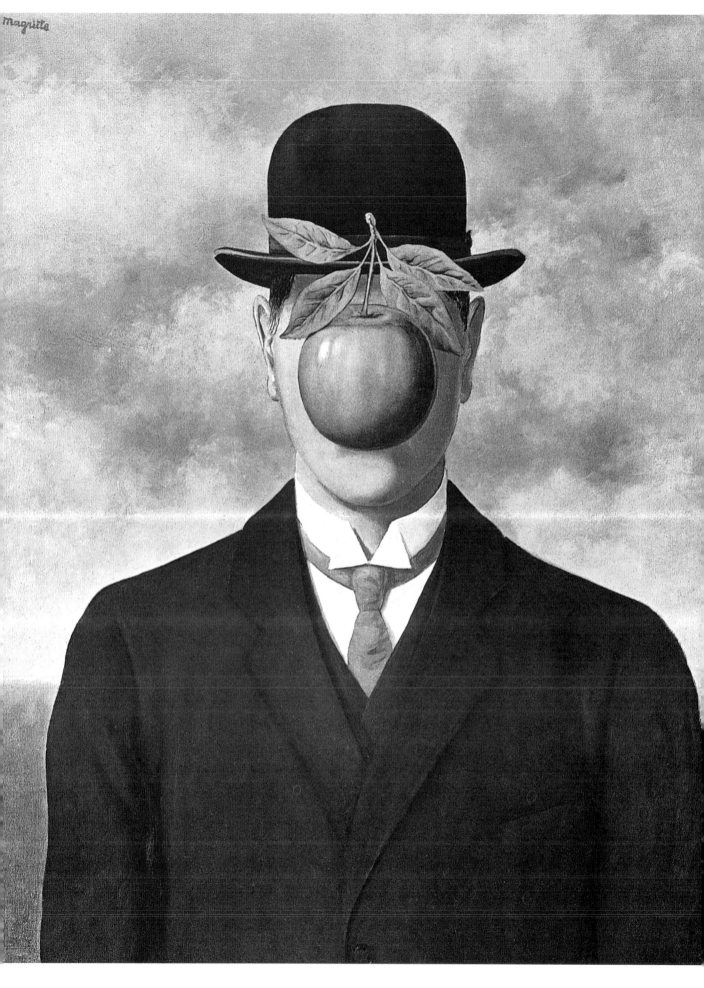

RENÉ MAGRITTE (1898–1967)
The Great War, 1964
Private Collection. Courtesy of Giraudon

MAGRITTE often painted a bowler-hatted man, as seen in *Pan, God of the Night* (1954), who stands upright, stiff, and without expression or emotion. Sometimes this man, who can be regarded as a portrait of the artist, appears in pairs or in groups. This man is anonymous, part of the crowd, an awkward but sympathetic character. In *The Great War*, Magritte once again shows us this man on the edge of catastrophe. His eyes, however, do not meet ours because of the sudden and unexpected appearance of a ripe apple. An impending tragedy is expressed through an everyday object that cuts off our view. There are two canvases entitled *The Great War*, the second depicts a woman dressed in a fine, white, embroidered dress with matching hat and umbrella. A bouquet of blue flowers conceals her face. In Magritte's world, man must endure a strange set of affairs which he is powerless to change. The artist once said: "I don't believe that man decides anything. I think that we are responsible for the universe, but that does not mean that we decide anything."

René Magritte (1898–1967)
Pan, God of the Night, 1954
Private Collection. Courtesy of Giraudon. (See p. 222)

PAUL DELVAUX (1897–1994)
The Meeting, 1942
Courtesy of Christie's Images

BELGIAN Paul Delvaux was not a direct member of the Surrealist group, but in 1936 he began taking an interest in de Chirico and Dalí, and works such as *The Great Masturbator* (1929). Before seeing their work, his opinion of modern art, especially Cubism and Abstract painting, was low. Once exposed to Surrealism, however, he quickly formed a style that remained with him for the rest of his life. Many of his paintings are filled with silent women dressed in elaborate nineteenth-century clothing, or other historical costume. In this example, like so many other paintings, the women do not talk or communicate. They walk with purpose, but do not reveal their intentions. Delvaux has carefully balanced the clothed and the nude figures in this composition: for every nude there is a clothed figure. The deep avenue gives the painting a visual drama and tension that is extended in time. Even the architecture jumps between contemporary Belgian and ancient Roman designs. The composition is framed on the left by a wall, and on the right by the figure of the artist, who illuminates this scene with a candle.

Salvador Dalí (1904–1989)
The Great Masturbator, 1929
Luis Buñel Collection, Mexico.
Courtesy of AiSA. (See p. 171)

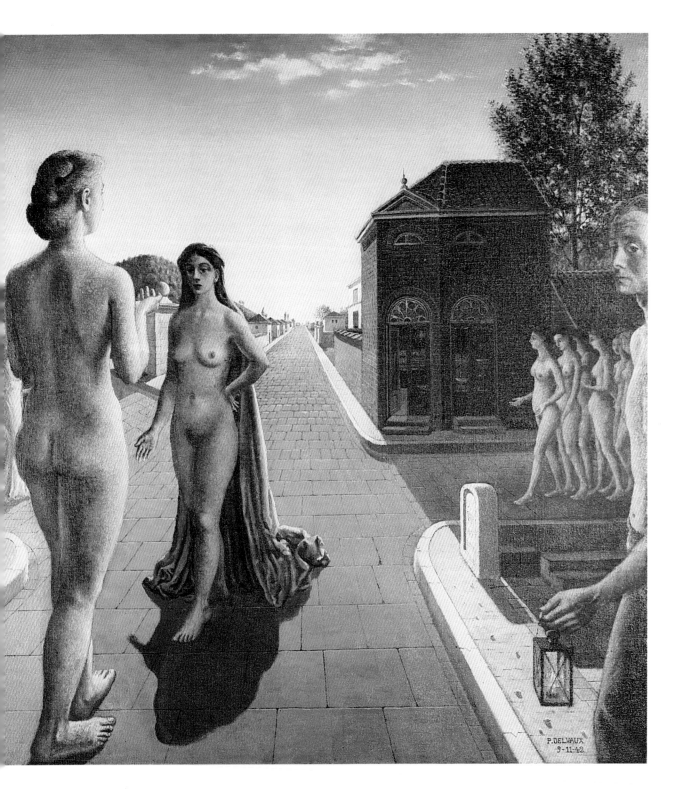

PAUL DELVAUX (1897–1994)
The Visit, 1939
Courtesy of Giraudon

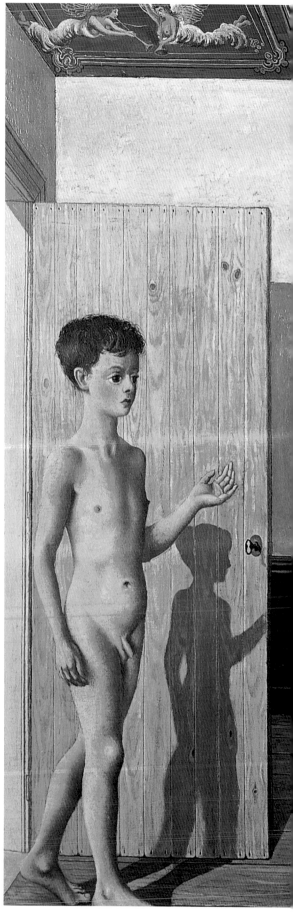

*I*N Delvaux's painting, there is often a male figure among the groups of women. Sometimes it is a doctor, sometimes a shabbily dressed man. In this case a boy, who has yet to go through puberty, walks into a bedroom in which a young woman sits fondling her own breasts. She seems oblivious of the presence of the boy who stares at her. Usually, Delvaux's women are chaste, their sexual drives hidden. In this scene, however, he broaches more intimate experiences, revealing a moment of sexual shock, which is heralded by the angels in the decorations on the ceiling. If female desire is made plain in this picture, the woman is withdrawn, unaware of being watched. The work possesses great detail, and Delvaux has given each hair a stroke of paint, each piece of wood a delicate grain. He loved pale colors and long crisp shadows.

Delvaux's style reflected a number of sources. Clearly, Magritte and de Chirico were among them, but there were also some element of Renaissance artists such as Piero della Francesca. Although the Surrealists treated him with a certain distance, Delvaux's works were very popular with collectors.

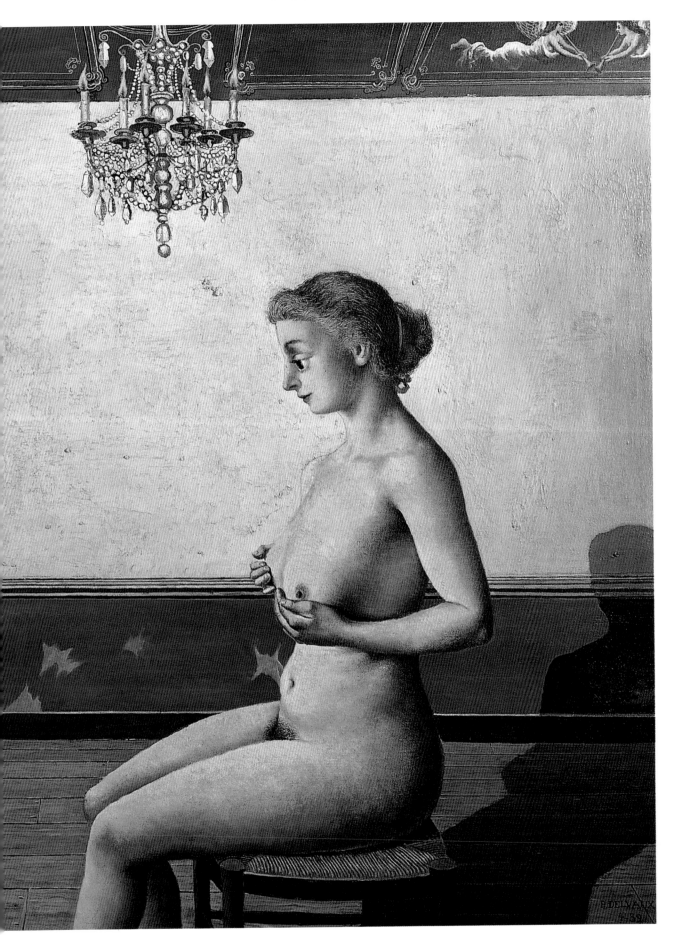

MATTA (1911–TO DATE)
The Disasters of Mysticism, 1942
Courtesy of Topham

ROBERTO Sebastian Antonio Matta Echaurren, or Matta as he was known, was a Chilean who was one of the most talented artists to join the Surrealists during their wartime exile in New York. Arriving in 1939, he developed a mature style very quickly, without working through Cubism or Dada. Matta had a considerable interest in magic, tarot cards, the Cabala, and similar literature, which he combined with the Surrealist methods of chance and automatism. He also shared Duchamp's interest in alchemy. He worked with great speed and concentration, often rubbing the paint onto the canvas with a rag and spreading it around to suggest hills and valleys. Some of the drawing in this canvas was made by scraping through existing paint to the colors below.

Yves Tanguy (1900–1955)
A Large Painting which Represents a Landscape, 1927
Private Collection, Tokyo. Courtesy of Giraudon. (See p. 156)

Matta's major influences as an artist were other Surrealist painters, such as Tanguy and Duchamp. One critic remarked that his landscapes recalled the paintings of Tanguy, as if in a blurred photograph. In *The Disasters of Mysticism*, Matta projects the shapes and spaces of his inner life and state of mind. Organic shapes pass through thick vapors or harden into diamond-shaped crystals. The rounded shapes of biological life are pulled and pushed by forces that seem to reside in the landscape itself.

MATTA (1911–TO DATE)
Against Your Assassins from Palomas, 1950

Cantini Museum, Marseilles. Courtesy of Giraudon

AROUND 1942 Matta stopped making landscape compositions and started working more in the manner of Miró, abandoning the use of a horizon line. Instead, there emerged in his work deep spaces which were more like a cosmic space that lies beyond human reach, either because it is too far away or so interior as to be inaccessible. The work becomes a journey into unknown space and the unconscious. The eye, however, does not have an easy journey in these pictures. It moves through thick fogs and is blocked by curiously shaped floating obstructions. Some of this work was made on large canvases that enhanced their drama of space and form.

This painting demonstrates Matta's increasing interest in science, which led to a series of paintings which some critics have regarded as illustrations of science-fiction stories. In this steeply angled view, a group of machines rush through a room. The painting is filled with the lines and forms of man-made objects, with the organic reduced to a small fruit lying on the floor. This version of science through the poet's eye was made, however, at a point when Surrealism had lost its greatest powers.

MATTA (1911–TO DATE)
Composition, 1966
National Museum of Modern Art, Paris. Courtesy of Giraudon

*T*HIS painting was a summation of Matta's many different styles of the previous 25 years. It captured in one image his many attempts to picture reality through the most advanced means at his disposal. This included the skeletal and biological forms in the background and reflected his interest in biological growth and germination. Walls have been used to separate out smaller sections of the canvas and each "room" contains structures similar to satellites, space ships, or laboratories. They also hint at the machines once made by Picabia and featured in *Parade Amoureuse* (1917) to refer to sex. In the very center, Matta created a more brightly colored assembly of forms that hovers between organic and machine shapes. Matta was of interest to some of the American Abstract Expressionists, who were particularly impressed by the effects of his large canvases although they rejected his illusionist style.

In 1954 Matta commented that: "an artist will only be actual if his work enters the two-way traffic of receiving from his people the consciousness of needs they have detected in themselves, and, as an artist, charges this consciousness with an intuition of important emotion, thus sending it back to widen their picture of reality."

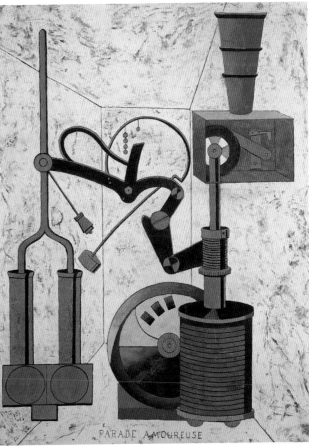

Francis Picabia (1879–1953)
Parade Amoureuse, 1917
J.L. Stern Collection, New York. Courtesy of Giraudon. (See p. 62)

PAUL NASH (1889–1946)
Landscape from a Dream, 1936–38
Courtesy of the Tate Gallery

*I*N Britain, Surrealism had a mixed reception. Although many artists and critics reacted hostilely, Paul Nash, who trained at the Slade School, was widely accepted as an artist of worth. He was official artist in both the First and Second World Wars—in the latter despite his interest in Surrealism. Initially, he wanted to be a landscape painter, but began to experiment with Cubism and Constructivism. After seeing works by de Chirico, he began to paint objects in isolated settings. Nash's work was then admired by the French Surrealists, who saw in it some of the intensity of de Chirico's early metaphysical paintings and he was invited to show in their 1936 London exhibition. Nash began *Landscape from a Dream* after the exhibition, meaning to return to his initial interest in landscape. The result was a seaside scene set with enigmatic objects from his earlier work. He sought the qualities of dreams and the unconscious, as was usual in Surrealist works. To intensify this effect, he used mirrors and painting within a painting.

Britain produced a number of artists and critics who were influenced by Surrealism. This group kept their links with European Surrealism throughout the war. The results of the links were visible well into the post-war period, in the work of such artists such as Henry Moore and Francis Bacon.

FRANCIS BACON (1909–92)
Three Studies for Figures at the Base of a Crucifixion, 1944
Courtesy of the Tate Gallery

*F*RANCIS Bacon began his career as a decorator. In this trade he developed a level of skill and understanding of paint that allowed him a great freedom of experimentation when he began painting pictures. His studio was always cluttered and dusty, even when he had become one of England's most famous living painters. It was this dust that he swept into his paint to produce a particular type of granulated dry smudge. In 1939 he turned to Surrealism, destroying most of his earlier work, which had been strongly influenced by Picasso, and he considered this painting to be his first success in the new style.

This image is at once irreverent, disturbing, and moving. Its title states that these creatures are standing at the base of a crucifixion, although they appear on a violent red background with hints of a linear architectural space. Bacon identified these half-human, half-animal figures as the Classical Furies, who wrought revenge upon the guilty. They howl, grin, and twist, either in grief or in vengeance. These Classical Greek beasts seem to mock the Christian belief in the suffering of Christ, while producing their own innate sense of terror and disaster.

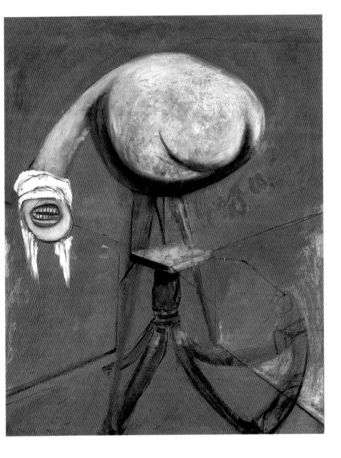

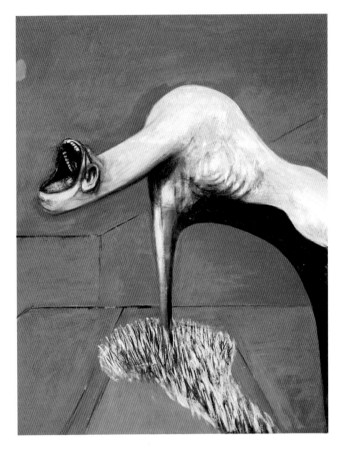

MARC CHAGALL (1887–1985)
The Poet Reclining, 1915
Courtesy of the Tate Gallery

*C*HAGALL was born in Russia into a large Jewish family. Moving to Paris in 1907, he began to paint in a style that the critic and poet Apollinaire called "*surnaturel*" as early as 1912. Chagall was in Paris to see the advent of Cubism, although he felt that painting required more "freedom" than this style allowed.

In the foreground, he has used flat Cubist planes to sketch out the face and figure of a sleeping poet. In the middle ground he has used a primitive, naïve style to depict a scene from the Russian countryside. A pink morning sky unifies the shifts in style and space into a single dream-like image. This canvas was painted in Russia, to which Chagall returned on the outbreak of the First World War. For the next eight years he stayed there, isolated and unable to travel.

Chagall returned to Paris in 1922, during the formation of the Surrealist movement. He particularly admired the group's use of literary techniques and their representation of stories. Although his work seems inspired by automatism and free association, it was not. He disliked this method and its claim to uncover the working of the unconscious. As he said: "for my part, I have slept well without Freud."

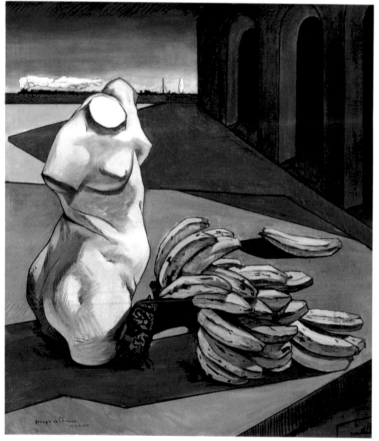

Giorgio de Chirico (1888–1978) *The Uncertainty of the Poet, 1913*
Courtesy of the Tate Gallery. (See p. 20)

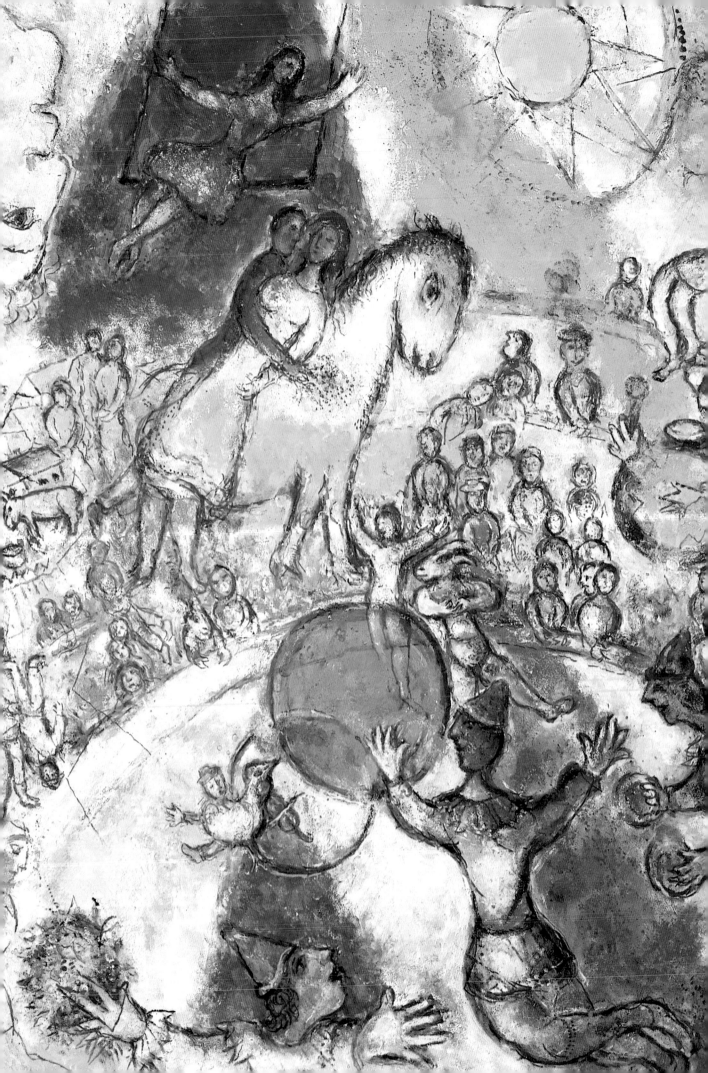

Marc Chagall (1887–1985)
Circus in the Village, 1966
Courtesy of Christie's Images

*C*HAGALL'S paintings are often noted for their fantasy and symbolism in the same way that Magritte adopted in *The Great War* (1964). Yet he said that he was against the terms "fantasy" and "symbolism," pointing out that because our interior world is reality "... To call everything that appears illogical, 'fantasy,' fairy-tale, or chimera—would be practically to admit not understanding nature."

This painting was laid out on a base of red, blue, and yellow— strong primary colors. On this, Chagall worked in black to develop a scene based upon his memories of a visit to the circus. He captures the drama and excitement of the performance and the romantic themes of love. In the center he has included a motif of a couple permanently attached as a single body. Many circus scenes have been added together to create a single, condensed memory of an event.

While some of Chagall's paintings were somber and dignified, he also loved the theater, and designed many stage sets and costumes for ballets in Russia and America. As can be seen in this painting, Chagall loved strong color and black line drawing, a style he also used in his stained glass windows and printed illustrations of the Bible.

René Magritte (1898–1967)
The Great War, 1964
Private Collection. Courtesy of Giraudon. (See p. 229)

ARSHILE GORKY (1904–48)
The Waterfall, c. 1943
Courtesy of the Tate Gallery

GORKY was born in Armenia and moved to America where he met Matta and Breton. It was their influence which drew him away from Picasso toward Surrealism. Desperately poor during the Depression of the 1920s, Gorky stayed in several country retreats at this time; places which helped bring back memories of his childhood in Armenia, and convert them into memory landscapes in a Surrealist language. The waterfall of the title was near some of his favorite meadows. He visited them to study the flora and fauna, then returned to the studio to incorporate the studies into paintings of fantastic imaginary landscapes and creatures, but without the detail seen in *The Dream* (1910) by Rousseau. Here, the paint has been applied in thin, watery sheets to accentuate the qualities of the original scene.

Gorky was a powerful influence in American art, and to this extent his interest in abstract painting was also important. He became fond of the work of the Russian painter Kandinsky, who had painted some of the first abstract paintings of the century. They were based on the late work of Monet, with large fields of powerful, luminous color. The traditions developed by Gorky in a more figurative style, have since returned to abstraction in the hands of Mark Rothko and Barnett Newman.

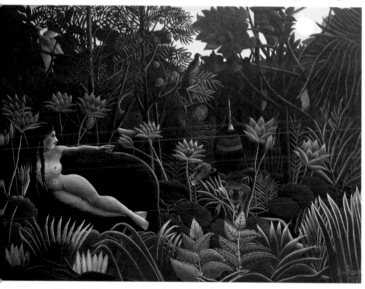

Henri Rousseau (1844–1910)
The Dream, 1910
M.O.M.A., New York. Courtesy of Topham. (See p. 16)

ARSHILE GORKY (1904–48)
Year After Year, 1947
Courtesy of Christie's Images

*I*N Gorky's experiments with the fine line between imagery and abstraction, he often ended up with forms and shapes that suggested animals and genitals. It was as if he were playing with the shift between abstraction and figuration, just as he played with the shift between inorganic and organic. There were many ways in which Gorky balanced his paintings. They were half figures, half abstract background; they were half-playful figures, half-dead earth; they were half-deep illusions of space and half-flat canvas surfaces. This constant shifting of qualities gave the paintings great dynamism and tension.

By 1947, Gorky was still working with the thin color of previous works, but laid on more lightly and sparingly. This painting is lighter in hue than the darker canvases of the early 1940s. This lighter application of paint allows the raw canvas to show through and demonstrate the absorbency of the material, as in this scene showing a watery landscape with damp-looking forms. Given their large size, the works were a revelation to a group of young New York painters who were then forming under the banner of "Abstract Expressionism." The use of bare canvas, for example, can be seen in the work of Jackson Pollock, such as *Alchemy* (1947).

Jackson Pollock (1912–56)
Alchemy, 1947
Courtesy of Giraudon. *(See p. 254)*

JACKSON POLLOCK (1912–56)
Two, 1945

Guggenheim Museum, Venice. Courtesy of Giraudon

*T*HE Surrealist movement largely survived the war, but it did not thrive in the peace that followed. A major exhibition in 1947 was badly received and, apart from some paintings from Gorky, contained no new work. As Surrealism seemed about to collapse, American painters were gathering under a different set of concerns. These painters, of whom Pollock was one, still maintained an interest in Surrealist techniques. Pollock also had considerable interests in psychoanalysis, particularly the work of Carl Jung. The idea that a painting could represent the unconscious, first mooted by Breton, was very attractive to Pollock, and he would often claimed to be "painting out of his unconscious."

This important painting was made when Pollock started to drift away from figurative painting toward completely abstract painting. For some time he had been making pictures of floating figures, which he understood to be characters from his own unconscious mind. Pollock went to a psychoanalyst for two years, and

Joan Miró (1893–1983) *The Lovers, 1934*
Courtesy of Christie's Images. (See p. 132)

was encouraged in his work with primitive images such as wolves, women, and the moon. Pollock felt that he had self-destructive and violent urges, which erupted between more protective and feminine aspects of his personality. It is these two forces that play across this composition in the form of the two standing figures.

JACKSON POLLOCK (1912–56)
Alchemy, 1947
Courtesy of Giraudon

THIS painting was one of a series prepared by Jackson Pollack for an exhibition that left the New York art world stunned and bemused. Pollock demonstrated his break with figurative painting by burying loosely drawn figures under a dense network of dripped lines, made while laying the canvas on the floor. This technique, which earned him the nickname of "Jack the Dripper," recorded the artist's gestures through its delicate skeins and pools. Pollock limited his use of color in order to emphasize gesture, line, and

the literal surface, yet removed any trace of direct contact between the artist and the canvas.

Seen from the right distance, these abstract paintings shifted from total flatness to an illusion of spatial depth. The appearance of space in the paintings, made by lines that never enclosed anything, led an increasing number of critics to hail them as "the triumph of American painting." While Pollock's drip paintings clearly owe a debt to Surrealist interests in painting the unconscious, using techniques of automatic writing and chance composition, they are not illustrations in the manner of Dalí or Tanguy. Among the Surrealists, only Arp and Miró used abstraction so boldly.

AUTHOR BIOGRAPHIES AND ACKNOWLEDGMENTS

For Lynn and George

Tim Martin has a BA from Dartmouth College in the U.S.A., and further degrees from Oxford University and the University of London. He is currently preparing a doctoral thesis on Robert Smithson, which utilizes the work of the psychoanalyst Jacques Lacan. Mr. Martin has written numerous magazine and journal articles on contemporary art, and teaches History of Art at the University of Reading. He is also the presenter for the forthcoming television series *Landmarks in Western Art*.

Dr. Mike O'Mahony studied History of Art at the Courtauld Institute of Art where he completed his doctoral thesis on Official Art in the Soviet Union between the Wars. He has taught at the Courtauld Institute, Winchester School of Art, and Reading University as well as lecturing at the Tate Gallery and the Victoria and Albert Museum.

Every effort has been made to contact copyright holders. We apologize in advance for any omissions and would be pleased to insert the appropriate acknowledgment in subsequent editions of this publication.

While every endeavor has been made to ensure the accuracy of the reproduction of the images in this book, we would be grateful to receive any comments or suggestions for inclusion in future reprints.

With thanks to Image Select and Christie's Images for their assistance in sourcing the pictures. Grateful thanks also to Frances Banfield, Lucinda Hawksley, Helen Courtney, and Sasha Heseltine, and to Karen Villabona for valuable editorial help.